Switchbacks

Jennifer Kramer

Switchbacks
Art, Ownership, and Nuxalk
National Identity

UBCPress · Vancouver · Toronto

15 14 13 12 11 5 4 3 2

Printed in Canada on acid-free paper.

Library and Archives Canada Cataloguing in Publication

Kramer, Jennifer
 Switchbacks : art, ownership, and Nuxalk national identity / Jennifer Kramer.

Includes bibliographical references and index.
ISBN-13: 978-0-7748-1227-6 (bound); 978-0-7748-1228-3 (pbk)
ISBN-10: 0-7748-1227-3 (bound); 0-7748-1228-1 (pbk.)

 1. Bella Coola Indians – Ethnic identity. 2. Bella Coola Indians – Material culture. 3. Bella Coola art. 4. Cultural property – Repatriation – British Columbia – Bella Coola Region. I. Title.

E99.B39K73 2006 971.1'10049794 C2006-900159-6

Canadä

UBC Press gratefully acknowledges the financial support for our publishing program of the Government of Canada through the Book Publishing Industry Development Program (BPIDP), and of the Canada Council for the Arts, and the British Columbia Arts Council.

This book has been published with the help of a grant from the Canadian Federation for the Humanities and Social Sciences, through the Aid to Scholarly Publications Programme, using funds provided by the Social Sciences and Humanities Research Council of Canada, and with the help of the K.D. Srivastava Fund.

UBC Press
The University of British Columbia
2029 West Mall
Vancouver, BC V6T 1Z2
604-822-5959 / Fax: 604-822-6083
www.ubcpress.ca

Contents

Maps

Acknowledgments

This book would not have been possible without the generosity and hospitality of the *Nuxalkmc* who shared their lives, their culture, and their spirit. I especially would like to acknowledge William and Merle Tallio, my adoptive parents, who opened their hearts and their home to me. I would also like to thank Karen Anderson, Dana Drugan, Evelyn Hopkins, Kathleen King, Alvin Mack, Joe Mack, Barbara Schooner, Darlene Tallio, and Peter Tallio, who gave unstintingly of their knowledge and friendship. Chiefs Lawrence Pootlass, Ed Moody, Derrick Snow, and Archie Pootlass made this research possible. I appreciate the time they spent with me and the viewpoints they shared. The students of *Acwsalcta* made my experiences in Bella Coola worthwhile. Many more could be thanked, but you know who you are. *Stutwinitscw*!

I have been inspired by the scholarship of Charlotte Townsend-Gault concerning the political agency of contemporary First Nations artists and their art. The significance of her guidance and encouragement go unmeasured. I am grateful to Alexander Alland, Jr., David Koester, Nan Rothschild, Enid Schildkrout, and Diana Fane for their mentorship and advice while I was a graduate student at Columbia University. I thank William and Shirley Corbeil, art brokers, who first introduced me to a number of Nuxalk artists and whose direction made my journey to Bella Coola all the easier. I have benefited from and am indebted to the writings of John Barker, James Clifford, Douglas Cole, Julie Cruikshank, Nelson Graburn, Aldona Jonaitis, Daniel Miller, Fred Myers, Ruth Phillips, Chris Steiner, Marilyn Strathern, Nicholas Thomas, and Annette Weiner. I wish to acknowledge the expert assistance and patience of Jean Wilson, Senior Editor, and Holly Keller, Production Editor, at UBC Press. Their confidence in this text is much appreciated. Finally, I would like to recognize Louisa Cameron, Diantha Frankort, Aaron Glass, Sharon Koehn, Megan Smetzer, Ingrid Summers, Terre Satterfield, and Rob Van Wynsberghe for being a warm and supportive cohort, providing constructive criticism, and, more important, sharing their enthusiasm and

encouragement. Of course I take responsibility for the final product, and any errors or omissions are my own.

I am grateful for research and fieldwork funding provided by the US National Science Foundation (Arctic Social Sciences Program), 1996-98; the Wenner-Gren Foundation for Anthropological Research (Research Grant), 1996-97; the International Council for Canadian Studies (Graduate Student Fellowship), 1996-97; and the Whatcom Museum of History and Art (Jacobs Research Grant), 1996-97.

This book is dedicated to my husband, John Michael Treacy, and to my parents, Fred and Janet Kramer. Their continued belief in me and love for me sustained this project to the end.

Prologue: The Repatriation of the Nuxalk Echo Mask

In August 1995, during my initial field visit to Bella Coola, I attended a wedding anniversary feast in the Nuxalk hall. First we ate, then there were speeches, and finally there were what the Nuxalk termed "Indian dances." This was my first encounter with Echo. Echo is a supernatural creature known by the Nuxalk from when they first descended to the Bella Coola Valley from above, thousands of years ago. It is said that Echo (or *sats'alan* in Nuxalk) was very clever at learning languages and so acted as a herald to call people to dances. He often imitated the voices around him and possessed a proud and aristocratic disposition (McIlwraith 1992, 1:46, 306; 2:274). The Nuxalk represent Echo with a masked dancer, who performs a specific choreography of mouth changes, while a song about Echo's activities is sung in Nuxalk (*Coast Mountain News* 1990a, 15; Sandoval 1997, 9).[1] The mask I saw danced was painted bright green with circular bulging eyes, swirly eyebrows, and a shock of hair on top. Bright red mouths were inserted representing different facial expressions. I remember I was very impressed with Echo; its features were mesmerizing, its eyes hypnotizing. I felt an intensity of meaning but could not pinpoint its source because I was not given an explanation of Echo's value to the Nuxalk. No story was told to go with the mask, the song, and the dance steps. It appeared to me a mystery or a secret, and, at the time, I could not ask for an explanation.

I witnessed this performance only once, because two months later, in October 1995, a Nuxalk elder of Bella Coola sold the mask to a non-Native art dealer from Victoria for Cdn$35,000. This particular mask had been photographed in 1924 by anthropologist Harlan Smith (Tepper 1991, 139-41). The mask, which is believed to be over 140 years old, was passed down through the generations, gaining an incredibly complicated genealogy both in the minds of the Nuxalk who remember and the scholars who photographed and recorded its existence.

There is much contention in Bella Coola over who owns this Echo mask. As one Nuxalk man told me: "Too many people owned it. The people owned

it ... Everybody wanted it, like it was everybody's mask, so many families. Even today I don't know who it belongs to. It was always in dispute as long as I can remember. It is family-owned, but a big family." I was told by various members of different Nuxalk families how they could claim or had claimed ownership of this mask. There are two interconnected explanations for this confusion. First, the Nuxalk, like many First Nations in British Columbia, had their population decimated due to diseases brought by European and American explorers and settlers. The Nuxalk were most affected by the 1862-63 smallpox epidemic. Families were so reduced that there were many interfamily adoptions, which wreaked havoc with the traditional inheritance of chiefly status and secret society membership, thus creating a tangle of crests. The second explanation for this confusion, which partially stems from the first, is that it is not remembered whether this particular Echo mask is a secret society (*kusiut*) or chiefly (*sisaok*) privilege; consequently, there is much uncertainty about its ownership before the epidemic. In any case, the Nuxalk elder who sold the Echo mask probably did so to get rid of an object that was causing much interfamily squabbling.[2]

It is curious that the selling of the physical mask seems to have stopped the dance's performance in Bella Coola for a number of years. As the art dealer told me, he bought the physical mask, not the rights to perform the Echo masked dance. Technically, another Echo mask could have been carved and been used in the dance.[3] In fact, the art dealer claims he had a copy of the mask made for the elder. I have no knowledge of whether this is so, although I do know there exists at least one, and maybe two, recently carved Echo masks in the Bella Coola Valley. Perhaps the contentions in Bella Coola over ownership made the public performance of the Echo dance impossible as it would have caused too much dissent. But the elder's act did not end the problem of ownership: it merely transferred it out of the valley into an international arena.

The art dealer who bought the Echo mask stripped off the green paint to reveal a much older blue paint beneath - a cobalt blue called "Nuxalk blue" and considered to be representative of the traditional Nuxalk art style (Holm 1965, 26). The art dealer found a buyer in Chicago who was willing to pay approximately US$250,000 for the mask, but his plans to sell it were squelched when the Canadian government, citing Canada's Cultural Property Export and Import Act (Canadian Statutes Chapter C-51), refused to grant an export permit for such an important piece of Canadian heritage.[4] This 1977 act defines "Canadian cultural property" and thus, by trying to prevent sales outside of Canada, serves as a barrier against the loss of this property (Walden 1995). Specifically, under this act the Canadian Cultural Property Export Review Board has jurisdiction to delay granting export permits to any object:

- of outstanding significance by reason of its close association with Canadian history or national life, its aesthetic qualities, or its value in the study of the arts or sciences; and
- is of such a degree of national importance that its loss to Canada would significantly diminish the national heritage. (Walden 1995, 205)

An expert examiner, chosen by the government, determines whether or not an object falls under this category. If it does, then the delay period is to be used to alert Canadian institutions, mostly museums and cultural centres, to arrange an internal sale in order to keep the cultural property within the country. The federal Department of Heritage has an annual budget to provide matching funds to Canadian institutions that want to purchase those objects determined to be cultural property.

In the case of the Echo mask, the expert examiner determined that the mask was "rare," that it had "associated documentation," and that "its export from Canada would result in an irreplaceable loss to the moveable cultural heritage" (Alan Hoover, personal communication, 17 April 1998). Therefore, in January 1996 he recommended against issuing an export permit. Subsequently, a six-month delay period was granted to allow the Cultural Property Export Review Board to identify a Canadian institution that would purchase the mask.

Up to this point no one in Bella Coola knew that the Echo mask was gone because it had been sold in secret. The chair of the archaeology department at Simon Fraser University alerted the Nuxalk band council that the mask had been sold out of the valley (Phil Hobler, personal communication 16 March 1998). He knew this because the Museum of Archaeology and Ethnology at Simon Fraser University had been offered the chance to buy it. Once the Nuxalk found out about the mask's sale, they mobilized to ensure its return to the valley. The actions of the Canadian government had given the Nuxalk Nation a few months to make a bid to win institutional status for their cultural centre and then to buy back the mask with federal money from the Department of Heritage.

Because the delay period was quickly running out, the Nuxalk band council decided to sue the art dealer. They claimed that, under traditional Nuxalk law, the elder who sold the mask should be considered its custodian rather than its owner and that, therefore, she had no right to sell it. They took the dealer to civil court, and the case was heard in the British Columbia Supreme Court. The court imposed a longer interim waiting period, placing the mask in the custody of the Royal British Columbia Museum in Victoria until a resolution could be worked out between the Nuxalk Nation and the art dealer. Although the case was eventually settled out of court, it may have given the Nuxalk Nation leverage against the dealer. The use of the

court injunction to stave off the immediate sale of the mask outside of Canada was publicized in newspaper articles from Victoria to Toronto and carried sufficient negative publicity to convince the dealer that the mask should be sold within Canada to Nuxalk buyers (Canadian Press Release 1996a and b; McDowell 1996; Todd 1996). Although the dealer continued to proclaim his legal right to buy the mask, in the out-of-court settlement he agreed to allow the Nuxalk Nation to buy it back. The mask was purchased for Cdn$200,000. Most of the funds were provided by the Canadian Department of Heritage, with a portion being donated by the art dealer himself. The mask thus became the property of the Nuxalk Nation as a whole in December 1997. The elder who had sold it was no longer involved in the mask's care.

The Nuxalk Nation publicly welcomed the mask's return. It now resides in a display case in the foyer of the local Bella Coola bank, taking the place of an automated banking machine (Kuhn 1997). The label beneath the mask reads:

> The Echo mask belongs to the Nuxalk people. The Echo mask is a ceremonial mask which was carved in 1860 by a Nuxalk master carver. The mask is carved from alder, it has 6 interchangeable mouth pieces and has its original horse hair attached to the forehead. The Echo mask dance was performed as recently as 1995 at a winter ceremony.
>
> The Nuxalk Nation were successful in preventing this sacred mask from being sold to a Chicago art collector. The Echo mask was repatriated to the Nuxalk people in November [sic], 1997.
>
> The Nuxalk Nation are grateful to the federal government for their assistance in the repatriation of this very important mask to the Nuxalk people. We are also grateful to the Williams Lake and district Credit Union for their assistance in storing and safekeeping of this mask.
>
> *Stutwinitscw^s* – Nuxalk Nation

Traditionally the mask would have been hidden out of sight to be brought out only for specific winter ceremonies and potlatches. It is now on twenty-four-hour display, visible to all who walk by the bank. The choice of the mask's location was based on a compromise between the Nuxalk Nation and the Canadian Cultural Property Export Review Board, who did not think that the Nuxalk community centre was sufficiently safe to prevent theft.

Aware of this, I was concerned about whether I had the right to photograph the Echo mask in its new location. I had meant to ask the elected band chief when I interviewed him in June of 1998, but ran out of time. Instead I queried the bank's non-Native employees regarding whether there were any stipulations about outsiders photographing the mask. After sequestering themselves in a back room, they came out and told me it would

be fine if I photographed the Echo mask as long as I did not photograph the bank itself! They were concerned more for the safety of the bank than the safety or sacredness of the mask!

Discussion

I begin with this story to alert the reader to the fluidity of material cultural objects and the complexities of exchange, which are the main foci of *Switchbacks*. I shall return to this case study in Chapter 5, but it is offered here to invoke the themes of this book: (1) the difficulties of determining ownership of cultural objects; (2) the Nuxalk use of cultural heritage as proof of nationhood; (3) the significance of Nuxalk entanglements within Canadian law and the Western art market; (4) the relationship between selling Nuxalk art (viewed as commodification) and the creation of contemporary Nuxalk identity; and (5) the Nuxalk's strategic use of accusations of cultural appropriation.

In general, I focus on the anxieties and ambivalences manifested by the Nuxalk as they negotiate interactions with outsiders. I propose that the Nuxalk oscillate between opposing stances (which I will refer to as Position A and Position B) – a paradoxical yet effective strategy. Position A: The Nuxalk take a stance of "strategic essentialism" (Spivak 1987, 1993), which I term "self-objectification," in order to remain free from external definitions. This self-proclaimed identity cannot be disputed because it relies on the hard limits of an asserted unity. Ironically, it was anthropologists who first labelled "Nuxalk culture" as fixed and unchanging. Position B: The Nuxalk make use of their right to a dynamic and flexible strategy – employing Canadian federal law when it supports their cause but relying on Nuxalk law, which predates the Canadian legal system. They wish to be full participating members in a thriving art and souvenir market, recognized as possessors and creators of "authentic" First Nations art. This art can be considered "inalienable": valued in an international art market as a salable commodity yet also opposed to that market, which is perceived as being alienating to Nuxalk national identity.

In this book I use the term "switchbacks" to evoke this oscillating movement between two poles. I selected this term for its rigidity: a switchback road zigzags back and forth between fixed points, much like the essential positions that the Nuxalk employ rhetorically, if not actually. Yet, while seemingly static, a switchback does eventually move forward. Although the Nuxalk sometimes deny the influence of the non-Native world, it is my premise that it is precisely their entanglement with the outside that creates and validates contemporary Nuxalk identity.

The first half of Chapter 1 introduces my research topic and some foundational issues in the field of Northwest Coast First Nations art. The second half discusses fieldwork in Bella Coola and my use of the term "switchbacks."

Chapter 2 explores the conceptualizations of theft and its complexities within Nuxalk history and culture, along with the related issue of ambivalence. Chapter 3 examines the cultural context of selling art and the resulting debates. Chapter 4 describes and interprets my fieldwork experience at the Nuxalk band school known as *Acwsalcta*, or "Place of Learning." Chapter 5 addresses "physical repatriation" in the contentious case study of the Nuxalk Echo mask and compares this strategy of national identity construction to that of the "figurative repatriation" of the Nuxalk Sun mask while it was part of the museum exhibition entitled Down from the Shimmering Sky: Masks of the Northwest Coast. Chapter 6 discusses the place of contemporary theft and accusations of cultural appropriation in Nuxalk lives, both inside and outside Bella Coola. Finally, Chapter 7 concludes with an examination of the relevance of an ownership-based rhetoric for today's Nuxalk as they seek recognition of their national identity and self-determination.

In these chapters I explore attempts by the Nuxalk to negotiate such complex issues as: Who owns culture? What constitutes "authentic," or "traditional," cultural practice? How should cultural practices be transmitted to future generations? Where does selling and buying Nuxalk art fit into these attempts to regain control of heritage? Overall, I chart and analyze the Nuxalk's ambivalent reactions to both ownership and appropriation of their culture and discuss how these very anxieties and their resulting actions create contemporary Nuxalk identity.

Switchbacks

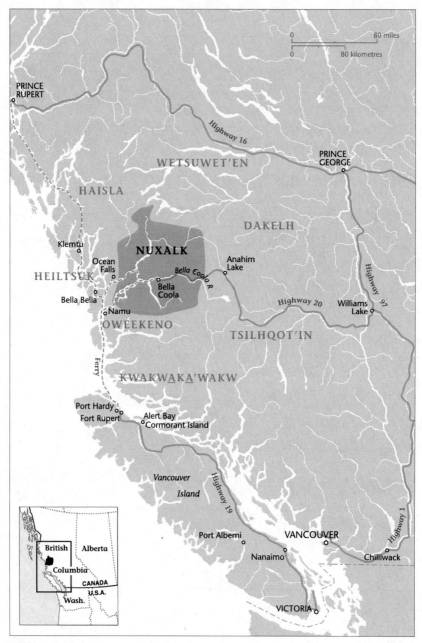

Map 1 Traditional territory of Nuxalk Nation in relation to other central coast First
Nations in British Columbia

1
Introduction

Beginnings

This book is the result of sixteen months of fieldwork in the town of Bella Coola, British Columbia, Canada, conducted between June 1995 and November 2001. An additional three months of fieldwork were completed in the City of Vancouver, British Columbia, prior to my residence in and travels to Bella Coola.

I chose Bella Coola, the home of the Nuxalk (pronounced *new hulk*) Nation, as my field site after spending the summer of 1994 trying to understand the various relationships between First Nations[1] Northwest Coast art and the Western art market system of galleries, auction houses, and museums in Vancouver. My attention was initially drawn to these entanglements when a cooperative of Nuxalk artists from Bella Coola held an exhibition of their artwork at the Harrington Art Gallery in Vancouver in May 1994. The exhibition was entitled Valley of Thunder: Art of the Nuxalk Nation from Bella Coola, BC, and it was billed as constituting the first time a Northwest Coast tribal group had collectively chosen to display their art under the banner of nationhood. What intrigued me most about this was the fact that the nation was Nuxalk, a group whose material culture had been severely underrepresented in the many art galleries I visited in Vancouver. Even the older name for Nuxalk, Bella Coola, was rare in this venue. In response to my questions most art gallery owners informed me that, of all the nations of the Northwest Coast, the Nuxalk of Bella Coola was the only one not experiencing a cultural revival. With my interest piqued, I decided that a trip to Bella Coola was the only way to get to the heart of the matter.

I spent the following summer of 1995 in Bella Coola and was amazed to find a place filled with artists producing a startlingly broad array of art objects, from carved masks, paintings, and silk-screened prints to silver and gold jewellery, beaded hair barrettes, and T-shirts. I quickly realized that the Nuxalk were indeed experiencing a cultural revival, yet very few of the art objects being made were reaching Vancouver and a non-Native art clientele.

I probed further and discovered that the primary reason for the lack of Nuxalk art on display and for sale in Vancouver was the presence of a significant, but diffused, pressure placed upon local Nuxalk artists not to sell their art outside the Bella Coola Valley. In fact, the Harrington Art Gallery exhibition had generated much controversy in Bella Coola regarding whether such important cultural materials as dance masks, button blankets,[2] and even paintings of supernatural spirit figures should be sold to a non-Nuxalk audience (Stainsby 1994).

Some hereditary chiefs were aghast, arguing that an art exhibit with the solitary purpose of sales and monetary profit is a desecration of Nuxalk heritage as well as a negative commentary on what it means to possess Nuxalk identity. As one artist whose work was in the exhibition told me: "They figure we're selling our culture." Those who held this view associated commodification with a loss of Nuxalk identity. On the other hand, some Nuxalk, including the elected chief and council, seemed encouraged by the fact that contemporary Nuxalk artists were working together as a group under the label "Nuxalk Nation" to gain recognition from outside the community (along with commercial sales). Nor were these individuals disturbed by the selling of contemporary copies of individually or family owned objects or images that might have continued spiritual significance. Ultimately, what I discovered was the existence of a diversity of opinion among the Nuxalk regarding issues related to identity, ownership, old and new ways of conceptualizing and passing on cultural property and knowledge, and the meaning and utility of commodification. Upon visiting Bella Coola and talking with various Nuxalk I quickly realized that the important question was not "Is cultural revival happening here?" but "Why is there so much anxiety revolving around issues of exposing your culture and its evident flourishing to outsider eyes?" This initial introduction to the Nuxalk Nation focused my attention on the significant concern expressed by the Nuxalk about experiencing cultural appropriation. Nuxalk discussions of their art and culture almost always seem to end up expressing a fear of theft and what is risked by selling, or even merely showing, Nuxalk art outside of Bella Coola.

Theoretical Underpinnings and Objectives

The object of *Switchbacks* is to investigate how Nuxalk art is used to negotiate identity in Bella Coola. It is my premise that, among the Nuxalk, artists play a crucial role in cultural revival and the production of contemporary Nuxalk national identity. Through their art Native artists mediate the differing agendas of political leaders, everyday Nuxalk art consumers, and scholars. Paradoxically, although contemporary art is crucial to the Nuxalk, most gallery owners in Vancouver, Victoria, and Seattle are not aware that it exists. This is in part due to non-Native scholars who view contemporary

Nuxalk art as inferior and of little value when compared to older, supposedly "aesthetically superior," examples residing in museums. Yet, Bella Coola is rich in Native art production.

There is a lingering scholarly belief that material collected in the late nineteenth and early twentieth centuries and housed in Western museums represents the pinnacle of Northwest Coast art because it is used as the standard by which traditionalism in Native art is judged (King 1986, 70). Traditional art-historical analysis plots art styles on a bell curve of innovative nascence, classical apex, and decadent and static dénouement. Meyer Schapiro labels this the "organic conception of style" that "attributes to art a recurrent cycle of childhood, maturity, and old age, which coincides with the rise, maturity, and decline of the culture as a whole" (Schapiro 1953, 296).

Nineteenth-century cultural evolutionists tended to designate as "corrupt" or "degenerate" any non-Western art that displayed change from a so-labelled "traditional" or "authentic" culture. Thus non-Western art that displayed a hybridity of design by incorporating both Native and non-Native styles or media, and that was made to sell in an external market, was treated as inferior and as evidence of the culture's decline as a whole (Ettawageshik 1999, 28; Phillips 1998, 18). Ruth Phillips summarizes the problem: "In consequence, change has been represented as a decline from authenticity rather than as a dynamic and progressive development, as it is asserted to be in the narratives of Western art history and other 'great traditions'" (Phillips 1998, 168).

Anthropologists inadvertently retain the residues of this cultural evolutionist thinking combined with art history's ideals of what constitutes a "pure" aesthetic style, with the result that First Nations get weighed down by this almost invisible classification system. Following these evolutionist models leads to quality judgments that relegate contemporary Native art to a lower-level niche than that occupied by older Native art, thus adversely affecting the appreciation and recognition of contemporary Nuxalk art.

However, I see no reason to assume that art styles develop in an orderly progression towards a pinnacle. Nor do I assume that objects made for sale deserve to be rejected as inauthentic. My project in part considers why there is such a wide discrepancy between Native and non-Native perceptions of Nuxalk art. Specifically, I investigate how art gains cultural currency with certain people in certain places and times. This requires examining art production, use, and education from the vantage point of the present-day Nuxalk rather than from a scholarly constructed past.

Art and Identity Construction: Art as Argument
As many anthropologists have concluded, art represents identity, both individual and national. Many have written about the art of the Northwest Coast as property (objects) that tells us about the ownership of clan names,

land, resources, responsibilities, and/or honours (e.g., see Boas 1955; Codere 1966; Halpin 1994; Suttles 1991). Although I view this interpretation of the function of Northwest Coast art as important and valuable, this is not the focus of *Switchbacks*, which, rather, rests upon the idea that art is not principally about objects but about actions (Gell 1998). As a result of my research I have come to think of "art" as a verb. If we accept this definition, I believe we gain a deeper and more nuanced understanding of what art can do. "Art as argument" is what Charlotte Townsend-Gault (1997) calls this kind of cultural production.

Art as argument is both a process and an invitation to engage in dialogue. As such, it both taunts and intrigues; harangues and incites reaction; incurs apology and, perhaps most important, brings recognition. Yet art also feints when it represents. It is both tangible and intangible, alienable and inalienable (Weiner 1992). Its power is its ability to walk this line of uncertainty, and this line of uncertainty – this ability to be never all/never nothing, always shifting – is its strength. For this reason it cannot be pinned down, no matter how hard people try to do so. Labels of national art styles (Macnair, Hoover, and Neary 1984) or names of components such as "ovoid" or "formline" (Boas 1955; Holm 1965) do not do it justice. Such terms, which describe a predictable, unifying, static form, cannot capture and make still the movement of art. The power of art lies in this shifting quality, which allows it to be many things to many different people. First Nations Northwest Coast art's strength is its ability to be meaningful yet never totally known (Halpin 1994; McLennon and Duffek 2000, 9). The argument will never be resolved. Art opens the door to a place of entanglement (Clifford 1997; Thomas 1991; Ostrowitz 1999) and transformation (McLennon and Duffek 2000).

Western and Nuxalk Art Worlds

Sociologist Pierre Bourdieu (1993, 35) wrote: "The work of art is an object which exists as such only by virtue of the (collective) belief which knows and acknowledges it as a work of art." For the purposes of this book, I consciously and strategically define art as that which the Nuxalk believe to be art. This perspective gives agency to the Nuxalk, enabling them to define their own art world. However, this act of Nuxalk empowerment is vulnerable to external definitions of authentic Native art. Inspired by Bourdieu's ideas on the "field of cultural production," in which he examines not only production and its end result, the art object, but also the art object as a category of art within the processes of production, circulation, and consumption, Nuxalk art must be examined within the fields in which it circulates (Marcus and Myers 1995; Myers 2001b; Phillips and Steiner 1999).

I believe that, although Nuxalk artists struggle to self-define the value of their artistic production within Bella Coola, they must recognize the legiti-

macy that their art garners when it is valued by the Western art worlds of Canada, the United States, and Europe. Philosophers of art, such as Arthur Danto (1988) and George Dickie (1989), crucially explicate how art is given value in the Western art world only when it is recognized as such by museum curators, gallery owners, and connoisseur art buyers. Nuxalk artists attempt to refute external definitions of what Nuxalk art should be but, at the same time, are aware of how inherently enmeshed their art is with outsider expectations. I see this as a crucial ambivalence manifested by Nuxalk artists – an insider/outsider dichotomy that creates contemporary Nuxalk identity.

Nuxalk artists' denial of being affected by the Western art world is not so very different from Western artists' often stated desire to avoid the impact of the Western art world. Bourdieu (1993) pointed out this ambivalence for Western artists who deny a pecuniary motivation for the production of their art when, in fact, they are involved in the sale of that art and when art gallery owners play a large role in influencing what is considered art. The Nuxalk refute external values being placed on their art via the finances of the art world and fair market value, but they also play into these valuations. In this way Nuxalk can claim to be defining their own art form while, at the same time, gaining from its external validation.

Bourdieu (1993) believes that "the pure theory of art," which claims that true art is created without pecuniary incentive and outside the money economy, actually stems from art created as a commodity for profit within a money economy. He shows, however ironically, that a disinterestedness in money is profitable for artists. Bourdieu refers to the "field of cultural production" as an inversion of the regular money economy. Specifically, art's value in terms of "symbolic capital" is a metaphor of how art becomes valued within subjective, institutionalized structures that determine legitimacy. These structures are mediated by the way in which previous artists and gallery owners have positioned themselves within them and how their actions shape future art production. For example, Western artists' fame accrues profit and is encoded in recognizable names and signatures, which are in turn validated by Western art institutions. In this way, art both reflects already existing beliefs about legitimate value and becomes part of the process of value making. For this reason, as I asserted above, art can be viewed as a verb as well as a noun.

This description of Western individual artists is applicable to Native artists, although the latter may gain notoriety through their indigenous national status as well as through their individual status. Nuxalk artists must deal on both fronts: that of the Western art market (which values Nuxalk artists according to Western standards) and that of the Bella Coola Valley (which values Nuxalk artists according to local standards, perhaps as representatives of Nuxalk national identity) (Graburn 1993).

It is under these anxiety-producing conditions that Bourdieu's theory affects contemporary Nuxalk artists. It is due to this need to refute profit as the motivation for artistic production that Native artists in general have an uneasy relationship with selling their art. In the minds of the non-Native public and the Nuxalk themselves, who value the spiritual side of Nuxalk art, selling Nuxalk art (which is seen as commodifying Nuxalk cultural heritage) can easily be read as a negative act. Nuxalk artists must balance both the art world's general contempt for artists who produce for sale and the more specific contempt of Native artists who, in order to be appreciated as "authentic," are not supposed to profit from their spirituality. According to Phillips and Steiner (1999, 9): "Rather, until recently, both art historians and anthropologists have resoundingly rejected most commoditized objects as spurious on two grounds: (1) stylistic hybridity, which conflicts with essentialist notions of the relationship between style and culture, and (2) their production for an external art market, which conflicts with widespread notions of authenticity."

In *Switchbacks* I attempt to show the difficulties Nuxalk artists face when commodification is assumed to be a detrimental act that steals contemporary Nuxalk identity. Even though the Nuxalk have, in part, absorbed negative feelings about selling their art outside the Bella Coola Valley, they do get something positive (other than dollars) from doing so. When non-Nuxalk buy their art the Nuxalk receive recognition of its positive value, and this functions to legitimize not only what they produce but who they are. Bourdieu (1984, 291; 1990, 141) might read this as Nuxalk "symbolic capital" (honour, respectability, charisma, authority, legitimacy) produced through commodifying Nuxalk art.

Interpreting art as a process (Cruikshank 1995; Gell 1998; Halpin 1994; Jackson 1989, 1995; Jonaitis and Inglis 1994; McLennon and Duffek 2000; Morphy 1995; Myers 1994, 1995, 2001a; Thomas 1991, 1996) rather than as an object allows me to bring into focus not only the contesting forces and values that go into making art objects but also the contesting forces that derive *from* art once it has come into existence. For the Nuxalk, the significant function of art has always been to shape social identity and to construct culture rather than to produce an end product (i.e., the art object). The art object is always replaceable, but the act of art production is not. Therefore, the interpretation of "art as verb" reflects what I believe to be Nuxalk perspectives. The classical anthropological view of an art object is that it has a fixed meaning that can be revealed through scholarship (Boas 1955; Duff 1981; Lévi-Strauss 1982; Stott 1975). However, there is ample evidence that, in Bella Coola, art objects represent contested values and offer multiple interpretations.

Literary critic Stephen Greenblatt (1989, 12) writes: "The work of art is the product of a negotiation between a creator or class of creators, equipped

with a complex, communally shared repertoire of conventions, and the institutions and practices [of society]. In order to achieve the negotiation, artists need to create a currency that is valid for a meaningful, mutually profitable exchange." It is this "currency" that I explore: How has value developed in Nuxalk art? When and how does Nuxalk art come to be considered and valued as "Nuxalk art?" How does Nuxalk art influence art consciousness (the Native awareness of art) and art practice (the creation and everyday use of art) in Bella Coola? I examine the relationships among the forces that negotiate legitimacy both inside and outside Bella Coola.

Control over the display and reproduction of Nuxalk art has become as important as the historical content of that art. For the Nuxalk, there are two significant aspects of Native art: (1) its material existence in Bella Coola after years of external pressures to eradicate Native art production and to remove what remains to Western museums and (2) Nuxalk ownership of art and non-Nuxalk recognition of this ownership. Nuxalk art's dual contemporary roles reside in its being viewed as cultural patrimony and national property (Handler 1986, 1988; Handler and Linnekin 1984).

It is important to emphasize that the Nuxalk ascribe vital meaning to the process of art production and to its subsequent utilization by owners rather than to the iconography and style of art, which was previously stressed by scholars. Anthropologist Franz Boas' emphasis on crest analysis as the key to understanding the role of Northwest Coast art no longer seems to apply (Boas 1955; Halpin 1994). For example, in the summer of 1995 I witnessed the production of a number of button blankets for a family hosting a potlatch. The maker recognized the need for each family member to have a button blanket or vest to wear but did not seem overly concerned with the actual design employed. She saved the cost of having an artist create new crest designs for her by, instead, using designs made available to her for free. It was fine with her that they were all the same and that they did not represent the individual wearer, as had previously been the function of button blankets. The emphasis seemed more on ensuring the production of these blankets and vests in time for the family event than on any specific animal depicted (in this case a killer whale) or the origin story that traditionally had validated this crest animal. This is not a denial of the importance of the family crest in general but, rather, a recognition that there has been a subtle shift away from the crest's specifics and towards the crest's presence.

Of course there are shared ideas among the Nuxalk about what constitutes Nuxalk art styles and typical Nuxalk art forms. Families do maintain certain crests as their own, and it would be an insult for one family to appropriate the specific crest design of another family. But my point here is to avoid continuing to define the authentic Nuxalk art form from the outside – as many scholars have done in the past (Boas 1955; Macnair, Hoover, and Neary 1984; Stott 1975). This emphasis on continuity and exact replication

appears to me to be more of a Western than a Nuxalk obsession. Certainly some Nuxalk artists are aware of the styles that have typically been considered part of the Nuxalk stylistic canon – convex, bulging faces; leaf-shaped eye orbits; exuberant colouring; an emphasis on transformation (Macnair, Hoover, and Neary 1984); and a preference for a specific shade of blue (Holm 1965). My argument does not contradict these traditions but, rather, suggests that the Nuxalk do not cling to them as tightly as outsiders might wish. The Nuxalk, while being aware of past stylistic traditions, are not concerned with mindless repetition. I believe that their main concerns are focused on having art (both old and new) in Bella Coola and on making sure that everyone knows that this art is collectively owned by the Nuxalk Nation. This self-presentation asserts Nuxalk control not only over the art objects but also over Nuxalk heritage and identity; however, it is necessary to have an audience to witness these claims. This, rather than some stylistic, formal definition created by academics concerned with master paradigms, is the crucial function of art in Bella Coola today.

Cultural Appropriation

In spite of their nonchalance with regard to Western academic definitions of Nuxalk art, the Nuxalk are intimately aware of their entanglement with the West and are working to extricate themselves from it. My research comes at a time when accusations of cultural appropriation are commonly heard in British Columbia (Doxtator 1996; gii-dahl-guud-sliiaay 1995; Keeshig-Tobias 1997; Todd 1990; Townsend-Gault 1991, 1995). Voiced by First Nations leaders, artists, and students, British Columbians often hear about Native fears of having been robbed. This is reflected in political issues such as land claims and treaty negotiations; newspaper, radio, and television stories; art exhibits; and stage plays. A general anger over the history of interaction between First Nations and Euro-Canadians is palpable (see Chapter 2).

The exchange between Native and non-Native peoples often includes the accusation of theft. As the Nuxalk recollect how their own history intertwines with colonial and Canadian histories they articulate their anger relating to theft. Many Nuxalk actively voice their opinion of the injustice inherent in museum collecting. (For a discussion of the history of museum collecting and its effects on Native culture, see Chapter 2 and Berlo 1992; Cole 1985, 1991; Dominguez 1986; Doxtator 1996; gii-dahl-guud-sliiaay 1995; Jonaitis and Inglis 1994; Townsend-Gault 1991, 1995.) Each Nuxalk visit to a museum in British Columbia brings not only respect for their ancestors' artistic skills and creativity but also the feeling of having been exploited. The Nuxalk are consciously uncomfortable with their objects' being located in Western museums, whose origins lie in their role of justifying colonialism and imperial expansion.

I think that the accusations of "theft" directed at the British Columbian and Canadian governments, which took land and material objects from Native peoples, is a demand for self-determination and control. Except for one significant exception, to be discussed in Chapter 5, instead of demanding the repatriation of objects to Bella Coola, the Nuxalk are reclaiming their cultural heritage by actively producing contemporary Nuxalk art. I label this an act of "figurative repatriation" because, through declaring that they have been the victims of theft, the Nuxalk are actively reclaiming what they possess as a nation. In the same way that Nuxalk political leaders fight for the return of their land and resources, Nuxalk artists fight for the right to express cultural knowledge and to control the construction of Nuxalk national identity. Each interaction between artist and art possessor involves a negotiation of this identity. In this context art becomes a cultural commodity (Bourdieu 1984; Haug 1986; Miller 1995; Sahlins 1988) and artists become the bearers of the past for the benefit of the future – an enormous responsibility.

Nuxalk artists represent their culture to the non-Native world in a contested field in which political leaders (both elected chiefs and hereditary chiefs) try to control artistic production. Nuxalk chiefs attempt to influence which stories artists may depict, whose crests they may draw, and the audience to which they may sell or give their art. They do this through the respect engendered by their position, through gossip and public censorship, and through the powers derived from the control of provincial and federal funds. Furthermore, political leaders objectify aspects of their collectively owned culture in order to use them as lobbying chips in dealings with provincial and federal politicians. Political leaders weigh the benefits of cultural exposure against the benefits of secrecy. On the one hand, elected chiefs pressure artists to make their work the basis of economic growth and profit through tourist art, and they advocate the exhibition of Nuxalk art and the sharing of Nuxalk cultural knowledge; on the other hand, hereditary chiefs fear the "cultural prostitution" that results from selling Nuxalk art to non-Native people outside Bella Coola.

A poignant example of this fear of cultural prostitution occurred in 1994, when the Nuxalk government refused a provincial grant to build an ocean-going canoe that would have been used in the welcoming ceremonies of the Commonwealth Games in Victoria (the capital of British Columbia). The acceptance of this grant would have provided an opportunity for cultural expression and the preservation of traditional skills. However, it would also have put Nuxalk culture on display outside of Bella Coola, raising fears of commercialization and exploitation, and it could have been seen as an endorsement of the provincial government. Ironically, a project designed to strengthen pride in Nuxalk national identity was cancelled in order to

preserve and retain Nuxalk sovereignty. This example illustrates the dilemma of Nuxalk artistic production and highlights the complex relationship between cultural education, commercialization, and politics.

Contemporary Nuxalk wish to assert their right to define themselves and to control the images that represent them. I argue that this struggle is negotiated through, and can be seen in, the work of Nuxalk artists. Thus, the creation of art in Bella Coola can be read as a political statement (Thomas 1995) in that it is an act of identity construction. I further argue that art as identity construction is an invitation to dialogue (McLennon and Duffek 2000, 9) because identities are never constructed in a vacuum: they must be recognized and validated by others.

Bella Coola: Getting There

There are many paths to Bella Coola. All are indirect, and, in a way, this indirection, along with the arduousness of the physical trip to Bella Coola, bears a close, and perhaps an anticipatory, relationship to the psychological journey – at least for an outsider like myself: a Jewish anthropologist from New York City. Bella Coola can be reached by plane, ferry, or car. From Vancouver, the most populous city in British Columbia (Canada's western-most province), it is an eight-hour drive through the Fraser Canyon and along the Thompson River to Williams Lake, Bella Coola's nearest city. On the second day of the journey, there is still another five to six hours of driving ahead. One heads west across the Chilcotin – British Columbia's "cowboy country" – which is filled with cattle ranches and people with independent spirits.[3] The dirt and gravel road is often lined with split-log fences, and every now and then one has to slow down to rattle over a cattle guard or to avoid a cow that seems in no rush to get out of the way. On the road one is passed by hardy, dirt-caked four-by-four Ford trucks or by lengthy logging trucks bringing wood to sawmills and pulp mills around the province. The road is often unlined, and, when passing an oncoming vehicle, you often find yourself hoping there is enough space to squeeze by. Every sixty kilometres or so there is a tiny town, basically a gas station with a cafe doubling as a convenience store. The cafe's decor is rugged: exposed wood with a frontier motif, sometimes with gingham curtains if someone has bothered to make the effort.

After about four hours of driving west, the road becomes paved again, and you realize how bumpy it had been when, suddenly, you feel as though your car is moving like a hot knife through butter.[4] This is when you know you are almost at Anahim Lake, the last town before Tweedsmuir Provincial Park and the descent into the Bella Coola Valley. At this point, if you happen to live in Bella Coola, you know that in less than two hours you will be home. After leaving this tiny town, you are soon back on dirt roads, which seem to meander in ways that suggest the surveyor was either drunk or

admitting defeat before the larger forces of nature. A straight road will suddenly hairpin turn without warning; fun in springtime, but potentially deadly when icy and snowy in winter. The Plateau, as this area is called, is high up in the mountains (5,000+ feet), which ensures that the snow remains for three-quarters of the year. Hopefully, you leave Williams Lake early enough to avoid the setting sun; otherwise, you find yourself driving into a giant red ball, which virtually blinds you to any oncoming traffic. Once you have traversed the Plateau, you are ready to make the steep and treacherous descent into Bella Coola, which lies below sea level, nestled in a valley near the coast.[5]

The Hill

You find yourself in front of a wide area on the road where a large sign warns you that you are entering a potentially dangerous area of steep inclines and should stop and put on your tire chains. You are given space at the side of the road to perform this feat, and you hope you remembered your gloves. It could be April and spring-like in Vancouver, but here there might be three feet of snow. The sign also warns trucks to check their brakes. There is a metal barrier painted yellow, which has the potential to close the road to traffic due to unusually dangerous conditions, such as ice, fog, or avalanche. And then there are the potholes. Potholes in the Chilcotin can be so deep locals joke that a whole truck can disappear into one. You hope the grader has come by recently. If the barrier is up, you are now going to have to navigate "the hill" and its innumerable switchbacks.

The road here is compacted gravel and lacks a railing along its edge. Some visitors prefer to get out and walk at this point, although locals scoff at their fear. "What is there to be afraid of?" they muse. Depending on your speed and confidence level, driving the hill can take anywhere from twenty-five minutes to an hour. You hope you do not meet an oncoming car at a place in the road where there just doesn't seem to be enough space for two vehicles to coexist. Some hairpin turns occur around interior rock, making it impossible to see oncoming cars. Honking to alert those around the corner seems advisable, although only tourists, as they creep along, bother to do so.

The switchbacks get steeper and steeper, with the steepest one reaching a grade of eighteen degrees. Trucks have been known to fall off the road at this point. There are avalanche-warning signs everywhere at spots where one can see trees and debris that have fallen before. Everyone in Bella Coola has stories of flat tires, long waits for aid, and icy conditions. Miraculously, however, only a handful of people have been killed by avalanches or car accidents since the road was carved out of the steep cliff by local residents between 1952 and 1953 (Kopas 1970; Wild 2004).

Bella Coolans are proud of the difficulty of reaching their valley – a valley walled in by 6,000-foot snow-capped mountains. This valley was cut over

time by the flowing waters of the Bella Coola River, which reaches an estuary at the point of the town of Bella Coola, an hour's drive from the hill. Although it is never articulated, you realize that the difficulty of navigating the hill accentuates the power of the place that is Bella Coola. Only the hardy and brave are rewarded with the sight of the Bella Coola River, home of the oolichan[6] in April and the salmon in spring and summer, the nesting site of bald eagles, and the place where hungry brown and black bears, who emerge from their mountain dens in spring, come to fish.

The hill is never a boring topic for local Nuxalk: overheating radiators; silly tourists too frightened to drive down the hill in their campers, who needed to be helped; and stories of trips "out" to Williams Lake are told again and again, with memorable ones reiterated often. Such tales are likely to centre upon: how fast the dirt roads were navigated, a time when a moose was hit and meat for winter was provided, and who you met and picked up on the way. The landscape is not mere background for the lives of people in Bella Coola: it shapes their very existence and makes them proud of their identity.

In addition, Bella Coolans like to hear that you, as an outsider, a visitor, were frightened coming down the hill. In this way their bravery is doubly emphasized and your outsider status is marked. Familiarity with the hill becomes a recognition of ownership – a major theme of this research – ownership of the space between the valley's mountains. And yet not all things Nuxalk are owned in such an unambiguous way as are stories of the hill. As I spent more and more time in Bella Coola, interacting with Nuxalk people, I began to notice the ambivalence and anxiety lurking below the surface. This anxiety appears in relation to Nuxalk identity formation *as a nation*, one of the initial aspects of that 1994 Vancouver Nuxalk art exhibition that first prompted me to make the fearful journey down the road of switchbacks into the Bella Coola Valley. Throughout this work I contend that a battle is being waged on two fronts: (1) between Nuxalk in Bella Coola and non-Native people outside of the valley with regard to recognition of Nuxalk national identity and control of Nuxalk cultural patrimony, and (2) and no less important, *within* the valley among Nuxalk individuals themselves, also in regard to the same two issues mentioned in (1).

Switchbacks

Over time, I became more and more intrigued by the dialectic involved in identity formation in Bella Coola. Nuxalk identity formation is not a one-sided process that occurs in isolation from the outside world; rather, it involves a series of switchbacks. I have described the hill's terrain so explicitly because it affords the reader not only a backdrop for understanding the environment of the Nuxalk Nation but also because it functions as a territo-

rial trope. Just as Crisca Bierwert (1999) offers "the figure" of the river in all its changing, flowing movement as a useful metaphor for discussing Coast Salish ways of knowing, so I use the metaphor of the hill and its switchbacks to reflect contemporary Nuxalk methods of identity construction. The Nuxalk move between essentialist categories of modern and traditional, Western and "Indian," just as travellers on a switchback move from left to right but never stay in one place. The Nuxalk oscillate between the historical and the contemporary, between culture with a capital C invented by anthropologists (Keesing 1994; Kuper 1999) and between postmodern culture, which is always in process (Clifford 1991).[7] This movement can cause anxiety, just as travelling the hill causes moments of hesitation, fear, and loss of direction; and yet the Nuxalk do move towards their goal of creating a strong, cohesive Nuxalk identity. The metaphor of the hill and its switchbacks allows for both this movement and a feeling of being trapped in a dangerous space where choices are limited. The Nuxalk are working to sustain a viable national identity in a postcolonial world. Their anxiety about this is reflected in the pages that follow.

I am suggesting that the physical landscape and the cultural landscape converge. Just as visitors to the valley, frightened of traversing the hill, reinforce a Nuxalk sense of self, so non-Nuxalk outsiders, who are in a kind of switchback relationship with the Nuxalk, are able to create a sense of Nuxalk ownership with regard to their identity and culture. This process was noted by some Nuxalk themselves. As one Nuxalk woman told me when discussing tourists coming to the Bella Coola Valley, "It takes outsiders to see wealth." She was referring to the bounty and beauty of the Bella Coola Valley itself, which most occupants take for granted. People only seemed to recognize the special qualities of their place when they encountered the reactions of others – for example, when visiting campers, hikers, and other tourists told of how surprised they were when everyone they passed on the road waved to them as they drove by. This simple but unexpected gesture is called the Bella Coola wave, or the Bella Coola hello. You raise one or two fingers of the hand on your steering wheel at every passing vehicle, whether you know the occupants or not. If you fail to do so, you will meet with criticism in the local co-op supermarket, something to the effect of: "Snob, didn't you see me waving?" While tourists register pleasant surprise at this custom, more revealing is the fact that *local* residents place considerable importance on outsiders' positive reactions to them and their community. This suggests that it is important to valley residents to see themselves through visitors' eyes, and this vision is a good one – one that recognizes value. I highlight this point as it is crucial later on. One of the central theses of *Switchbacks* is that, for the Nuxalk, external recognition is needed if they are to truly appreciate their own natural and cultural environment.

Outsider Access

Another reason I begin with stories of the hill is that they emphasize the serpentine route, sometimes dangerous, sometimes beautiful, that guides my journey towards an understanding of Bella Coola and Nuxalk culture. There is nothing easy about gaining access to Bella Coola, its people, and its ways. As an anthropologist and outsider I am marked as a tourist, someone who brings both positive and negative things to the valley. In terms of the positive, I am the awed and appreciative admirer of the valley's elegant scenery and different way of life, at least from the perspective of Vancouver and New York City. When I go to Bella Coola I bring cash (something always needed in this poor community). During my stay I become somewhat analogous to a "daughter" in the sense that I must be guided, cared for, and fed. In terms of the negative, I am seen as someone who imposes her own priorities upon this place and its residents – a potential liability given the nature of my reasons for going to Bella Coola in the first place.

Part of being an anthropologist is wanting to turn a strange place into a familiar place, where one can say one now belongs. Yet there is a danger, an audaciousness, in believing that one can truly break through the outer shell of Nuxalk culture, where the Nuxalk display what they own and who they are for touristic, outsider pleasures. Clifford Geertz (2000, 33) has written eloquently about the "ethically ambiguous character" of fieldwork and the difficulty of maintaining relations that are both "engaged" and "analytic": "The anthropologist inevitably remains more alien than he desires and less cerebral than he imagines" (40). My concerns and experiences certainly parallel those of many other anthropologists who have come before me and who will follow afterwards.

The risk in the minds of the Nuxalk is in what the anthropologist or tourist can take away, or "steal," in the local idiom. Not only can the outsider afford to buy Nuxalk art – masks, plaques, jewellery – when in fact many Nuxalk cannot, but the outsider's presence can dilute Nuxalk culture. This was related to me by a Nuxalk woman who explained that "tourists bring access to outside ways, allowing Nuxalk children to understand a bit of what life might be like outside the valley, but tourists also bring roads, which can lead children away." From this typical Nuxalk perspective, the tourist's (or the anthropologist's) presence is seen as a threat. I would add, however, that roads go two ways: they can take children and art out of the valley, but they can also facilitate an easy return.

Taking That Which Is Not Freely Given: Doing Fieldwork in Bella Coola

Writing about Bella Coola and the people that inhabit its valley is problematic. The anthropologist as producer of ethnographic text has long been a concern of reflexive anthropology (Clifford 1988; Clifford and Marcus 1986).

The interweaving of representation and power must be acknowledged. I know that people in Bella Coola are very cautious upon learning that they will be written about. Indeed, such hesitancy was what usually greeted me upon posing questions, and it could mean many things. For example, hesitation could indicate a desire to carefully plan what one was about to say so as not to be misunderstood, or it could be employed as a device to unsettle the questioner. In other instances a pause might be used to stop oneself from saying what it was not one's right to say, or it could provide the speaker with a moment to evaluate the intentions of the person who had asked the question. There were no simple questions in Bella Coola. Everything from "Why use alder wood when smoke-drying cut salmon?" to "How did the 'Mask, Dance and Song' curriculum at the local band school develop?" evoked this hesitancy. I believe that all the pauses and hesitations I encountered resulted from a fear of saying the wrong thing and thus opening oneself to attack. Many in Bella Coola have retreated behind closed doors so as not to be forced to answer a question that might require a politically sensitive response.

People in Bella Coola speak as if they would like to excise politics from their lives. For example, when asked whether they like a certain cultural arts teacher or whether they will attend a potlatch, people would often answer (after pausing) by saying, "I don't get involved in politics." End of conversation. Their reticence is understandable. Their avoidance is a way of trying to stop the pain brought on by too many questions, and not just those being asked by outside researchers.[8] Related to this urgency to circumvent politics and local alliances is a tendency for many Nuxalk to involve themselves in neutral community activities such as intergenerational basketball or Bingo, while others just stay home.[9]

Anxiety about Politics

Much anxiety revolves around the issue of local political divisions within Bella Coola and the Nuxalk Nation. Many speak quietly about the divide in Bella Coola between the elected band chief and the hereditary chiefs. The elected chief is in a position of leadership designed by the Canadian Department of Indian Affairs (DIA).[10] The DIA instituted a system of band government based on democratic elections. The elected band chief has a council of twelve elected band councillors who distribute monies given by the DIA and thus decide how health, housing, and education issues will be dealt with in the community. The Bella Coola band system was set up in 1952, ostensibly to replace the antiquated Indian agents, who were non-Native representatives of the DIA. However, the DIA maintained a non-Native "superintendent," or "district manager/supervisor" in residence in Bella Coola until 1979. Formerly, the Indian agent had ruled local reserve life, and any interaction with the DIA or the nation of Canada had been conducted through him.[11]

The hereditary chiefs are the traditional chiefs of individual families who inherit the right to lead their extended family. These are usually elders who have now taken on the responsibility of collectively guiding the Nuxalk Nation. In Bella Coola today there are approximately sixteen traditional chiefs representing individual families. The hereditary chiefs envision their role as one mandated by the elders to protect Nuxalk land and resources from further misuse and to guide the Nuxalk Nation spiritually. They call themselves "traditionalists" or "sovereigntists."

When I was in Bella Coola in 1997 the elected chief and council were trying to work with logging companies to gain employment for the Nuxalk community. The hereditary chiefs, on the other hand, opposed logging companies entering the valley at all and supported the presence of Greenpeace and an environmental group called the Forest Action Network, who wanted to save an area of land that they referred to as the Great Bear Rain Forest.

Although prior to my fieldwork a hereditary chief had been elected band chief, this was not the case when I was in residence in 1997. Interestingly, in the recent past family members of the elected chief had worked to have him made a hereditary chief, but there was still controversy over whether he had received the hereditary chieftainship under proper circumstances. Also, some felt that the elected chief was only a puppet of the DIA, while others felt that the Nuxalk had to coalesce around this modern form of government rather than remain in the past. Many in Bella Coola were loath to say which side they supported for fear of being ostracized by the other. Most people had family members on both sides, and major fissures were opening between the generations and among siblings. Overall, tensions were extremely high. This division between the elected chief and the hereditary chiefs was festering at the time I conducted my fieldwork, and it continues today.[12]

In general, Nuxalk people do not like controversy or being at odds with their neighbours, and for this reason very few of them will contradict an opinion with which they do not agree; instead, they will refuse to communicate – a response that says, "We have no common ground," or "Danger, we are about to disagree." Nor are people likely to declare their opinions in any public venue, all of which makes being an anthropologist in Bella Coola tricky business. Not only is it difficult to conduct interviews, but the very act of eliciting information labels one as political and, therefore, potentially harmful.

While I do not wish to present the Nuxalk as provincial and unsophisticated (which they are not),[13] within the confines of their small community it is known that secrets are hard to keep. Although the Nuxalk are not limited by local mentalities they *are* limited by the fact that their numbers and the size of their main reserve are small enough to produce an environment within which knowledge is both at a premium and dangerous. In sum, too

much information in such a small community can be detrimental to one's mental health and well-being.

Shortly after I began fieldwork it became apparent that the value of words was stronger than I had imagined. My own culture taught me that "opinions are free," but in Bella Coola giving your opinion implied a deep trust in the person who elicited it. Acceptance of my own right to pose questions was calculated. And yet so much hinged on getting a response, an answer. The choice of *not* answering was always in the equation between the Nuxalk and myself. Silence was always their right – a silence that might mean not only a refusal to participate but also negative feelings about my question or even about myself. It was always difficult to discern what was meant. Silence is power in Bella Coola – a refusal to participate – in the same way that not showing up at a potlatch implies censure of the business conducted there or a negative judgment of the people hosting it.

The Nuxalk I met were very hesitant to express negative judgments. If someone spoke, it was almost always in a supportive vein. The most a Nuxalk person would do was *describe* a behaviour they deemed negative, and through this description, perhaps through tone of voice, imply a critique. When I spoke of a person in the community an informant did not like, I often heard, "I don't involve myself with that person" or "I don't know about him/her." Statements like these implied not a lack of knowledge about that person but, rather, a refusal to be part of his/her life. Such avoidance functioned not as a criticism but as a censure – a more effective measure of disapproval (i.e., silence). Thus, the Nuxalk rarely criticize; they just remain silent. Anger, like the fear of criticism, was usually masked through avoidance. Because of this, outbursts were infrequent; however, when they did occur they had a huge impact.

This kind of language usage has both positive and negative implications. Words have a way of attaching themselves to the person towards whom they are directed. Hence, while negative statements have the power to harm those upon whom they alight, positive statements may also bestow power on an individual. For instance, when I tried my hand at things like baking bread, cutting fish, or painting Nuxalk designs in Bella Coola, I heard only compliments. Unfortunately, I was not always so lucky.

Mail is delivered to Bella Coola only three times a week, on Mondays, Wednesdays, and Fridays. Consequently, it is always an event. On these days you meet everyone you know at the local post office, and it is a time for friendly chatter. Children come on their bikes. Adults pull their trucks up to the corner and, leaving their engines running, amble into the post office to check their boxes. On one particular afternoon, as I was walking home from the post office three blocks away, I ran into a long-time Nuxalk friend of mine. I saw him almost every morning when he came for a cup of

coffee to the home of the people with whom I was living. Each morning he would be sitting on the sofa in the living room, looking out the big picture window with the rest of us as we contemplated the new day. He always had a hug for me and, with a twinkle in his eye, asked when I was going to marry him (he was divorced and had four children and many grandchildren). He was also a hereditary chief, but that rarely affected our relationship. Usually I would go sit next to him and he would poke me in the ribs trying to get my attention while I tried to crochet or drink coffee.

The day I met him on my way back from the post office, for whatever reason, he decided to ask me about my research. His questions were familiar ones. Specifically, he wanted to know what I was going to write about and who had invited me to come to live in Bella Coola in the first place. In other words, "Who gave you permission to be here?" Finally, he asked, "Aren't you going to make a lot of money when you write a book?" I had heard these questions many times before but usually from someone who did not know me as a friend. Typically, I answered that I was getting a PhD so that I could teach at university. I then explained that I was interested in Nuxalk art and how people in Bella Coola were learning about their art and, through their art, about themselves. I told my questioners the story of how I had met a number of Nuxalk artists in Vancouver and how they had challenged me, if I was truly interested in Nuxalk art and life, to come to Bella Coola to learn. And so I had come. I said I needed to write a book-sized paper but that there was no guarantee that it would get published. I invariably added that usually anthropology books did not make money. For two reasons I always tried to answer these questions calmly: first, I wanted to reassure the person questioning me that she/he had a right to do so and to know the eventual results of my work; second, I needed to reassure myself that I did, in fact, have every right to be in Bella Coola asking questions. I had, after all, been invited by the Nuxalk themselves, at least some of them.

It was in this way that I also calmly answered my friend's questions. He then changed his tactic and declared that I would make a lot of money as a university professor. This upset me because, although he continued to tell me it was not the case, I felt as though I was being attacked. He then implied that I had not been talking to the right people and suggested the names of several hereditary chiefs with whom I should speak. Although I had already tried, unsuccessfully, to speak with these chiefs, for the sake of argument I told him he was right. In the end he hugged me and invited me to come and sit with him at his house, but I was shaken. How could someone I considered a friend question me so untrustingly, as though I were suddenly a stranger?

When I related what had transpired to my adoptive Nuxalk "mom" and "dad," the same people who had introduced me to him and with whom I was living, they were angered by his behaviour. This was one of the rare

occasions when criticisms were openly levelled. My Nuxalk father encouraged me to continue with my work and to approach, once again, the elders and hereditary chiefs my friend had mentioned and ask for their help. Later that evening another hereditary chief called to say he had heard about the incident, proving once again that news and gossip travel like wildfire in this small community. Moreover, he had called to tell me that he did not think a hereditary chief had the right to speak to me as my friend had, upsetting me in the process. From his perspective, my friend had acted inappropriately as an individual; that is, he had spoken to me of "politics" without first consulting the other chiefs. The chief who called added that a meeting must be held to rectify the situation. This meeting never took place. Ultimately, although I had been criticized by one member of the community, the reassurances I received from others helped quell my worst fear – namely, that I did not have a right to be in Bella Coola asking the kinds of questions I thought I *should* ask.

I tell this story from the field in order to tangibly illustrate the points I made above regarding the dangers of question asking and becoming involved in sensitive political issues related to Nuxalk identity. I have related it both to situate myself within the cultural milieu I have been describing and to emphasize how difficult conducting fieldwork in Bella Coola can be for an anthropologist, who perhaps *should* pose difficult questions that few want to answer.

How did I deal with Nuxalk reactions of avoidance, anger, and silence? I made them the centre of my study. If information and opinion were difficult to collect because they were seen as possessions too dangerous to share with outsiders (or even certain insiders), then I decided I would look at why this was the case. I felt, and still feel, that ownership of content has become more important in Bella Coola than the content itself, a point to which I return in later chapters. It became critical for me to understand these feelings of secrecy, to explore and to understand the fear driving such actions as having an opinion but being unable to share it or owning a mask but being unwilling to dance it. This palpable fear went beyond the fear of physical theft, which was something dealt with daily on the reserve, to something less tangible but incredibly important: a fear of theft of cultural knowledge and, with it, a theft of Nuxalk identity.

Returning to my place within all of this, I have to conclude that a part of this project involved my taking something that was not freely given. Thus, my writing about Bella Coola is a theft of sorts, and for this reason I must explain my act of writing both to the Nuxalk and to myself. I am clearly guilty – but of what? Can there be a positive side to this act of theft? Is it really theft if certain knowledge was given to me freely by certain Nuxalk? Not to spin too deeply into paranoia, it must be said that many Nuxalk are very giving, providing food and shelter to the unknown anthropologist,

sharing difficult childhood memories and even adopting her into their family structure, replete with sisters, nieces, uncles, aunts, and other relations.

And yet the following thoughts are unavoidable. Writing is about establishing one's authority to speak (Clifford and Marcus 1986; Smith 1999; Trinh 1989). How should I write about my experiences of being with the Nuxalk? Ethnography creates, it does not merely describe. Given the possible effects of my writing, how can I write about the Nuxalk without in some way appropriating their voices or their right to write about themselves? I am certainly doing more than writing about myself when I put down what I did, thought, and learned while living in Bella Coola and asking questions that were, for some, impossible to answer. One way I responded to my own critique was by trying to respect the boundaries of Nuxalk ownership, even when they were not clear. I do not want to contribute to the feelings expressed by some Nuxalk that the display of their art, or even photographs of it, has the potential to reveal knowledge that belongs to the owner of the cultural object and that should stay secret. My goal is to respect the limits of representation set by the Nuxalk while also reading them as important messages about Nuxalk identity.

Even a written description of a mask or other cultural object allows an artist to make a copy. Some Nuxalk believe that duplication of Nuxalk art is theft because it dilutes the power of what the Nuxalk possess as a culture and as an identity. Since I do not wish to wrestle control away from the Nuxalk I have not included any photographs in this book. In refusing to display I am acknowledging that I do not own the inherited right to do so. Even so, I am aware that *Switchbacks* creates an access point to the Nuxalk, who are vulnerable when exposed. In order to protect individual Nuxalk from unwanted exposure I have not included any personal names in this work. The only time I use Nuxalk names is when the individual is deceased and has already been recognized in published form as an important member of the Nuxalk community. I feel it would be a slight not to mention the names of Nuxalk people who have already been publicly acclaimed. I am not entirely pleased with this solution, and I am sure it will not please all Nuxalk.

However, if art is indeed argument – the opening up of a kind of dialogue – it is my contention that it requires a response. If the only way to write a safe response is not to write at all, then I think a reply must be risked. This writing, then, is my response to the art of the Nuxalk people.

2
The History of Bella Coola: A History of Theft

In order to discuss current Nuxalk feelings around theft in Bella Coola today, it would be helpful to chart historical Nuxalk experiences of theft. There are many categories from which to choose: theft of resources such as timber and fish (due to DIA policies and the Department of Fisheries and Ocean allocations); theft of people (due to European disease-induced population decline); theft of land (due to reserve system); theft of children (due to residential schools); theft of material art and objects (due to anthropologists and other collectors); and, finally, theft of cultural knowledge (due to missionization, the anti-potlatch law, and anthropology). I describe each of these. But I begin with the origin of the name "Nuxalk," which many see as a powerful collective designation, but which can also be read as a theft of the original identities of the amalgamation of peoples that make up the present-day Nuxalk Nation.

The Names "Bella Coola" and "Nuxalk"
The town of Bella Coola, located at the mouth of the North Bentinck Arm, is the present-day home of the Nuxalk Nation. Although its size (thirteen square kilometres) may be small, its significance as the location of an independent First Nation is large in the minds of its members. Bella Coola's collective personality speaks loudly and has multiple meanings. First, the name Bella Coola refers to a town with both Native and non-Native residents. Bella Coola is also the name of the river that flows through this town and the name of the valley in which the town is located. Finally, Bella Coola is the original ethnographic name of the First Nations people who live in this valley and who today refer to themselves as the Nuxalk.

Not unusually, Bella Coola gained its name through linguistic error. The earliest anthropologist to work with the "Bella Coola Indians" (as they were then called) was Franz Boas, who, in 1886, was a fledgling German academic trying to gain recognition in North America by securing a curatorial

position in the museum world (Cole 1982, 117-18). Boas wrote: "the name 'Bella Coola' is a corruption of the word 'Bilxula,' by which name the tribe was known to the Kwakiutl [another Northwest Coast indigenous nation among whom Boas conducted fieldwork in the 1890s]" (Boas 1898, 26). Linguist John Rath argues that the name Bella Coola was an anglicized version of *belwxela*, a word from the neighbouring Heiltsuk First Nation that refers to all speakers of the Nuxalk language (Hilton 1990, 338). This makes sense when we realize that the Heiltsuk people used to be included among the peoples whom anthropologists referred to as the Kwakiutl but are now known to be a separate nation.

While scholars have debated its origins, I was informed by a number of Nuxalk residents that Bella Coola is, in fact, Spanish for "beautiful valley" and that the area was so dubbed by a visiting ship captain or an early explorer. Others claimed that the words are Italian or Latin in origin, again with the meaning "beautiful valley." Although technically this is an incorrect translation of these languages and was probably not the historical origin of the name, it has contemporary salience for Bella Coola's occupants. For the Nuxalk, the beauty of their home is significant not only because they can be proud of living there but also because of their claim to ownership of this special territory.

Members of the Nuxalk Nation are unusual among First Nations peoples in that they still live on land that has been theirs for thousands of years. Whether they came down from the sky, crossed the Bering Land Bridge thousands of years ago, or moved north from the interior Salish country to the southeast, the ancestors of the present-day Nuxalk have occupied the Bella Coola Valley and surrounding areas for as long as any human can remember (see Map 1). Linguistically, Nuxalk is part of the Salish language family, although it is a geographic isolate (Davis and Saunders 1997; Kinkade 1991; Nater 1984).[1] Archaeology and Nuxalk origin stories (*smayustas*) converge around one central fact: the Nuxalk have been in the Bella Coola Valley for nearly 10,000 years (Hobler 1990) and possibly "since time immemorial." Many contemporary *Nuxalkmc*[2] say they were put in their original villages by their supreme deity, *Manakays*, sent down from above wearing the coats of their crest animals (McIlwraith 1966, 58-59; Richardson 1982, 32).

The Nuxalk Nation is recognized by scholars and the Nuxalk themselves as an amalgam of four groups of people who previously lived in distinct territorial areas: Nuxalk, Kwatna, Taliomi, and Kimsquit. Yet today Native inhabitants of the valley refer to themselves collectively as the Nuxalk Nation, a practice adopted as recently as the early 1980s. Many elders found it important to inform me that they or their ancestors did not originally come from the town of Bella Coola but were from one of the other three populations that have now been subsumed within the overarching term "Nuxalk."

Following this assertion, they proudly list the four types of Nuxalk people: *Nuxalkmc* (those from Bella Coola itself), *Taliyumc* (those from Taliomi), *Kwalhnmc* (those from Kwatna), and *Sutslmc* (those from Kimsquit). Although they have formally accepted the name Nuxalk, *Nuxalkmc* originally referred only to those people living in the Bella Coola Valley off the North Bentinck Arm of the ocean inlet (McIlwraith 1992, 1:11). As for the other three, the *Kwalhnmc* people lived near the Kwatna Inlet adjacent to Burke Channel; the *Sutslmc* lived on the Dean Channel; and the *Taliyumc* resided near the South Bentinck Arm (see Map 2). Regarding the emotional impact this subsuming of earlier appellations has had on local people, Ruth Kirk (1986, 17) writes: "People from Talio, Kimsquit and a half a dozen other villages in the region regret losing their particular identities to the new name, but at least it is a word in their own language." It was anthropologists and linguists who conceptualized these separate communities as one collective based upon what they assumed was a shared culture and language. People in Bella Coola point out, however, that though they could understand each other, each of the four previous groups had their own dialect and, more important in terms of the theme of this book, their own styles of art.

Nuxalk elders interviewed by ethnographer Thomas McIlwraith (1992, 1:5-16) in 1922 remembered the names of forty-nine villages scattered throughout the four groups' territories. This suggests that people formerly identified themselves first by their ancestral village name and family crest rather than by one of the four larger groups associated with a particular geographic area. Whatever the case, the extent of internal cohesion of each of these four branches, in turn, composed of a fair number of smaller villages, is unknown. Nonetheless, the fact that present-day Bella Coola elders have a strong sense of identity relating to which branch their ancestors came from suggests that the four prior groupings were significant demarcations for the people concerned. In the early 1920s, due to their dwindling populations, the people of Kwatna, Taliomi, and Kimsquit asked permission to move to Bella Coola. The site was chosen because it had a store,[3] a Methodist mission, and a hospital (Barker and Cole 2003, 12-13). The village of Kimsquit was the last to be abandoned, sometime between 1923 and 1929 (Kennedy and Bouchard 1990, 337; McIlwraith 1992, 1:16; Prince 1992, 72).

Thus, when the people of Bella Coola refer to themselves as the Nuxalk Nation, this is a relatively recent development. Neither anthropologists nor Nuxalk believe that the Nuxalk conceived of themselves collectively as one political unit, one people, or one nation until two decades ago. Yet this present-day identification is important to the arguments I make here. This disjuncture in identity construction complicates my analysis as it forces me to jump back and forth between the present and the past. In order to avoid confusion, it is important for the reader to be aware of why I use different

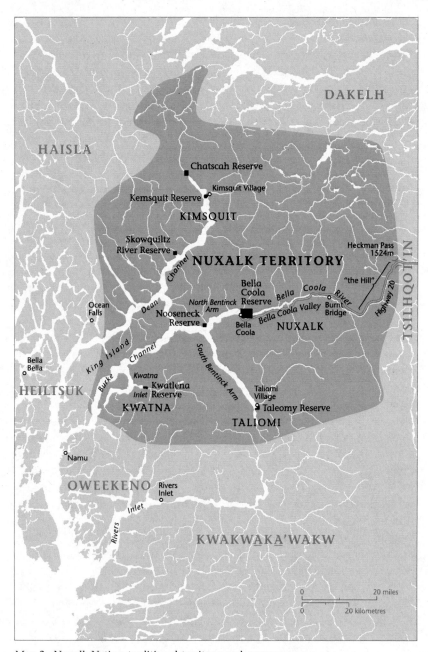

Map 2 Nuxalk Nation traditional territory and reserves

terms as I negotiate the complicated relationship between past and present. The recent nature of the formation of the concept "Nuxalk Nation" is crucial for my contextualization of identity construction. Additionally, this history enhances an understanding of contemporary discourses surrounding Bella Coola, which inevitably contain references to the earlier divisions between the distinctly named groups and cultures listed above. For example, it allows the reader to understand the larger context referenced when people in Bella Coola call themselves Nuxalk, then refer to one of the four branches from which their ancestors came, and ultimately use the name of their own family and crest.[4]

Finally, let me caution that, though the Nuxalk Nation is a relatively recent construction, this does not imply that this identity is invalid. As Barth (2000) argues, boundaries are more cognitive than actual, yet they create opportunities for social ties. He also points out how, although they appear as barriers, they are actually quite permeable and can be deployed by people with specific agendas in mind. Clifford (1991, 236) concurs when he emphasizes that "the politics of identity" are conflicts "over the right to name, circumscribe, and essentialize specific groups." Therefore, the concept of a unified Nuxalk identity, however recent, is of great importance for the people who live within this self-named and bounded nation.

A History of Theft

During my fieldwork in Bella Coola, many Nuxalk told me that buying Nuxalk objects in order to take them from the valley was equivalent to theft. For example, one Nuxalk man told me that he considered the material objects historically sold to anthropologists to have been stolen, even though he knew they were paid for. Today many Nuxalk remain ambivalent towards the sale of art outside Bella Coola. This is because the loss of these objects is viewed as severing the Nuxalk from their culture. In fact, during my fieldwork I was told of one family who sent an old dance mask to the local Royal Canadian Mounted Police (RCMP)[5] unit in order to ensure that their father would not sell it to an aggressive art dealer in order to buy alcohol. Ironically, this mask spent two years "in jail" so that it could remain in the valley. Unfortunately, during its stay with the RCMP it was out of Nuxalk hands and thus out of Nuxalk control (Archaeologist Phillip Hobler, personal communication, 16 March 1998). Even so, its sale, perceived as a theft, was averted. Nuxalk perceptions of theft lead me to frame my recounting of Bella Coola history as a series of thefts. This orientation provides the reader with the historical knowledge crucial to understanding my analysis of present-day Nuxalk art and the related issues of cultural production and identity making in the Bella Coola Valley. After providing a brief introduction to the history of contact between Nuxalk and non-Nuxalk, I address each category of historical theft in turn.

History of Contact between Nuxalk and non-Nuxalk

Although the Nuxalk live in a seemingly isolated valley surrounded by 1,500-
to 1,800-metre snow-capped mountains, six hours by boat inland from the
open ocean (approximately 120 kilometres), and 560 kilometres (as the raven
flies) northwest of Vancouver, they have always engaged in trade and inter-
action with outsiders. They have traded, intermarried, potlatched, and warred
with the Heiltsuk (also known as the Bella Bella of Waglisla). They also had
regular contact with the Anahim Lake Ulkatcho people and other interior
groups, such as the Dakelh (Carrier) and the Tsilhqot'in (Chilcotin)
(Birchwater 1993; Goldman 1940; Kennedy and Bouchard 1990, 325), as
well as the Kwakwaka'wakw[6] of Vancouver Island and neighbouring main-
land, and the Haisla and Wetsuwet'en to the north (Kopas 1970; Thornton
1966).

George Vancouver was the first non-Native person to meet the Nuxalk
when he and a member of his crew explored Dean Channel, Burke Chan-
nel, and the North and South Bentinck Arms in June 1793 (Kennedy and
Bouchard 1990, 336). A more canonized "first contact" occurred, however,
when the explorer Alexander Mackenzie arrived overland in the Bella Coola
Valley, having come west searching for a passage to the Pacific Ocean.
Mackenzie recorded his meeting with the Nuxalk at Burnt Bridge in his
journal, renaming the area Friendly Village due to the warm welcome he
received there on 17 July 1793 (Lamb 1970, 358-94).

For the Nuxalk, interaction with non-Native people continued with the
great land-based fur-trading boom of the early nineteenth century (1820s-
50s) and the establishment of a Hudson's Bay Company trading post in
Bella Coola in 1867 (Kopas 1970, 139-40). During this period the Nuxalk
worked as fur trappers and began to make use of trade goods such as to-
bacco, rum, muskets, wool blankets, indigo and orange cottons, metal pots,
and molasses (Fisher 1992, 7; Prince 1992, 47). Life began to change drasti-
cally for the Nuxalk, however, when contact with non-Native people brought
not only trade but also epidemics, alcoholism, and missionaries. The effects
of European colonization upon the Nuxalk are shared not only with other
First Nations in Canada and the United States, but were also experienced by
indigenous peoples around the world.

These earliest instances of contact with Europeans experienced by the
ancestors of contemporary Nuxalk were not entirely negative. Initially, trade
appears to have been carried out to the benefit of both sides. Nonetheless,
the relationship between the Native and settler groups deteriorated into a
series of thefts systematically perpetrated against the former by the latter
and their descendants.

Theft of Resources

The Nuxalk moved into wage labour in 1900 with the rise of commercial

fishing and the creation of canneries. At that time two non-Native men, Tom Draney and John Clayton, founded a cannery across the estuary from the town of Bella Coola. This was followed by the opening of several more canneries: two near Kimsquit in 1901 and 1907, respectively, and a third in Taliomi in 1917 (Prince 1992, 63-64; Sirois 1996, 41-42). Many Nuxalk, especially women, were employed in these canneries, and, in some cases, in those further afield in Namu, Klemtu, or Rivers Inlet. At this time Nuxalk men also entered the world of wage labour, working on fishing boats for canneries, in the sawmill at Rivers Inlet, or as hand loggers (Prince 1992, 58). Although the work was often difficult, several Nuxalk elders told me they have fond memories of working in the canneries with their parents and of the good money to be made in the logging and fishing industries. Thus, even as early as the turn of the twentieth century, Nuxalk voluntarily combined wage labour in commercial production with subsistence activities, thus participating in an external economy from which they received some benefit.

As commercial fishing and logging expanded and intensified throughout the twentieth century, the benefits that once accrued to the Nuxalk from their participation in these non-Native-dominated industries began to wane. From the perspective of many Nuxalk, the result of this expansion has been the theft of resources the Nuxalk believe are theirs to use and to control. Theft of resources is seen to be the result of two interrelated factors: (1) the unsustainable overextraction of natural resources for commercial activities and (2) government regulation, which limits and sometimes denies extraction rights to the Nuxalk (and others) altogether. Somewhat ironically, this second measure is designed to counteract the shortages that have resulted from the former. For those Nuxalk who have become dependent upon the fishing and canning industries, the subsequent closure of all the canneries in the area made economic survival increasingly difficult. Moreover, because the Department of Fisheries and Oceans (DFO) has the exclusive legal right to "manage" commercial as well as Native fisheries, the Nuxalk are extremely unhappy that they are only allowed to fish for ceremonial, social, and subsistence purposes – a practice labelled "food fisheries."[7] Although, technically, fishing for commercial profit is still possible for the Nuxalk, they cannot do this without a commercial fishing licence. Thus, the Nuxalk are only permitted to profit from fishing if they first pay the Canadian government for the privilege of doing so, a stipulation that seems ridiculous to them because they view the rivers and forests as resources passed on to them by their ancestors.

Recently the number of commercial fishing licenses available for purchase has been severely restricted, along with the amount of "food fish" that can be caught. The DFO has also limited the number of days per week the Nuxalk can fish.[8] These government-instituted countermeasures are all

deemed necessary because of shortages resulting from the unsustainable fishing practices of the non-Native-dominated commercial fishing industry. While the Nuxalk do not deny that commercial fishing, in which they have participated, is at fault for the tremendous reduction of fish stocks and the dearth of salmon and oolichan[9] coming up the Bella Coola River, they also blame the DFO for precipitating many of the problems and then expecting the Nuxalk to pay the price. For example, many Nuxalk allege that the absence of oolichan in the Bella Coola River for the last seven years is the result of the DFO's failure to halt the detrimental commercial fishing practices of mostly non-Native fishers downstream. In this case, commercial fishers are allowed to continue to catch shrimp using seine nets, which also inadvertently catch oolichan fry before they are able to swim upstream to spawn (Wild 2004, 249). Because it turned a blind eye to this, the DFO is viewed by many Nuxalk as having stolen both their fish and their right to subsistence.

Similar feelings of ambivalence exist around the issue of forest depletion in and around the Bella Coola Valley. Commercial logging began in the Bella Coola Valley in 1939, and, as in the fishing industry, many generations of Nuxalk men have worked as loggers for non-Native-owned companies such as International Forest Products (Interfor) or Crown Zellerbach (Coast Mountain News 1990b). Today most of the forests in and around Bella Coola have been clear-cut, and many Nuxalk, including influential hereditary chiefs, feel that the remaining forested lands must be protected. Indeed, one young hereditary chief has noted that Nuxalk hereditary chieftainship was reactivated when clear-cutting began in order to establish a collective Native body capable of resisting it.

Opposition to industrial logging by outsiders has been supported by some Nuxalk for several generations, as evidenced by the following statement by a hereditary chief: "My grandmother told me she watched logs being trucked out of here ever since she was a little girl. It has to stop" (Feinburg 1997, 1). In fact, in April 1997 a contingent of Nuxalk travelled through Europe to express how they felt about Nuxalk land and resources being appropriated without a treaty having been signed, and they met with environmental groups from around the world to try to stop the export of Nuxalk logs. In England one Nuxalk man went to a log yard and claimed publicly that these were Nuxalk logs that had been stolen from the Nuxalk Nation, even though they had been "legally" purchased from a logging company in Canada. There is a general feeling in Bella Coola that logs are being stolen from the valley and, thus, from the Nuxalk Nation. The reason such thefts are possible lies in the fact that land claims have not been settled to the Nuxalk Nation's satisfaction.

Theft of Land

Like First Nations in other parts of British Columbia, the Nuxalk did not

sign a treaty to sell their land and resources with either the British monar-
chy or the Canadian government. In 1763 King George the Third's Royal
Proclamation guaranteed Aboriginal rights to land not actively surrendered
or sold by First Nations peoples. Following this decree, in 1851 Governor
James Douglas of Vancouver Island began making treaties and buying land
from fourteen tribes living in the vicinity of the towns of Victoria, Nanaimo,
and Fort Rupert. Four years later, when the government could no longer
afford to legally purchase Native land, Douglas changed his tactics: he con-
tinued creating government reserves for First Nations communities with
the intention of compensating them for the land they would lose once
monies became available (they never did) (Carlson 1997; Duff 1969; Fisher
1992; Tennant 1990).

Consequently, in 1882 the provincial government allocated reserve land
to the Nuxalk (then called the Bella Coola band). The land was surveyed in
1888, and the official reserve maps were approved in 1889. The largest area
set aside for the containment of the Nuxalk was known as the Bella Coola
Reserve (formerly called *Koomkoots*), which covered approximately 1,355.5
hectares. The other reserves carved out of the area the ancestors of the
present-day Nuxalk inhabited were tiny parcels of land at the mouths of the
Dean River (Kemsquit Reserve, 203.2 hectares), the Taleomey River in the
South Bentinck Arm of the Burke Channel (Taleomy Reserve, 202.3 hect-
ares), the Kimsquit River (Chatscah Reserve, 173.2 hectares), the Kwatna
River in Kwatna Bay (Kwatlena Reserve, 53 hectares), and the Nooseneck
River in the North Bentinck Arm of Burke Channel (Nooseneck Reserve, 5.3
hectares) (Kennedy and Bouchard 1990, 324; Prince 1992, 55; Sirois 1996,
29). In 1913 these reserve boundaries were readjusted, and the McKenna-
McBride Commission, designed to address the "Indian Land Question," added
the Skowquiltz River Reserve (32.4 hectares) at the mouth of the Skowquiltz
River in Dean Channel (Sirois 1996, 29) (see Map 2). As a result of this
historical partitioning, the Nuxalk now own seven reserves in total. Thus,
the Nuxalk, as well as most other First Nations in British Columbia, entered
reserve life without receiving payment for their lost land or signing a treaty.

The Nuxalk also saw their territories diminish with the arrival of a group
of Norwegian colonists from Minnesota, who came to the Bella Coola Val-
ley in 1894 to begin a utopian religious community. Interestingly, the Nor-
wegians came to Bella Coola as a result of a series of newspaper articles that
had been published in the United States by a Norwegian immigrant and
artifact collector, Bernard Fillip Jacobsen. Jacobsen, who had visited Bella
Coola, had written glowingly of the area, stating that the alpine landscape
reminded him of his Norwegian homeland. The Nuxalk treated the Nor-
wegian community with respect and aided their first difficult years in the
valley. Subsequently, the new arrivals remained, establishing the town of
Hagensborg seventeen kilometres from Bella Coola. Its occupants today own

some of the best farming and cattle-grazing lands in the valley (*Coast Mountain News* 1987b). Current relations between the Nuxalk and the Norwegian settlers' descendants have been described as cordial but distant (due to unresolved land claims) (*Coast Mountain News* 1991a and 1991b).

The Nuxalk fight to regain land taken from them without treaty or payment in 1882 continues today. At the forefront of this battle is an organization known as the House of *Smayusta*, which is composed of a number of hereditary chiefs and elders, who have banded together to work with environmental groups to prevent the clear-cutting of Nuxalk land. Members of the House of *Smayusta* refer to themselves as "traditionalists," or "sovereigntists," because their goal is Nuxalk self-determination and self-government. Upon welcoming Greenpeace to the Bella Coola Valley the head hereditary chief stated unequivocally in the local Bella Coola newspaper, the *Coast Mountain News*, "We're making the statement ... Nuxalk [land] belongs to the *Nuxalkmc*. This land has been taken without our consent" (Schooner 1994, 3). The unavoidable connection between land claims and resource extraction was further highlighted by another hereditary chief in 1995, when he spoke out (along with a number of other hereditary chiefs) during a logging blockade against Interfor: "They [Interfor] say we are trespassing, but how can we trespass on our own land? It is they who are trespassing" (Hall 1995b, 1).

Contemporary Treaty Negotiations

Although many of the larger breaches between the elected and hereditary chiefs had been mended by 2002, when I was in Bella Coola in 1997 there was a crucial divide over the decision to participate in the British Columbia Treaty Commission process, which had only been activated in September 1992. This is a tripartite process whereby the Canadian federal government, the province of British Columbia, and each First Nation in British Columbia negotiate to settle land claims that have remained unresolved since the nineteenth century. To begin the negotiations, a First Nation must submit a claim declaring itself willing to abide by the rules of the treaty commission and the resulting outcome of the bargaining table in perpetuity, whereby all future claims would be extinguished. The goal of this process is to resolve conflict regarding land ownership, resource access, and Native government. In treaty terms, a state of "certainty" must be achieved, whereby economic and political accord is reached between First Nations, resource extractors, the Province of British Columbia, and the Crown.

In 1997, when the Nuxalk elected chief and many of his council considered participating in negotiations, some labelled them as "sell-outs" or "DIA Indians," implying that they were in the pocket of the provincial government. Nuxalk hereditary chiefs refused to recognize the provincial government's right to sit at the treaty table, arguing that this should be a

nation-to-nation negotiation and that the province's presence was unnecessary. This position was highlighted when a local non-Native motel owner attempted to build a fence over a Nuxalk graveyard. In the midst of the ensuing legal conflict over land ownership, the head hereditary chief explained: "it's the federal government's problem now, not the [the motel owners'], not the provincial government's. We don't negotiate with third party interests ... It's always been Nuxalk land. We haven't given it away, or signed it away. All the resources still belong to us. Everything" (Hall 1995a, 11).

The Nuxalk stance was based on the assertion that, according to the Royal Proclamation of 1763, the Nuxalk had never extinguished Aboriginal title to their ancestral land. This attitude reflects the Nuxalk distrust of British Columbia's motives, which have historically been anti-Native. The hereditary chiefs desire national, not provincial, recognition of Aboriginal title (as do the elected chief and council). They feared coming to the treaty table because doing so might have abrogated their Aboriginal title and rights by subsuming them under a larger political agent – the British Columbia Treaty Commission.

By 2001 a Nuxalk community mandate (a quorum of voting adults) decided not to bring their land claims to the BC Treaty Process. The Nuxalk have joined a small faction of other First Nations communities in British Columbia who are refusing to participate because they believe that the process can only end with loss of rights. This position is supported by the Union of BC Indian Chiefs and is voiced by hereditary chiefs in Bella Coola. The Nuxalk Nation refuses to participate in the British Columbia Treaty Process, but the return of Nuxalk land and resource rights is of paramount concern to all contemporary *Nuxalkmc*.[10]

Theft of People

According to a Hudson's Bay Company census, the 1835 population of the valley was 2,000, although it is unclear whether this includes the Taliomi, Kimsquit, and Kwatna geographic areas (Duff 1969, 39). By 1925 the smallpox epidemics brought by the European and American sailors and settlers in 1836-37 and 1862-63 (Keddie 1993, 7), the measles epidemics in 1848 and 1868, and the whooping cough and influenza epidemics in the 1880s had reduced a thriving archipelago of villages to a single village containing approximately 450 inhabitants.[11] Many lost their entire families, and often there were not enough people left to bury the dead. The population fell to 249 in 1929 (Boyd 1990; Duff 1969, 39; Kirk 1986, 225). Some in Bella Coola believe this decimation was planned and that blankets and/or tobacco infected with the smallpox virus were given as gifts or sold to the Nuxalk. Although this cannot be verified, it illustrates the contemporary Nuxalk belief that population loss is the result of interaction with non-Native people.

And this is certainly a theft – a theft of people. Only recently has the population begun to reach its nineteenth-century heights. According to records compiled by the DIA in December 2004 there were then 1,363 registered Nuxalk band members.

Theft of Children

The 1894 amendment to the Indian Act, which made school attendance compulsory for all Native children, was being enforced in the 1920s (Fournier and Crey 1997, 61; Haig-Brown 1988, 31; Miller 1991, 197). Like other First Nations in Canada, the Nuxalk were experiencing increasing pressures to assimilate to mainstream culture, and this was manifesting itself as indigenous cultural repression. By the early 1930s, unless their parents could prove to the local Indian agent that they were capable of feeding, clothing, and caring for them, Nuxalk children were forced by the federal government to attend distant residential schools on Vancouver Island, Cormorant Island, and in Greater Vancouver (Barker and Cole 2003, 15).

At residential schools, Nuxalk children were denied daily contact with their parents and elders and were forbidden to speak their Native language. The children who were removed from their homes in this way suffered both physically and psychologically as they often felt that their parents had rejected them. The Eurocentric school system emphasized academic subjects such as reading, writing, and arithmetic, but it also included subjects such as Christianity, hygiene, and trades. In addition, most children were used as sources of unpaid labour in residential schools, where they worked long hours in kitchens and laundries or were contracted out to local farmers in order to support the schools financially (Fournier and Crey 1997, 56-57). Although they received a basic level of education, students were discouraged from aspiring to enter institutions of advanced learning or professional programs. In other words, a basic level of education and literacy was deemed necessary in order to assimilate Native children into Euro-Canadian society (e.g., as manual labourers), but anything that would have allowed for real financial and social "success" or the ability to directly challenge Euro-Canadian domination (e.g., through a knowledge of the legal system) was denied.

Overall, the residential school system provided a venue in which missionaries taught First Nations children to feel ashamed of their parents and culture. In addition, a shockingly large number of attendees experienced physical, psychological, and sexual abuse at the hands of those entrusted to care for and teach them. Today many refer to the children who attended residential schools as "the lost generation" because they are bereft of Nuxalk cultural knowledge and the ability to speak the Nuxalk language. During my fieldwork I had the opportunity to speak to a number of people about their perceptions and experiences pertaining to this aspect of their history. One Nuxalk man in his seventies, who attended St. Michael's Residential

School for Boys in Alert Bay between the ages of eight and seventeen, stated: "They were trying to drive it – our culture – out of us." He then went on to explain that a number of the boys with whom he attended school managed to "get their culture back," while others never did. A hereditary chief and former elected band chief commented: "The first generation [the elders], they have their culture. It's solid for them. The next generation, they're the ones who got it stripped away through the residential schools. The third generation – my generation – we're lost. The fourth generation – our kids – there's real pride with the elders now as they see the fourth generation coming on" (Kirk 1986, 247).

For these reasons, many Nuxalk view the era of residential schooling as having had a drastically negative effect on their history in that it both attempted to erase Native culture and created many of the social problems experienced by Native peoples today. For example, children who were sent away to residential schools, often not returning home until their seventeenth birthday – not even for winter or summer holidays – had no models for how to raise a family. This led to cycles of family instability that included physical, psychological, and/or sexual abuse.

The cycle of lost children continued even after the residential schools were phased out in the 1960s and First Nations children were beginning to attend local schools.[12] Tuberculosis, introduced through contact with non-Native people, led to many Bella Coola children being sent to sanitariums in Nanaimo on Vancouver Island. And, as recently as the late 1960s, Nuxalk children were sent as fosterlings to Mormon homes in Alberta. It was only in 1996 that the BC government introduced a new child, family and community service act that "called for aboriginal bands to be involved in the planning regarding any of their children in care" (Fournier and Crey 1997, 92). The loss of three generations of Nuxalk children due to cultural deprivation has dealt a severe blow to the continuity of Nuxalk culture.

Addictions

Presently, the people of Bella Coola are faced with problems of alcoholism and drug use. The Nuxalk first came into contact with alcohol during the fur trading era. Non-Native traders discovered that First Nations people seemed to have a low tolerance for alcohol, and it quickly became a coveted trade item. Depression from loss of Native lifestyle and population decimation was assuaged by chronic drinking. By 1922 ethnographer Thomas F. McIlwraith identified alcoholism as rampant in Bella Coola (Barker and Cole 2003, 93). We know alcohol was viewed as a problem by the Nuxalk because a temperance society was formed under the auspices of the Methodist Church. Methodist missionary William Henry Pierce (1933, 97) recalled that, on a return visit to Bella Coola in 1931 for the Jubilee Celebrations of the missions, 132 Nuxalk signed an agreement to abstain from alcohol consumption. More

recently, many Nuxalk informed me that they joined the Pentecostal Church in order to get away from alcohol abuse. One Nuxalk spoke to me about the irony of a Christian temperance society since he believed it was the Christian-run residential schools that fostered feelings of low self-esteem and loss of cultural identity, which, in turn, led many Nuxalk youth to self-medicate with alcohol. This legacy of alcohol abuse has continued, and the range of addictive substances has grown. Thus, alcohol has resulted in another theft – that of people lost to addiction and self-abuse.[13]

Theft of Cultural Knowledge: Missionization and Christianity

Missionaries were invited to come to Bella Coola at a time when people's faith in the old ways had been greatly shaken by the smallpox epidemic of 1862-63. The first Methodist missionary in Bella Coola, William Henry Pierce, was invited from neighbouring Bella Bella by a Nuxalk leader, referred to as "Chief Tom." Upon his arrival in 1883 Pierce converted many of the survivors of the epidemic to the Methodist faith. Under Methodist guidance those Nuxalk who converted were directed to burn their non-Christian religious regalia. The fine example that Chief Tom set for his new flock was duly recorded by Pierce (1933, 45-46): "[Chief Tom] burned two boxes of treasures, even a secret whistle his grandfather had refused to sell for a slave!" Although many *Nuxalkmc* willingly converted to Christianity, some refused to relinquish their old faith. However, all Nuxalk were encouraged by the now resident missionaries to sell or burn their ceremonial masks and to abandon their old ways (Seip 1999, 280).

Additional efforts were made by non-Native outsiders and some Nuxalk insiders to assimilate the Native population to Euro-Canadian culture. Perhaps one of the most notorious attempts occurred in 1884 when the anti-potlatch law was added to the Indian Act. This addendum made the Northwest Coast potlatch ceremony illegal. The law was created at the behest of local Indian agents and missionaries, who viewed Native dancing and rituals as hopelessly aberrant and an anathema to the laws of Christianity and civilized society (Bracken 1997; Cole and Chaikin 1990). The anti-potlatch law was never formally enforced in Bella Coola through court trials or the jailing of participants, as it was in some other Native communities, but there was significant pressure from missionaries and Indian agents to halt its practice. While potlatching in Bella Coola appears to have abated somewhat beginning in the 1880s, ethnographer Thomas F. McIlwraith observed winter ceremonials and secret gift-giving as late as 1923 and 1924. The current head hereditary chief also recalled that his grandfather gave the last official potlatch in Bella Coola in the early 1930s, after which he discontinued the practice because he was warned it was illegal. A potlatch held in Bella Coola in 1979 is believed to be the first in recent years (Barker and Cole 2003, 24).

The Pentecostal Church arrived in Bella Coola in 1955 and gained prominence in the 1970s. Today it continues to have an important influence on the younger generation's attitude towards Nuxalk culture (Kennedy and Bouchard 1990, 337). The Pentecostal Church is uncomfortable allowing Nuxalk drums in church or permitting Nuxalk to wear their regalia, even though the United Church of Canada set a precedent for this when, in 1986, it apologized for its past actions and embraced a synthesis of Native and Christian cultures in its services. One Nuxalk artist informed me that, when he was a member of the Pentecostal Church, he was pressured to give up carving, which was viewed as the creation of pagan idols. Thus, he was being forced to choose between the Pentecostal Church or Nuxalk art; he chose the latter. A similar conflict arose for a teenage Nuxalk church member, who informed me that she left the Pentecostal school, Mathetes Christian Academy, because it did not approve of her participation in potlatches or of her singing Nuxalk traditional songs while she was a member of the Pentecostal choir.

Many Nuxalk with whom I spoke are practising Christians, but some expressed dissatisfaction with the apparent incompatibility between their Christian faith and their Nuxalk identity. Still others expressed outright anger towards Christian churches, identifying them as the principle sources of culture loss and shame.

Theft of Cultural Knowledge by Anthropologists

Another type of historical theft of culture was perpetrated by the activities of early anthropologists and others who conducted fieldwork among Native communities of the Northwest Coast. Even before Franz Boas became known as the "father of American anthropology," he met some Nuxalk in Berlin in January 1886 when a troupe of nine Bella Coola dancers toured Europe, having been brought overseas by the Norwegian brothers, Captain J. Adrien Jacobsen and B. Fillip Jacobsen (Cole 1982; Haberland 1987).[14] Boas was inspired by this experience to begin researching the indigenous peoples of the Northwest Coast of Canada. In September 1886 he began collecting Nuxalk stories from Nuxalk living in Victoria, British Columbia. He finally visited Bella Coola in July 1897, where he had arranged to meet his research assistant and collaborator, George Hunt, in order to continue his work. Within a two-week period he and Hunt collected Nuxalk mythological tales and drew and catalogued the dance masks associated with them. He left Hunt and archaeologist/photographer Harlan Smith to collect and buy material objects from the Nuxalk. In 1898, Boas published the results of his work among the Nuxalk in a book entitled *The Mythology of the Bella Coola Indians*. Unfortunately, he left no notes about the reception he received while doing this fieldwork (although we do know he paid his informants). One Nuxalk artist I interviewed in August 1995 told me how much he likes Boas'

book, particularly because of the sketches of nineteenth-century Bella Coola masks. Thus Nuxalk artists have been able to draw upon Boas' work and use it as an inspiration in their own carving. This shows the ambiguous nature of the results of research such as Boas'. On the one hand, Boas built his career and reputation by extracting cultural knowledge from his brief encounter with the Nuxalk; on the other hand, his work has provided present-day Nuxalk with a valuable means of regaining lost cultural knowledge, which has aided the current cultural revival process.

Another early scholar, Thomas F. McIlwraith, followed in Boas' footsteps. Living in Bella Coola from March to August of 1922, McIlwraith conducted research for the Victoria Memorial Museum in Ottawa under a contract with curator Edward Sapir (Barker 1992, xi). He returned to work in Bella Coola in September 1923 and stayed until February 1924. In 1948 he published what would become the definitive ethnography of the Nuxalk, a text entitled *The Bella Coola Indians* (2 vols.). It appears that McIlwraith was well liked in Bella Coola as he was adopted by one of his first informants and given names, dance privileges, and ritual rights. According to McIlwraith's (1987, 54) own account, the Nuxalk were eager to have their origin stories written down and perhaps published: "News that a white man was collecting stories from Joshua soon spread through the village. At first it was only a matter of interest, but when it became known that Joshua's information was to be published in a book and so preserved for posterity, jealousy was aroused. 'Why should the adventures of Joshua's ancestors be recorded and not ours?' ran the comments." He was also encouraged by the last surviving ritual prompter[15] to write down Nuxalk songs so they would not be forgotten (58). McIlwraith was allowed to participate in the winter ceremonials of 1923-24 and may have encouraged a resurgence of Nuxalk interest in their culture through his clear appreciation of their dances and general lifestyle.

Many households in Bella Coola now own McIlwraith's thick volumes and seem pleased that he was in Bella Coola to record Nuxalk culture in the 1920s. In fact, the Nuxalk hold McIlwraith's memory in such high regard that his two children were honoured guests at the Lily Brown-Patrick Squash Memorial Potlatch held in Bella Coola on 12 October 1991, where they addressed those gathered as follows: "We've seen what amounts to a turn around. We're here at a time where we can see a growing, vital, energizing society, quite the reversal of what our father experienced fifty and sixty years ago. The fact that the community is conscious of the writings of our father and the role it has played in making the reversal possible is very, very gratifying" (Hall 1991, 9).

While McIlwraith's work has not led to claims of cultural appropriation, Bella Coola's more recent history discloses a number of other non-Native scholars and laypeople who have pursued less well-received projects. One

such individual was Cliff Kopas, a long-time resident (now deceased),[16] whose *Bella Coola* was published in 1970. Kopas' work centres upon local Native stories as well as a history of the interaction between the Nuxalk and non-Native settlers in the Bella Coola Valley. One Nuxalk man observed that, although *Bella Coola* is "good to the eye" and has provided the area with much positive publicity, he doubts the overall integrity of Kopas' motives for writing it. Kopas, he pointed out, made personal profit from the sale of his book, without giving back to the community. McIlwraith, on the other hand, is consistently viewed by the Nuxalk as having provided them with a font of useful historical data. Kopas, in fact, was accused of asking elders to tell him their stories without adequately explaining to them his ultimate reason for doing so.

Theft of Cultural Knowledge by Linguists and Ethnomusicologists

From 1972 to 1974, and again in 1983, the linguist Hank F. Nater conducted research in Bella Coola on the Nuxalk language, the results of which were published in two books, *The Bella Coola Language* (1984) and *A Concise Nuxalk English Dictionary* (1990). Nater shared his linguistic work with fellow linguists Philip W. Davis and Ross Saunders, and this resulted in the publication of numerous academic articles as well as two additional books, *Bella Coola Texts* (1980) and *A Grammar of Bella Coola* (1997).

I also wished to study the Nuxalk language but was surprised when a Nuxalk language teacher said she would have to consult the other elders before taking me on as a student. At the time I could not understand how learning a language in which few were interested could be harmful to the Nuxalk Nation. I quickly realized that the request was not as simple as it appeared. The elder was not sure she had the right to decide whether or not I could learn the language. It is perceived as belonging to the Nuxalk Nation and, therefore, is considered to be cultural property that is vulnerable to appropriation.

Broaching the topic of Nater's work, I spoke with a hereditary chief about the matter. Specifically, I asked him whether he was pleased that Nater had published a Nuxalk/English dictionary. He told me that he was not, adding that he worried about going into court one day and finding the prosecutors all speaking Nuxalk! Although this seemed far-fetched, I began to realize that, if one views the Nuxalk language as Nuxalk national property, then one might resent having it published for non-Nuxalk use. The underlying issue here, as elsewhere, is for the Nuxalk to maintain, and in some cases regain, control of their cultural knowledge.

Similarly, in 1975 ethnomusicologist Anton F. Kolstee spent the summer recording Nuxalk traditional songs. He eventually published his thesis, *Bella Coola Indian Music*, as a book in 1982. A cultural teacher at the *Acwsalcta* School told me of how this work had led her to fear outside researchers.

After Kolstee had completed his study in Bella Coola he spent time in the town of Bella Bella. The teacher was upset to learn that, once in Bella Bella, Kolstee taught privately owned Nuxalk songs to the Heiltsuk, who then began adapting the melodies to flute compositions without the permission of the Nuxalk families who owned the songs. She was very angry with Kolstee and cautioned me to pay attention to the fact that cultural knowledge is *owned* in Bella Coola and that these property rights must be respected.

Differing views in the Nuxalk community concerning cultural appropriation became apparent in the event that followed the publication of Nuxalk stories told to a non-Nuxalk man by Clayton Mack,[17] a hunter and guide. These stories were recorded by Mack's doctor, Harvey Thommasen, during Mack's stay in the Bella Coola Hospital. Upon Mack's death in 1993 Thommasen published two books of these stories, entitled *Grizzlies and White Guys* (1993) and *Bella Coola Man* (1994). I was told that certain members of the Mack family were upset that a non-Nuxalk person had published them. However, others in the community supported the publications, arguing that the family itself could have taken the time to record Mack's reminiscences but had not done so. Still others believed it was a good thing that somebody had recorded Mack's numerous stories before they were lost forever. Situations like these provide examples of the kind of ambivalent attitude many Nuxalk have towards non-Native people making use of Nuxalk cultural knowledge.

Theft of Cultural Knowledge through Technology

Another area of anxiety for the Nuxalk is digital technology, including compact disks and the Internet, which is capable of recording and disseminating massive amounts of data globally. There are those Nuxalk who are hesitant about the merits of computer technology and photographic replication. Once photographs of Nuxalk art are published, recorded on compact disks for easy duplication, or put on the Internet, the images are out of Nuxalk control. Given the long history of outsider theft in Bella Coola, issues of who owns these representations and who should have access to them, whether the Nuxalk Nation as a whole, a family, or an individual, are highly contentious.

On the other hand, Lisa Seip (2000), who wrote her master's thesis on Nuxalk masks, created a CD ROM filled with colour photographs of all the Nuxalk masks in museum collections in North America. Her work was received with open arms in Bella Coola because Nuxalk carvers were excited about finally having a compendium of older Nuxalk pieces that had been hidden away in museum storage collections. Seip was asked to give numerous slide shows of the photographs she had made and to talk about her research; she even spoke at a potlatch in 1996. Her work on cultural prop-

erty was supported because she brought extremely useful information back into the community rather than simply taking it out.

Theft of Objects: Ceremonial and Everyday

Since 1884 Bella Coola has been the focus of concerted collecting campaigns for ethnology museums and world expositions. Records tell us that, in 1884, curator James G. Swan used agents in Bella Coola to obtain two house-posts and masks for the Smithsonian Museum in Washington, DC (Cole 1985, 46). Also, by 1884 Norwegian-born B. Fillip Jacobsen had begun collecting Nuxalk artifacts to be shipped abroad to the Museum für Völkerkunde in Berlin. The museum collecting race was on, and Bella Coola artifacts were highly prized for their uniqueness and bright colours.

We know that, although the Nuxalk were probably only too happy to sell everyday objects for money, they had a deep-seated fear of selling ritual dance masks. Nuxalk did not wish to sell *sisaok* chiefly masks because these represented a family's inheritance and ownership of lands and privileges. *Kusiut* dance masks could not be sold either because they originated within secret societies and were literally thought to be supernatural beings rather than mere representations of them. Traditionally, *sisaok* masks and regalia were stored in elaborate wooden boxes and only brought out for specific ceremonies. As for *kusiut* masks, no one except secret society members were permitted to know about the carving of these masks, which were supposed to be burned after each winter ceremonial (Richardson 1982, 59). For these reasons the Nuxalk, understandably, feared selling both *sisaok* and *kusiut* regalia to outsiders. This hesitation to sell ceremonial objects is affirmed by B. Fillip Jacobsen's experiences of collecting in Bella Coola: "Fillip [Jacobsen] quickly learned the art of nocturnal privacy and most of his significant purchasing in the summer of 1884 was done at night. 'You see,' he wrote in his peculiar English, 'No Indian will sel any of his wolluabele Dans mask and let any of his neobor know anything obout it. Any ordinary haus article I of couce could buy in the Day time but when it cam Wooden masks Dans Ratels and wissels wich was all uset in the secret Danses I had to be soo careful'" (Cole 1985, 302).

McIlwraith also wrote of the difficulty he had in buying Nuxalk ceremonial objects. In 1921 a Nuxalk man secretly sold a government official a merganser (a species of duck) representation that had been used ceremonially. The buyer allowed the object to be seen by several Nuxalk as well as by some Native people from the Ulkatcho (Alkatcho Carrier). The story reached the Heiltsuk, who believed the seller would suffer disaster for letting a secret object be seen by outsiders. The seller's wife subsequently died, a death the Nuxalk attributed to the bad thoughts of the Heiltsuk. As a result of this ritual infraction, McIlwraith was denied access to ritual items he apparently

wished to purchase: "This incident was too fresh in the minds of several men to allow them to sell ceremonial objects to the writer" (McIlwraith 1992, vol. 1:697). In a letter to museum collector Charles F. Newcombe, C.R. Draney, the wife of a Bella Coola businessman, recalled: "When Jimmy Kimquish, one of Jacobsen's Bella Coola troupe, died in 1899, his masks, instead of being destroyed, were brought to the Indian agent's house and dropped through an open window in the dark of night. They were paid for in a similar way, for I was not to know which of the tribe brought them" (Cole 1985, 302).

For all the evidence that selling ceremonial objects in Bella Coola was met with disapproval, the practice continues to this day. B. Fillip Jacobsen continued to collect in Bella Coola between 1891 and 1892, but this time for the 1893 Chicago World's Fair. Jacobsen purchased both clan and secret society objects as well as stone implements. In fact, this collecting expedition was commissioned and organized by Franz Boas, who purchased the objects through Jacobsen for $554 (Cole 1985, 123). Boas' Native assistant, George Hunt, also purchased secret society objects for the same purpose.

From 1896 through to approximately 1901 James Teit, a Scotsman who lived in Spences Bridge, British Columbia, collected for Boas, who was by now at the American Museum of Natural History (Cole 1985, 148). In addition, in 1897 Boas, with the help of George Hunt and Jacobsen (who lived in the Bella Coola Valley at the time), collected nearly sixty Nuxalk masks for the American Museum of Natural History (Seip 1999, 281). At the time, Boas wrote to Hunt in Bella Coola saying he wanted "just as many masks and rings as you can get, but also the ordinary everyday things – fish traps, blankets, hammers, pestles, etc." (Cole 1985, 153). With this collection, as well as materials bought elsewhere, Boas was able to open the Northwest Coast Hall at the American Museum of Natural History in New York City in 1898. This is considered to be the most complete set of objects of its kind in existence.

From 1899 until the early twentieth century, C.R. Draney bought Nuxalk objects in Bella Coola, some of which eventually found their way into the hands of the famed New York City collector of Native artifacts and founder of the Museum of the American Indian, George Heye (Cole 1985, 216). In 1903 curators Charles Newcombe and George Dorsey, in an effort to compete with Boas, hired Jacobsen to purchase objects for the Chicago Field Museum's Bella Coola collection (134). As well, in 1909 and 1915 Samuel A. Barrett collected in Bella Coola for the Milwaukee Public Museum and managed to obtain a large number of masks, a fact Cole attributes to the anti-potlatch law and its resulting religious turmoil (248-49).

In 1923 McIlwraith, while conducting ethnographic research in Bella Coola, noted that, because of so many competing buyers, it was difficult to collect local objects. Finally, one of his informants gave him four masks,

with the request that: "I keep them forever as I was more to be trusted with them than the young Bella Coolas" (Cole 1985, 278). Unlike other outside visitors to the area, McIlwraith did little collecting because, as he put it, "[collecting] interfered with the willingness of my people to discuss the secret parts of certain rites." Additionally, he noted that "practically no new ceremonial objects are being made ... [and] any losses curtail the already too much curtailed sacred life to that extent" (279).

Another way that older objects have left Nuxalk hands was in the form of collateral for payments owed to either the local Hudson's Bay Store or the local Kopas General Store, which is non-Native-owned and sells clothing, household goods, books, and Nuxalk art. For example, one elder described how her husband had his Clown mask taken from him as collateral for a debt. She told me this story on three different occasions, which indicates how significant it was to her. According to her daughter, the loss "really bothers my mom." Apparently, she did not fully understand what putting their masks up as collateral meant as she told this story as an example of deception, unfairness, and theft.

The sense of having been tricked and violated is often very intense for the Nuxalk. One informant explained how she feels physically ill each time she reads the University of British Columbia Museum of Anthropology's catalogue, which lists specific objects along with the non-Native donor's name. This is because she knows to whom many of the objects originally belonged. As she put it, she finds "knowing who got ripped off" to be very upsetting. She also described how many Native people were pressured by Cliff Kopas and John Clayton to put their masks up for collateral against merchandise bought in their stores. When they couldn't pay, their masks were simply kept.[18]

An Anthropologist Negotiates the Past and the Present

Given these historical circumstances, it is no wonder that contemporary Nuxalk are hesitant to display older masks that are still in their hands, to sell art to those outside the community, or to accept the idea of non-Native people's researching and writing about Nuxalk art and culture. As already detailed, numerous cultural anthropologists, ethnomusicologists, linguists, historians, and archaeologists have come to Bella Coola seeking information. Although all these scholars have been aided and welcomed in some fashion, the question just below the surface is: "What will be taken this time?" There is an overwhelming awareness that outsiders seem to take and take but never give back. As I demonstrate in subsequent chapters, this fear is also directed towards Nuxalk artists as they are sometimes viewed as people who take Nuxalk art designs for their own profit, while giving little back to the community.

This history creates problems for the anthropologist. When I was interviewing one elder, her daughter asked me who was sponsoring my study of

Bella Coola, to which I replied, "A university." She responded that I was doing this research for a degree, insinuating that this was a self-serving and hence illegitimate reason for conducting it. She said that she believed that "only Natives should be writing about Natives." She then asked whether the elders were speaking to me; in other words, had they given me their approval? (No elder had refused to speak with me.)

How did I, as anthropologist, as cultural knowledge taker, negotiate this important issue while still managing to carry out a research project in Bella Coola? I did so by centring my research upon issues of ownership and theft, which enabled me to avoid writing down, recording, taking, or otherwise stealing the content of Nuxalk culture itself. I did not record songs, write down stories, publish photographs of art, or even learn the language. In my opinion, confirmed by my reception in the community, I walked a fine line between taking from and giving back to the Nuxalk community.

3

"Selling Out" or "Buying In"?
Identity Politics and Art
Objectification in Bella Coola

In the summer of 1995 I met a young Nuxalk artist in Bella Coola and interviewed him about his work. He very excitedly told me about a Thunder mask he had recently carved. In order to validate the legitimacy of his creation he could have told me any of a number of things: how he was inspired to make that particular kind of mask; how he chose the style in which to carve it; what it meant to him to be carving; where he was educated in art techniques. Instead, he told me that another Nuxalk, a hereditary chief, had offered to buy the mask sight unseen and still only half finished for $500. He seemed very proud that this chief was willing to trust his skill in carving, and he was thrilled about the money he would make when the mask was completed.

Several days later I had the opportunity to speak with the mask's buyer about the sale of Nuxalk art and the necessity of keeping it within the valley so as to prevent its exploitation. He told me about the above incident involving the purchase of the Thunder mask but from a completely different perspective. He had been aghast to learn that this young man was carving a Thunder mask without having the cultural right to do so. Masks representing supernatural creatures are owned by certain families whose members have the sole right to reproduce them. He was sure that the artist would sell the mask to a non-Nuxalk outside the valley, and, therefore, he had been forced to buy it himself. He had not explained this to the artist, who had interpreted the sale as a compliment rather than as a censure. Ironically, the hereditary chief had to buy his own culture in order to ensure that it was not sold outside of Bella Coola. He informed me he was having the mask danced in a potlatch and that afterwards he would give it to the *Acwsalcta* School Dance Society. This hereditary chief condemns those who sell art outside, seeing them as "selling out" to a capitalist economy. Yet these situations harbour ambiguities and contradictions. The chief was still forced *to pay for* the mask in order to avoid its commodification. The sale of this

mask, even internally to another Nuxalk, was also an act of objectification because it resulted in Nuxalk culture's being represented through a tangible object.

By "commodification" I mean the creation of a relationship with an object via the spending of money or the creation of a relationship with an object via selling it to a buyer. Anthropologist Nicholas Thomas (1991, 39) defines a commodity as: "objects, persons or elements of persons which are placed in a context in which they have exchange value and can be alienated. The alienation of the thing is its dissociation from producers, former users, or prior context ... These terms are deliberately vague in order to allow scope for the nuances of particular movements." In this instance, Thomas does not attach a negative meaning to the word "alienation" but, rather, uses it to denote the separation of an object from its producer.

Returning to the perspective of the young artist presented above, although the act of selling art objects to those within one's own culture may seem less significant than selling them to outsiders, many artists were keen to validate their art production by telling me how much they had obtained for each piece, whether it had been sold to a Nuxalk or to a non-Nuxalk. In both cases the price seemed to serve as evidence of the artist's achievement. For example, one Nuxalk artist proudly told me about an elaborate pencil drawing he made, in which he copied an old photo of a chief in Western clothing but changed this garb to Nuxalk regalia (button blanket, wooden crest headdress, and cedar-bark neck ring). He sold the sketch for $300 to the grandson of the chief in the portrait. I see no reason to downplay the significance of this kind of sale as the Nuxalk are fully integrated into a capitalist system in which, for them, selling art is not only a possible source of needed money but also one of the most reliable sources of income in an otherwise unreliable economy.

Another example may serve to strengthen this point. A silversmith I know, in order to avoid having to negotiate prices for his jewellery with friends and neighbours, has opted to sell his creations to the Kopas general store, which then sets the prices. This is a controversial choice because many artists with whom I spoke in Bella Coola feel that the Kopas store exploits Nuxalk art and artists. They believe that the non-Native owners are profiting from a culture that is not theirs and from an art that they are forbidden to make. This artist, sharing a common anxiety over the sale of art in the Bella Coola Valley, chooses to use the store as an intermediary because he perceives it as easier and less stressful than the alternative. When discussing the meaning of his art, he explained: "Some artists do it only for the money, some do it for the value of the heritage, some abuse it. For myself I try to gather my own ideas and do my own way of engraving it. People must like it because they are *buying* it." While claiming that he is not making art for monetary profit (which I believe is true), he nonetheless is legitimizing his

skills through his ability to sell his art (as a viable commodity) to other Nuxalk and non-Nuxalk. This example presents an individual strategy for dealing with the sale of Nuxalk art inside the valley.

This chapter explores issues surrounding the selling and buying of art in Bella Coola, and the cultural identity construction (sometimes called cultural revival) that results from certain processes of commodification and objectification. Ultimately, my aim is to rethink such loaded terms as "objectification," "authenticity," and "commodification," collapsing such divisions as "traditional" and "modern" along the way.[1] These categories, fixed and oppositional, do not do justice to the kinds of exchanges in which the Nuxalk engage through the production and sale of art. Furthermore, these labels suggest that contemporary culture making is somehow an inauthentic activity, an ideological quagmire. I argue against this position.

In order to emphasize that the most important characteristic of culture is process not product, I consider some of the multiple academic critiques of objectification. Objectification is often viewed negatively as that which denies change, negotiation, struggle, and vitality, resulting in fixity, homogeneity, and reification (Dominguez 1994; Jackson 1989; Keesing 1989). Rather than simply accepting this position, I review the concept and explore the possibility that there is something redeeming in objectification, even something basic to the process of cultural production itself. I argue that it is necessary for the Nuxalk, literally and figuratively, to buy into their culture through commodification and self-objectification in order to enhance their sense of identity as Native people while, at the same time, reclaiming their right to control their own culture and its ongoing production.

Tourist Art and Authenticity

Jean Jackson (1989, 127) begins her aptly titled article, "Is There a Way to Talk about Making Culture without Making Enemies?" by observing "the difficulty encountered in our attempts to describe, in a non-offensive manner, how a given group of people invent, create, package, and sometimes sell their culture." She writes of the contemporary self-determination activities of the Tukanoans in Colombia and notes how quickly outsiders jump to conclusions about inauthenticity and loss of culture when Tukanoan culture changes. In a later article on the Tukanoans, Jackson (1995, 18) identifies value judgments "lurking underneath many assertions about culture," noting that "the new cultural forms that Tukanoans and other Native people are creating, though perhaps not historically accurate, are not corruptions; they are neither spurious nor contrived culture." Jackson's enterprise is representative of a larger body of work that takes a constructivist approach to anthropological endeavours.[2]

Anthropologists who choose a constructivist lens do so in order to refute the previously held vision of culture as positivistic, essentialist, or fixed.

However, the language of cultural invention is "inflammatory" because the general public typically interprets "invention" as "made-up" or "fictitious." Indigenous people engaged in projects that assert cultural identity are also angered because these labels are interpreted as an attack on their authenticity and cultural authority (Glass 1999, 4; Hanson 1989; Linnekin 1992, 249; Linnekin 1991, 446-47). It is ironic that the constructivist approach, which is intended to be non-judgmental and to avoid the pejorative connotations of many commonly used labels (e.g., authentic, inauthentic, traditional, historically correct), has been so poorly received by the very people whose activities it is meant to validate.

Anthropologist Aaron Glass (1999, 4) asks the important question: "How then are we to speak about tradition(s) while avoiding both strict empirical judgment (anthropologists accusing First Nations people of falsifying specific practices as invented) and attacks by Native advocates (First Nations accusing anthropologists of falsifying their entire culture as invented)?" Glass answers: "By insisting that tradition and innovation are part of the same cultural processes and products, we avoid both the debates between empirical and advocacy-minded researchers, and the pitfalls of the authenticity issue because we avoid altogether making 'truth' claims for current cultural projects based on presumed historical accuracy. Instead we focus on the ways in which people invoke concepts of tradition to negotiate, validate, contest, and control contemporary cultural transformations" (5). Within this theoretical context I propose to complicate the way we read certain terms and activities of culture making. In doing this I hope to avoid making external judgments while enhancing our understanding of how the Nuxalk themselves make sense of their activities.

I want, at this point, to add the terms "tourist art" and "souvenir" to the discussion. One could devalue some contemporary Nuxalk art objects by saying they possess a "souvenir" quality: they are easy to purchase and are sometimes mass-produced. This, however, is not my aim; rather, I would like to stress that the Nuxalk buy their art the same way a tourist might. They collect fragments in order to create an integral culture (Stewart 1993). Just as a tourist might buy souvenirs in order to get a feeling for the "authentic" Nuxalk culture, so Nuxalk might buy a variety of logoized,[3] commodified Nuxalk products for similar reasons. The problem is that the search for authenticity appears self-defeating as soon as it becomes self-conscious, and the terminology related to tourism is disparaging (see Phillips 1998, 18, 260). As Dean MacCannell (1976) and Jonathan Culler (1981) have pointed out, it is difficult to see the tourist project as succeeding because the search for the authentic requires signifiers to tell the tourist what *is* authentic. Alexander Alland (1977, 117) encapsulates the tourist's dilemma when he quotes from an article in Air Canada's 1975 *En Route* magazine that deals with how to buy authentic indigenous art: "Be sure it's the real thing. There

is an increasing number of mass-produced imitations of Eskimo [sic] Sculpture sold today – clever imitations of no lasting value, but which can easily be mistaken for authentic art. To be sure, when you buy Eskimo sculpture, that you get the real thing, look for the igloo tag. It is attached to every authentic sculpture and is your guarantee of authenticity." The existence of these markers appears immediately to invalidate the authentic experience because it shows that the object has become mediated and manipulated, contaminated by the need to "sell" it to the tourist who is seeking authenticity.[4] The tourist's quest for authenticity appears doomed precisely because it *is* a quest for authenticity. How does the parallel struggle on the part of the Nuxalk avoid the same fate?

Although I try to redeem the term "tourist art" for local inhabitants of Bella Coola, Nuxalk are caught up in the contradictory perspectives of outsiders who believe that Native culture is reduced by tourism and that it is intrinsically opposed to a cash economy. This paralyzing double bind is clearly stated by Phillips (1998, 63): "When Indians [sic] resist commodification of their culture they retain respect and nobility, but doom themselves, as cultural beings, to die. When they succumb, however, they reveal their weakness and are rejected as 'deteriorated people' without cultural value." *Nuxalkmc* would be the first to deny that their art was ever sold as tourist art. Snared in the paradigm of museum objectification, which says that the sale of art is not a traditional practice, many Nuxalk I met denied that souvenir totem poles and baskets had been sold to explorers, traders, and tourists visiting Bella Coola in the late eighteenth and nineteenth centuries. They too have accepted a pejorative interpretation of selling such objects – one that assumes that their heritage and culture is devalued when they do so.

Objectification and the Construction of Identity

Objectification is often used pejoratively to mean that someone in authority has turned living, changing, historically situated peoples and things into static objects through an act of categorization, which requires distance in time and space. Johannes Fabian (1983) calls this the denial of "coevalness," whereby the subject studied is turned into an object through being refused her or his contemporary timeliness. Many scholars have pointed to the inequalities of power between the objectifier and the objectified, which allow a political agenda to be obscured by a claim of neutrality and objectivity. Virginia Dominguez (1994, 253) fears that "objectification" is "a comparative statement of value," although it presents itself as an ahierarchical activity.[5] Museum exhibition critics and those concerned in the 1980s with self-reflexivity and postmodern ethnography have been quick to accuse curators of reducing peoples by seeing them only through their representative cultural products (Clifford 1988; Karp and Lavine 1991; Marcus and Myers 1995; Miller 1995).

There are numerous examples of the objectification of indigenous peoples by European colonizers throughout the world. In New Zealand, Thomas (1995) describes how, since colonization, non-Native settlers have been appropriating Maori art styles to legitimize their (non-Native New Zealanders') identification as indigenous New Zealanders. While using Maori designs on stamps, currency, and national buildings, non-Native New Zealanders deny living Maori their rights to land, self-determination, and sovereignty. Similar situations have occurred historically and continue to occur in Canada (Barton 2001; Hawker 2003; Phillips 1995; Wallis 1991).

Another common criticism of the objectification process has been made by historians of African art. Sidney Kasfir (1992) points out the problems inherent in assuming that each culture has one national art style. This idea of a unified "national style" ultimately empowers collectors, curators, and scholars, who are then in the position to decide which art object falls within the acceptable range of authentic product and which does not. Under this system African objects stand metonymically for one national style of art and culture: and one national style of art and culture signifies one people (Schildkrout and Keim 1990). Once objects are separated and catalogued according to culture/style in a museum, it is then suggested (although perhaps not explicitly) that everything about each culture can be ordered, named, and displayed without any conflict, ambiguity, or change over time.

The repercussions of this kind of objectification imposed by empowered outsiders upon the culture and art of indigenous peoples go beyond the problem of passing on insufficient or incorrect information to the Western museum visitor. African artists are directly affected by the tastes, desires, and beliefs of the Western art market, which is itself influenced by museum exhibits and scholarship (Schildkrout and Keim 1998, 1990; Steiner 1994). Anthropologists and historians of African peoples are also, of course, affected by the way they are taught to conceptualize African cultures and have, in turn, had a tremendous impact upon colonialist government practices and resultant economic systems. As well, and perhaps most important, the museum model of culture affects the way African peoples and other objectified peoples envision *themselves*. It does this by perpetuating a cycle in which ethnic identities gain reality through being recognized and accepted by a buying Western public. For all these reasons, objectification can and has been regarded as a process of "museumification," of changing living peoples into containable units at the disposal of ruling objectifiers.

Interestingly, but not unexpectedly, I found that, in Bella Coola, the response to this kind of abuse has been one of self-objectification (what Gayatri Spivak terms "strategic essentialism" [1987, 1993]).[6] The self-objectification I observed among the Nuxalk, however, can be seen in a different light. I maintain that, through self-objectification, strategies deployed against indigenous

peoples are being reappropriated by Native political leaders in order to regain control of self-definition and self-display. Thus, self-objectification can serve not only as a powerful force when reappropriated by Native peoples but also as an indispensable tool for identity construction and culture making – the prime ingredients in the cultural revival process.

Native artists and Native hereditary chiefs serving as politicians have trouble defining the state of Native identity today. Of central concern to the Nuxalk is how to make use of traditions, often preserved decades or centuries earlier in scholarly ethnographies, while living in a modern world. Nuxalk artists and politicians struggle over how to represent Nuxalk national identity both to outside non-Native people and to Nuxalk insiders seeking stable identities. For Nuxalk politicians cultural revival and its programs (e.g., those that teach the Nuxalk language, art, origin stories, and dance; see Chapter 4) has become the linchpin for political statements concerning the existence of a vital Native identity deserving of nationhood. If nationhood can be proven through the tangible existence of a unified and objectified "authentic" Nuxalk culture (as manifested through language, art, stories, and dance), then the rewards that would be expected to follow would be title to land, national sovereignty, and indigenous rights. Towards this end Nuxalk politicians claim an innate right to control the dissemination of Nuxalk knowledge, art, mythology, language, and songs, often restricting non-Native access to these phenomena. On the other hand, they frequently fall prey to the way in which outsiders essentialize and objectify Nuxalk culture.

Consider a statement made by a hereditary Nuxalk chief and politician: "Selling art is prostitution of culture, of stories, of everything that we have and who we are. We feel strongly about it ... like a flag. We don't agree with non-Natives, non-Nuxalk, that copy our masks. [It] doesn't matter that it's other Natives copying, [we] still don't like it. It relates to our stories, *smayusta* [origin stories] ... It will always be there with us because nobody can take it or claim it or sell it. It's who we are and where we're from." Here, this hereditary chief discusses a Nuxalk culture that is both alienable and inalienable. He suggests that Nuxalk culture and art can be alienated by being sold to outsiders and thus exploited by non-Nuxalk, be they Native or non-Native. At the same time, he says that there exists a Nuxalk culture that is inalienable, and he likens this culture to a national entity that can be represented by a flag. Thus he is concerned with preventing the "selling out" of his culture, both literally (through selling art to non-Nuxalk residing outside the Bella Coola Valley) and figuratively (through "cultural prostitution"). Yet he also believes in, or rather "buys into," the idea that there is an objectified Nuxalk culture that, in some way, is cohesive and whole and that cannot be taken away or corrupted by outsiders.

This quote exhibits the ambiguity inherent in objectification: its positive potential (its inalienability) and its negative potential (its alienability). Webb Keane (2001, 75) adds insight to this observed duality: "Exteriorization and objectification ... work hand in hand with detachability and mobility. Therein lies both the promise and the risk posed by things, as vehicles of representation." The hereditary chief's statement has ramifications for understanding the risks involved in considering objectified, or essentialized, culture as property. For this reason, Jackson (1989, 135-36) writes that culture should not be thought of "in terms of possession, in terms of quantity retained versus lost." If one's culture is constructed as a series of objects that has the potential to be lost or taken away, then one becomes vulnerable to theft, to alienability. This issue is a complex and serious one for the Nuxalk, and I explore it at length in Chapters 5 and 6. However, returning to the issue at hand, my question is: How is objectification being used by Native leaders in Bella Coola today?

As we have seen, the scholarly objectification of cultures, what I refer to above as "museumification," is typically negatively critiqued by anthropologists and other academics. However, is it possible that there is something qualitatively different about objectification when it is engaged in by indigenous peoples themselves; that is, when it is self-objectification? Although confined by the difficulties of the terminology of objectification, it is my contention that indigenous peoples are finding ways to use it to their advantage (Kuper 1999). Roger Keesing (1994), for example, has pointed out how ironic it is that the notion of capital "C" culture invented by anthropologists in order to objectify indigenous peoples is now being reappropriated by indigenous peoples for their own political ends (1994). Glass (1999, 1), writing about the Kwakwa̱ka'wakw, has noted the same thing: "While the discipline has spent the last twenty years dismembering the concept of culture, Native people have deployed a reified and essentialized self-image for themselves and for outsiders." I turn now to a discussion of Nuxalk activities in order to illustrate these points.

What's in a T-shirt?
T-shirts emblazoned with Nuxalk designs are common in Bella Coola, as are sweatshirts, vests, and jackets with crest designs on the front, lapels, or back. These are mechanically reproduced, either silk-screened or sewn onto a factory-made product. A commercial company located in Williams Lake, Kamloops, or Vancouver transfers the image onto an array of mass-produced items. There are two ostensible reasons for this activity: either to produce commodities or to produce gifts. In the case of the former a Nuxalk artist will authorize the mass reproduction of one of his designs onto an array of wearable items in order to sell them. He can sell these products himself, usually through word of mouth and out of his own home, or he can use an

intermediary who will market them in stores inside or outside Bella Coola.[7] T-shirts made by artists are sold to Nuxalk and non-Nuxalk alike, community members (whether Native or non-Native) and non-community members (whether tourists or friends of Bella Coola residents), without distinction.

Although this transaction may have the appearance of pure commoditization, with the maker being alienated from his product, it became clear to me that the link between artist and mass-replicated object is not necessarily broken. In Bella Coola, Nuxalk are aware of who created the designs, even when clothing is worn as an everyday item. People commonly recognize other people's hand or style and are eager to indicate if the artist is a relative or friend. Nor do T-shirts sold to non-Nuxalk seem to break the connection to the Nuxalk artist. Barbara Kirshenblatt-Gimblett (2001, 262) suggests that Australian Aborigine Pintupi painters "keep while selling, because they can sell the object without selling, or giving away, the Dreaming." I suggest something similar is happening for Nuxalk artists.

In the case of gifts, a family hosting a potlatch commissions a Nuxalk artist to create a specific crest design for the event and has a commercial company reproduce it. This crest item also has the family name and date of the potlatch printed on it. The hosting family decides which commercial company to use – usually the one offering the lowest bulk discounts but having the highest-quality product. This designated business is the source for mass-produced T-shirts, fleece vests, jackets, and/or sweatshirts, which are ordered in bulk by a designated family member. This family member then distributes the items to kin, who have placed orders for specific styles, sizes, and colours and have paid in advance. During the potlatch all family members in attendance wear this purchased crest apparel.[8] At the end of the potlatch, during the give-away portion, each person in the audience is gifted with a T-shirt or a mug[9] with the family name and crest printed on it in the same design as that which appears on the more expensive vests, jackets, and sweatshirts worn by family members.

We could say that a T-shirt made for sale to a tourist in Bella Coola and one made to be given away at a potlatch are two completely different things, the former being a commodity and the latter being a gift, the former having exchange-value and the latter having use-value. In fact, however, the Nuxalk blur these divisions much more than economic theory would have us believe.

The Nuxalk see nothing strange in asking family members to pay for their own potlatch regalia. The artist commissioned to make the original design is paid for his work, as is the commercial company that prints or sews designs. The crest designs are all viewed as inalienably belonging to the family that commissions them. Nuxalk do not seem to differentiate between a mass-produced T-shirt and a hand-sewn button blanket in terms of their function as social identifiers. Both printed T-shirt and button blanket do the work of

visually portraying the owner's family crest.[10] Even though the family's crest is claimed as inalienably belonging to that specific family, such mass-produced objects can also function as commodities.

There are both risks and rewards to mass reproducing one's crest. One cannot control into whose hands an item will fall or who will copy or lay claim to it. While Nuxalk designs intended for potlatching are not made for profit, I have seen potlatch T-shirts and mugs sold at garage sales in Bella Coola without comment. In other words, these physical objects become detached from their original meanings and collect new meanings, which are potentially different from those intended by their maker. The result is that a family crest's replication on a broad array of objects, and its distribution in bulk, allows these designs to represent the family beyond the community. These items travel home with the potlatch guests to become a visual testimony of the ceremony they have attended.

A Nuxalk artist who lives in Vancouver but who often returns to Bella Coola sells original acrylic paintings in the valley as well as in galleries in Vancouver. He also markets art cards, silk-screen prints, and T-shirts. He told me that he thinks of his works of art as his children and that he feels that they work for him as they travel all over the world after being bought by tourists. He once said that he wished he could put a computer chip in each artwork in order to monitor where it went and what it was doing. However, he also expressed mixed feelings about such transactions when he said that he wanted to see every Nuxalk adult and child wearing his T-shirts but that he did not want to see outsiders doing so. An example of the potential for alienation through the sale of his art is illustrated by the following incident. He once saw a man wearing one of his T-shirts in Gas-town, a well-known section of Vancouver. The particular design was that of a hummingbird transforming into a butterfly. "Hey, you've got my T-shirt on," he told the wearer. The man, who was apparently high on street drugs, replied, "Oh, I'm transforming," and walked away. The artist smiled strangely while recalling this, suggesting both his pride as creator of the design and the alienating effect of his experience with this stranger.

In telling me about meeting his artwork on the street, this man was trying to convey what it feels like to be a contemporary Nuxalk artist who sells to the general public outside Bella Coola. He also noted that he is criticized in Bella Coola because he sells Nuxalk art for money. This is probably one of the reasons why he remains in Vancouver, although he expresses his desire to return to Bella Coola for artistic inspiration. In response to such pressure, which might conceivably prevent him from making a living from selling Nuxalk art, he commented: "I'm not stealing any thunder; I just want to contribute a little bit ... I don't want to be the whole." In other words, he wants to make a contribution to Nuxalk culture without being accused of taking from it or claiming to speak for all *Nuxalkmc* through the act of

commodification. The choice of the word "thunder" is doubly meaningful because Thunder is considered to be the most important supernatural being in Nuxalk *smayusta* (origin stories).

This artist feels the weight of representing the Nuxalk Nation through his artwork, even though he tries to free himself from this tension by endlessly asserting his personal art style and, thereby, affirming his individuality. He continued, "I'd much rather add to the culture than minus it." When I asked him what he meant by "minus it," he replied, "'Minus it' could be doing what the traditional artists are doing." By this he could be referring to the refusal of some to create art for sale, especially to non-Nuxalk. Or he could be referring to his use of new styles and media in his artwork. His responses are both defensive and self-supportive. On the one hand, this artist wants to share Nuxalk art with the rest of the world, thus commodifying both the work itself and, by extension, the culture. On the other hand, he wishes to protect Nuxalk art from prying eyes. His position is paradoxical yet not uncommon among Bella Coola artists. Many fear being accused of stealing Nuxalk art for profit as well as of representing Nuxalk identity to outsiders.

Art objects sold in Bella Coola include T-shirts and sweatshirts printed with logos that say "Bella Coola" or "Nuxalk Nation," sports team uniforms embroidered with the team name (e.g., "Nuxalk Braves"), hair barrettes beaded with ravens or eagles and personalized initials, silver pendants in the shape of coppers, wooden plaques with inset clocks and carved split-U designs, and silkscreen prints honouring a wedding union or graduation. Anthropologist Arthur Mason (1996, 2002) has suggested that the production of items such as these could be called the "logo-ization of ethnic identity."[11] As argued at the outset of this chapter, the process of commodification through the buying and selling of these logos is sometimes viewed negatively because it does not conform to purist notions of Native identity making, which can only be deemed "authentic" if somehow connected to a wholly Native (i.e., non-European), non-capitalist past. Yet I want scholars to use these words ("commodification," "logoization") vitally and meaningfully, I want them to be recognized as important, contemporary aspects of the culture-making and revitalizing process within Bella Coola and other of today's Native communities.[12]

Certainly in the past Nuxalk wore Nuxalk art as an act of self-display and community identity. Button blankets and wooden headdresses are no different from logoized T-shirts and hair barrettes when worn with the intent to show off Nuxalk nationality and cultural pride. Moreover, crests and logos are basically the same thing.[13] Historically, chiefs tended to acquire their regalia from the best artists, demonstrating that the idea of selling Nuxalk art in the valley is not a new one. Chiefs "paid" highly skilled carvers, known as "carpenters," with food and gifts to create regalia such as frontlets, headdresses, and masks. These "commissions" occurred when old pieces needed

to be replaced because they were too worn to be used or when chiefly names, crests, and prerogatives were being passed on to the next generation and new regalia was needed so that they could be validated during a potlatch ceremony (McIlwraith 1992, 1:269, 275).

Problems with Self-Objectification

Although thus far I have presented Nuxalk self-objectification as having a positive impact due to its contribution to cultural revival, there are problems inherent in this process. Native scholar Marcia Crosby (1997, 25) describes this strategy as a common contemporary First Nations phenomenon and, while dubious of its long-term efficacy, recognizes its necessity: "Reasserting form and tracing the origins of hereditary chiefs and traditional ways through 'time immemorial,' is what most First Nations in British Columbia are employing as a legal strategy in their disputes within the Canadian government." Inequality exists between those Nuxalk who have power (politicians) and those who do not. Because of their closer connections to provincial and federal funding Nuxalk leaders, both hereditary and elected chiefs, have more power to dictate how the outside non-Native world views Nuxalk identity than do other Nuxalk. Their stance is one that refuses to allow non-Native people the means to exploit Nuxalk culture – a position exemplified at the end of Chapter 1 with the story of how Nuxalk leaders declined provincial funding for the construction of a canoe to be used in the welcoming ceremonies at the Commonwealth Games in Victoria.

As status-laden spokespeople, both hereditary and elected chiefs bear cultural responsibility for their national identity, mediating inside and outside concerns and tensions. Nuxalk chiefs carry much power on the reserve as well. They are effective at dictating the means of passing on Nuxalk culture within the Nuxalk school system, and they also attempt to control the Native production of art objects. Interestingly, although many cultural revival movements are led by indigenous artists, this is not the case in Bella Coola. Nuxalk artists often seem to be paralyzed regarding the production of their art, not knowing how to fulfill the demands of Nuxalk leaders.

Many Nuxalk artists said that they feel "picked on" by various Nuxalk leaders who try to control what they can and cannot depict in their carvings and paintings. For example, one Nuxalk man who had participated in the Harrington show in 1994 told me that a certain Nuxalk hereditary chief was "giving him shit for selling his art." Apparently, this chief did not like the fact that this man painted versions of old Nuxalk dance masks to sell to tourists who came to the valley. He told me he could not understand why he was singled out for criticism when other Nuxalk sell their art too. Another Nuxalk artist told me that he was criticized when his output did not fit the expectations of those who believed that, since it represented the entire nation, his artwork should be done in proper "Nuxalk style." Ironi-

cally, when he stopped painting due to this criticism, he was then criticized for his lack of productivity! This artist did his best to avoid being controlled by outsider judgments and yet felt unable to escape them.

I heard a number of critiques from common *Nuxalkmc* who felt that one Nuxalk artist or another was not producing proper "Nuxalk-style" art but, instead, copying the 'Ksan style[14] or doing his own style, which was inappropriately modern or somehow "not correct." Sometimes a Nuxalk artist would be accused of using a family crest to which he did not have the right. One Nuxalk man, who seemed particularly sensitive to the anxieties of Nuxalk artists and the pressures upon them to curtail their production, told me that artists in Bella Coola are "very contained" and "careful" when it comes to what they make. They do not want to "run into a lot of conflict" or "exploit" their art. Since both using (and thus profiting from) Nuxalk-style art and not using Nuxalk-style art were viewed as disrespectful of Nuxalk national ownership of their art, many Nuxalk artists just stop producing.[15]

In short, the self-objectification of which I speak is deployed differently by Nuxalk elected and hereditary chiefs, Nuxalk artists, and Nuxalk consumers of art. Because of power differentials and divergent strategies, the Nuxalk have not managed to use self-objectification to come to terms with the problems inherent in cultural revival. Nonetheless, self-objectification functions to organize the display of Nuxalk national identity not only to non-Native Canadians outside the valley but also to those living within Bella Coola.

Authenticity Rethought

Authenticity is intimately tangled up with acts of objectification. There has been much critical work on the idea that authenticity is created by those in charge, by the elite, who empower their own accomplishments by making claims to continuity with the past (Benjamin 1968; Handler 1988; Hobsbaum and Ranger 1983). Political agendas have a big impact on aesthetic appreciation and art production, as does the commodity market. Yet for most people the concept of authenticity is an essentializing one. Our desire for something original, something genuine, encourages us to ignore what scholars have made evident again and again: authenticity is a socially constructed valuation bestowed upon objects and behaviours to further political and/or other kinds of ends.

Crosby (1997) critiques the idea of authenticating one's national status and identity through proving "uncontaminated" origins. Being of both Tsimshian and Haida ancestry and having been raised in an urban environment, she attempts to explode "the officially sanctioned context for aboriginal authority and expertise; that is, living in one's aboriginal territory, speaking one's own aboriginal language, following 'traditional' cultural practices, having the ability to trace a seamless lineage to one's geographic,

social and historic origins, and so on" (12). She goes on: "It seems to me that the various forms of practice which focus on binary oppositions (separating Self from Other) as a means of constituting ourselves, not only confines us to the 'authenticity' of our origins as a means of confirming our difference to a Western Other, but also creates hierarchy within and between First Nations peoples. To use these concepts as tools for culturally measuring the newly established hierarchy of 'Indianness' is a political strategy that mirrors the Indian act, whose racially based laws and policies narrowly define what constitutes 'Indian' through blood quantum" (24). Crosby lives the limiting effects of being defined by outside terminology with real political and economic results.

For the above reasons authenticity should be reconsidered within the context of cultural revival (i.e., of contemporary culture construction). I believe that one aspect of the definition of authenticity must be dropped. Authenticity refers to "the condition or quality of being authentic" (*American Heritage Dictionary* 1981, 89). Authentic, in turn, is defined as (1) "worthy of trust, reliance, or belief"; and (2) "having an undisputed origin" or authorship, "genuine" (*American Heritage Dictionary* 1981, 88). I want to emphasize the first definition, which is often forgotten in the attempt to prove the second. The second definition is the most coveted because, relying as it does on the indisputable, it seems to carry a far stronger claim to authority than does the first. But what exactly does "undisputed" mean? The crucial question is, "Whose authority is being invoked?" If, however, the first definition is emphasized, then self-objectification can be understood as an authenticating act, a requirement for constructing subjectivity and the making of cultural nationhood. In this shortened definition, cultural revival is authentic if its participants believe it is. This leads me to ask: What motivates people to want to literally and figuratively "buy into" their culture, and how is this accomplished? Before broaching the subject of what "buying into" means in the Nuxalk context, I want to discuss Arjun Appadurai's (1990) work on the global culture economy.

Appadurai's writing has provided me with the means for rethinking commodification and linking it to authenticity via self-objectification. Appadurai undermines the dichotomies of traditional and modern, local and global. He reworks a traditional Marxist understanding of the relationship between economy and culture by positing an ahierarchical, mutually informative relationship consisting of feedback and negotiation. In the same vein, Appadurai opens up the notion of authenticity by discussing how, for political reasons, the past is continuously reconstructed in the present. He defines these more fluid, less chronological networks of relationships as "imaginary landscapes," where national identities are built through global negotiations. With this understanding, he urges us "to enter a post-nostalgic phase" (Appadurai 1990, 4) that takes away simple models and replaces

them with "a complex transnational construction of imaginary landscapes" (6-7).

Appadurai (1990, 13), referencing Handler (1988), writes: "heritage politics seem remarkably uniform throughout the world." Supporting this view, Richard Wilk (1995, 118) discusses "structures of common difference" in which each country promotes national differences in a homogeneous way. However, Appadurai (1990, 13) believes that these nationalizing strategies of "heritage politics" only benefit large nation-states that seek to "exercise ... taxonomic control over difference, by creating various kinds of international spectacles to domesticate difference, and by seducing small groups with the fantasy of self-display on some sort of global or cosmopolitan stage."[16] For the most part I agree with this analysis, with the caveat that indigenous groups can be active agents in this process rather than merely passive victims. In other words, the "heritage politics" of which Appadurai writes need not be understood solely as something in which only large nation-states engage or that serve only their agendas. As Fred Myers (2001b, 26) aptly observes: "These objectifications are cultural constructs and artifacts that embody the mediation between imperial powers, local power interests, and the interests of the political class ... These objectifications, however, are also themselves the nation's inalienable possessions." The Nuxalk are clearly active agents in heritage politics.

In their descriptions of how Quebecois and Hawaiians strive for tangible signifiers of heritage and patrimony, anthropologists Richard Handler and Jocelyn Linnekin (1984) concur with the above notion of identity construction. These tangible signifiers (e.g., language, dance, food, and architecture) are displayed in order to affirm the existence of a valid culture and, thus, of nationhood. Similarly, the political leaders of Bella Coola try to display their culture in order to claim national, indigenous status within Canada. They, too, strive to project a homogeneous, unchanging culture in order to gain as much legitimacy as possible.

For this reason, internal differences and heterogeneity must be squelched whenever Nuxalk culture is represented outside the community. Furthermore, because indigenous peoples tend to become known through their art objects (Myers 1994, 681), it is of paramount importance that Native leaders of cultural revival, who are also Native politicians, ensure that art objects carry a cohesive message. For instance, instead of revealing that individual families in Bella Coola contest who has the right to wear a chief's headdress or to carve a certain crest or style, Nuxalk politicians attempt to promote the idea that crests, such as the Sun, are owned *collectively* by the Nuxalk Nation, thus smoothing over any internal factionalism.

Within this context, certain Nuxalk political leaders objectify their culture by recreating it in the form of a seamless, unified whole. This kind of self-objectification is similar to the type of objectification practised by museums

in their depiction of the cultures of indigenous peoples. In addition to repatriating objects from museums, the Nuxalk are repatriating their right to control and own their culture (see Chapter 5). Ironically, they have chosen (or have been forced by politics) to mimic the museum paradigm of knowledge. This places Nuxalk leaders in the ambiguous position of trying to reclaim an "authentic" Native identity based on the possession of "authentic," "traditional" knowledge, while at the same time trying to claim the right, like any other cultural group, to experience cultural change and to live in the contemporary world. The Nuxalk are fulfilling the double definition of authenticity by (1) laying claim to a genuine, original culture validated by academics and (2) allowing themselves space to assert that their belief and trust in their culture is proof of its authenticity.

Inalienable Commodities
A central conclusion of my research is that commodification can be an authenticating act and, therefore, an important part of the process of cultural revival. The examples of the buying and selling of Nuxalk art presented throughout this chapter demonstrate how commodification describes a dynamic process rather than an essential status. As Appadurai (1986, 16) cautions, however, "all efforts at defining commodities are doomed to sterility unless they illuminate commodities in motion." Appadurai and Thomas, as well as a range of other scholars (Ferry 2002; Kopytoff 1986; Miller 1987; Myers 2001b; Phillips 1998), have been working since the 1980s to rethink the commodity and what is meant by commodification. Their first point is that a commodity is not the essential state of an object but, rather, a judgment put upon it. Therefore, an object falls into and out of commodity status according to the social arenas in which it circulates (Appadurai 1986, 15; Ferry 2002, 335; Myers 2001b, 18; Steiner 2001, 210, 224; Thomas 1991, 28-29). As Myers (2001b, 6) puts it: "The value possessed by objects is subject to slippage," and "objects are 'on the loose'" (George 1999, cited in Myers 2001b, 6).

The second point these scholars make is that anthropologists have oversimplified the division between the gift and the commodity and, thus, between use-value and exchange-value as well as between pre-capitalist and capitalist societies (Appadurai 1986, 12-13; Ferry 2002, 351; Myers 2001b, 17; Thomas 1991). Anthropologist Elizabeth Ferry (2002) provides us with a way to escape these reifications. She offers the idea of "inalienable commodities" (as does Miller 2001). While seemingly contradictory, this term fits what Mexican members of a mining cooperative feel about the silver they mine. The miners use a language of "patrimonial possession" (Ferry 2002, 331-32). This enables them to maintain a connection to the silver through claiming the inalienable right to (1) pass their mining jobs onto their children and (2)

demand part of the profits from selling the silver in an international market. The miners do not view the sale of the silver as an act of alienation since its commodification does not weaken their legally inalienable connection either to the mine or to any future production and profit. Ferry's (2002, 351) position is radical enough that it deserves to be replicated in full: "We can thus recognize not only that commodities can be treated in different ways depending on situation, but also that commodities can be exchanged within market systems and simultaneously retain a connection to incommensurate and inalienable forms of value. Indeed, these alternate forms of *value are produced within and depend upon*, a system of commodity exchange. We are not talking about a separation of commodity and pre- or noncommodity exchange ... but about the ways in which local actors manipulate competing notions of value within a system of commodity exchange." Thus, not only does commodification not break the miners' connections to silver, but it is also what validates their patrimonial, inalienable claims!

I argue that something similar occurs for many Nuxalk. The Nuxalk tend to use their art as an inalienable commodity. As I have already shown, Nuxalk art is viewed as Nuxalk national patrimony. This perspective relies on the idea that the Nuxalk as a people can never be severed from their connection to their art. At the same time, various interested Nuxalk (such as politicians, artists, and hereditary chiefs) fight to retain control of Nuxalk art,[17] even when, or perhaps even *because*, it is sold to non-Nuxalk. I am suggesting that Nuxalk art needs to be perceived as a commodity when sold to non-Nuxalk, thus allowing the Nuxalk to gain a sense of their own value through outsiders' valuation of their art. Similarly, Myers (1994, 693) describes the recent practice of indigenous Pintupi painters displaying Australian Aboriginal sand painting to a consuming, non-Native New York audience: "Aboriginal art producers clearly feel that such recognition enhances their cultural power. As with indigenous people elsewhere, Aboriginal people see themselves often to be taken more seriously overseas than at home. Thus, the constructions of Aboriginal culture that take place in foreign venues have significant consequences for processes of Aboriginal self-production." Thus, commodification through the selling of art either to outsiders or to insiders serves not only to validate contemporary Nuxalk identity but also to reinforce contemporary Nuxalk culture.

Furthermore, as Ferry (2002, 347) aptly points out, in the process of creating tourism opportunities, it is "patrimony itself – embodied in the physical traces of the past – that becomes potentially commodified." I argue that the Nuxalk are aware of the value of their art and that this value, while not essential, can be deployed strategically through the sale of art for profit, political visibility, or even the creation of tourist ventures in Bella Coola (a possible future project for the Nuxalk).

Ferry (2002, 350) also situates Georg Simmel's examination of "ambiguity in the politics of value." In other words, she expresses the tensions that occur when objects are valued as either use-values or exchange-values, although she does not suggest an absolute differentiation between the two but, rather, the existence of a slippery slope. She shows how living actors (whether Mexican miners or Nuxalk politicians) play with these supposedly dualistic terms in order to capture the "charisma of the objects" and their "great social power" (348). This partially explains why the Nuxalk can be ambivalent about the sale of their art and still understand its potential to do many things for the Nuxalk Nation.

From the preceding discussions it should be clear that I wish to divest the word "commodity" of its often assumed negative meaning and to problematize the idea that money automatically leads to the alienation of the producer from the product (Miller 1987, 40). In regard to commodification I also wish to note Daniel Miller's (1987) analysis of Simmel's *The Philosophy of Money*. Simmel writes: "Money is the reification of the general form of existence according to which things derive their significance from their relationship to each other" (cited in Miller 1987, 71). This emphasizes the indivisibility of person and object, of being and having, where possession is both an activity and a relationship (75). According to Miller, freedom stems from the articulation of self in the medium of things (76).

These points are exemplified by what Nuxalk individuals told me about art making, selling, and buying, and they support my conclusion that, in Bella Coola, commodification both results from and gives rise to cultural revival and communal subjectivity. Thus, objectification, through both the production and consumption of objects, is necessary for the creation of cultural identity and subjecthood. Instead of voicing the typical modern hysteria that envisions objectification as a form of commodification in which money replaces relationships, Miller (1987) argues that objectification creates a positive relationship between people and objects. Further, objectification can be understood as the constant reappropriation of the object by the subject. Miller cites Hegel's position that identity production is a repetitive process in which the human subject grows and develops via a sequence of stages. The subject first extends her/himself through creation of the art object and then becomes aware of that created "something," which appears outside the self. What follows is a desire, through identity construction, to symbolically reincorporate the object one has created (Miller 1987, 21; Myers 2001b, 20-21).

Miller's argument can be applied to the Nuxalk artist as subject: the distance of the made object, say a carved mask, allows the artist to see himself[18] reflected in the mask. Identification results from the artist's realization that the mask he carved is really an extension of himself and, thus, is representative of himself.[19] If the artist is dissatisfied with his self-representation

in, say, the form of a mask, then he can rework it through recarving it or making a new one.

For example, one carver related to me the experience of attempting to make a Sun mask by copying the photograph of an old and well-known Nuxalk piece in the collections of the American Museum of Natural History in New York City. He spent a long time carving the mask because he had never attempted to make one like it before. I imagine that adding to his repertoire what the Nuxalk refer to as a "new/old"[20] mask was part of his project of "going back in order to go forward." In other words, learning about his culture (i.e., previously held Nuxalk spiritual beliefs, traditions, and history) gave him the material he needed to further his own life as an artist, a parent, a teacher, and a contributing member of the community. However, the results of his carving did not please him. He said the face seemed too oblong and the eyes were cut too deep. He eventually set the Sun mask aside in the corner of his studio, and for a number of years he ignored it. However, his wife kept imploring him to finish the mask. Although he felt he could not fix what was already wrong with the mask, he decided to try again. Eventually he was satisfied with the finished product, but while he was working on it he had not believed that this would happen. This Sun mask stayed in his living room for a number of years until, needing money for his family, he felt pressured to sell it. I think the cultural biography of this Nuxalk Sun mask (its creation, its stay in Bella Coola, and its eventual sale) speaks to what objectification does (see Kopytoff 1986). The artist now willingly tells the story of the carving of the Sun mask, acknowledging its importance in his own development as an artist.[21]

In this process the object aids the artist in his development and self-identity. In Miller's (1987, 27) words: "There is never a prior subject, because the subject is always constituted by the process of absorbing its own object." Neither object nor subject is the most important: one is a product of the other, and any division is specious.

While this may be an idealistic vision of how art functions for the Nuxalk, Myers (2001b, 20-21) is correct when he states: "In objectification, cultural objects externalize values and meanings embedded in social processes, making them available, visible or negotiable for further action by subjects (see Miller 1987). Material culture as objectification provides the basis on which subjects come into being, rather than simply answering their preexisting needs." Certainly, this Nuxalk artist explored his feelings about his artistic and technical skills (perfectionism), his relationship to old Nuxalk culture (authenticity), and his experience with selling art (commodification) via the creation of this Sun mask.

Another important component of Hegel's model for human development relies on his observation that human subjects gain awareness of their imperfections through the objects they create. As Miller (1987, 25) puts it: "An

integral part of [development] is the subject's ability to comprehend the process in which it is engaged"; in other words, it is due to this consciousness that the subject/artist longs for improvement.[22] Thus self-objectification is empowered through the act of doing rather than through absorbing a previously content-filled past.

For example, a Nuxalk jewellery maker who creates dream-catcher pendants and earrings told me she works hard to get the colours right. If they aren't right, she takes the objects apart. She gets a "thrill" from seeing her jewellery worn by others when it "looks right." The fact that neither dream-catchers nor beads are originally products of the Nuxalk culture but, rather, are a pan-Indian postcontact import does not alter the fact that this artist feels good when her dream-catchers are displayed by others. And the fact that other *Nuxalkmc* buy and wear her jewellery proves its importance as a statement of Nuxalk style, aesthetics, and identity.

The objectifying relationship between artist/subject and art object is analogous to the objectifying relationship between a nation and its cultural heritage. This theoretical model gives us a means of examining the current Nuxalk cultural revival without relying on false binaries. What becomes important in Nuxalk cultural revival is the conscious act of *doing* it – and the belief in reusing the past to reappropriate an identity that was perhaps taken away by colonizers, missionaries, scholars, and others. What is not so important is the actual content of the object produced or consumed. It is the Nuxalk, not outsiders, who have the power to decide what constitutes appropriate content. Getting the content "correct" in order to fit some imagined idea of traditional culture is not critical,[23] nor need one have an absolute belief in the object's significance. According to Myers (1994, 693), "To be useful, critical reading of emerging forms of cultural production must overcome not only continuing nostalgia for a cultural wholeness, but also the concomitant reification of the concept of 'culture' as more of a structure given than an imperfect fiction that is ambiguously mediated by multiple and shifting discursive moments." It is the process of doing, of creating a relationship with the object (which is, after all, an externalized self), that enables the Nuxalk to achieve cultural revival even within the strictures of such tautological terminology as "modern" and "traditional," "authentic" and "touristic." These are acts of reempowerment in which the Nuxalk exercise their choice regarding how to construct contemporary culture and identity.

Conclusion

I suggest that the Nuxalk are literally and figuratively buying into their culture by believing in the process of cultural revival rather than through demanding exact replication of so-called traditional beliefs or arts. Buying Nuxalk art, whether logos on T-shirts or wooden masks copied from Boas'

ethnography, is about performing or constructing one's Nuxalk identity. Based upon the ethnographic data I have presented here, it is clear that *market value can reflect cultural value* – a point to which I return later. Furthermore, authenticity *is* something that it is possible to create, even when the attempt to do so is burdened by such difficult terminology as "tourist art," "cultural revival," and "the making of culture." I argue that the emphasis needs to be on process – the act of revival and conscious self-objectification – rather than on what is actually produced. Getting the traditional content of the art correct is not paramount. I mean this in Bourdieu's (1990) sense, whereby one should look at the purpose of making art during cultural revival in a doxic, practical way rather than in an orthodox way (i.e., in terms of absolute belief and complete knowledge). In this way, authenticity, like money, is currency in the marketplace. Sales of Nuxalk art made by Nuxalk artists for local Nuxalk consumption serve as a process of self-naming, logoizing, and creating local and global indigenous identity. As I discuss in Chapter 5, I believe that sales outside the community have the same legitimizing and identity constructing effect as do sales inside the community.

Finally, "to sell" means not only to exchange an object for money but also "to sell someone an idea," to convince them that Nuxalk culture and identity can be "bought into." The internal dynamics of factional opposition in regard to cultural revival in Bella Coola do not yield homogenized, hermetically sealed identities. Even though contemporary Nuxalk chiefs, both elected and hereditary, mimic strategies of cultural objectification for the purpose of making political claims, in Bella Coola no Nuxalk believes completely either in a finite traditional culture or in her/his cultural inauthenticity should s/he be contaminated by the global cultural economy. Ultimately, even though the Nuxalk exist within a context that describes commodification and the sale of art pejoratively, we must recognize that cultural revival and the Nuxalk strategy of "buying into" their own culture is wrapped up in the process of logoization and commodification and that it is no less authentic for this fact. Self-objectification through the commodification of culture is producing the cultural subject of the contemporary Nuxalk Nation.

4
Privileged Knowledge versus Public Education: Tensions at *Acwsalcta,* the Nuxalk Nation "Place of Learning"

> You are lucky to have this school. I didn't have one like it. You
> need to learn your language, dances and songs because they are
> our gifts and they make us strong.
>
> > – Vice Principal, *Acwsalcta* School,
> > to misbehaving second graders during mask,
> > dance and song class, 5 May 1997

Acwsalcta, the Native-run band school on the First Nations reserve in Bella Coola, plays a crucial role in cultural revival and the creation of Nuxalk national identity. Many have assumed that, when cultural revival occurs, it is a simple reversion to the past, where First Nations attempt to replicate the behaviour and traditions of their ancestors. However, I argue that the process of cultural revival is far from a simple imitation of the past and that it involves a series of heated negotiations filled with tension, insecurity, and conflict. *Acwsalcta* has become a focal point for debate over how to teach cultural knowledge. Although all *Nuxalkmc* agree on the significance of education for their "children, grandchildren and children yet unborn," there is very little agreement over how cultural knowledge should be taught.

In this chapter I analyze the dilemmas created by alternative educational methodologies, which stem from the multiple perspectives and opinions of various Nuxalk administrators, parents, elders, and cultural staff as seen through the lens of a 1997 play potlatch.[1] *Acwsalcta* is a place of hope as well as a place plagued by problems. The direction in which it should move is not clear. *Acwsalcta* cultural teachers must decide between such seemingly opposite educational strategies as using oral or written teaching methods, using or refusing to use Western technology, and emphasizing individual, familial, or national ownership of cultural knowledge. While making decisions over the dissemination of this knowledge, the teachers of culture are

at risk of being accused of hoarding it. I argue that contemporary Nuxalk cultural identity is produced in each of these negotiated stances, all of which involve both secrecy and sharing.

History of Education in Bella Coola: The Birth of *Acwsalcta*

The first one-room school in Bella Coola opened in 1920 at the old townsite. This was on the north side of the Bella Coola River, across from the present-day location of the town. Thirty students were believed to have attended, but the ratio of Nuxalk to Norwegian children has not been recorded. By 1926 a public school was established on the new townsite across the river, the present location of the non-Native side of the Bella Coola township. Although the Nuxalk did not begin moving to the south side of the Bella Coola River until 1936 (when a flood wiped out the bridge across the river to the non-Native township), it is reported that Nuxalk girls were sent to this school, while boys were kept home to work (Hans 1997, 4). In 1929 the residential school, St. Michael's School for Boys, was established in Alert Bay on Cormorant Island, and Nuxalk boys were sent there by the early 1930s. As noted in Chapter 2, the explicit goal of residential schools was to sever the generations from each other in order to stop enculturation (Haig-Brown 1988; Barman, Hébert, and McCaskill 1987). Residential schools were also opening in Chilliwack near Abbotsford, in 150 Mile House near Williams Lake, in Port Simpson near Prince Rupert, and in Fort Rupert and Port Alberni on Vancouver Island. Nuxalk children were put on steamships and sent to these far-away schools for at least ten months per year, and sometimes up until the age of seventeen, without returning home for visits. One Nuxalk man in his seventies told me that when he returned to Bella Coola after nine years away, he had forgotten how to speak Nuxalk and people cruelly laughed at him. "[The residential schools] were trying to drive our culture out of us," he said.[2]

Although by the 1920s Indian agents were enforcing the 1894 amendment to the Indian Act, which required Native children to attend school, it seems that parents in Bella Coola could choose whether to send their children to residential school or to keep them at home to go to the local public school. As one informant in his fifties told me, it came down to whether parents were willing to fight hard enough against the Indian agent. If they wanted to keep their children at home, they had to prove they had enough food, clothing, and money to ensure their welfare according to non-Native standards.

Segregated schooling in Bella Coola began in 1930, when the Bella Coola reserve received its own eight-grade facility. If Nuxalk students wanted to continue their education (which they almost never did) they would have to go to the local public high school up valley called Sir Alexander Mackenzie

(SAMS), which opened its doors in 1949 (Hans 1997, 4). As it was, most on-reserve and residential school students did not make it past the sixth grade, preferring to work for pay or for their families as trappers, fishers, canners, or loggers.

In 1950 head hereditary chief Sam Pootlass[3] offered to donate some of his reserve land for the site of a future elementary school, but the provincial government turned him down. Although the Bella Coola Elementary School (BCE) was eventually built in 1952, it went up on the non-Native side of town. It became clear to the Nuxalk that they had no control over their children's education and that they were not welcome participants in the provincial educational system. However, according to a *Coast Mountain News* article, tellingly entitled "Bella Coola Experiment Leaves It to the Kids," non-Native Bella Coola residents were proud of their school, forging ahead with the new concept of integration in the 1950s (Kopas 1992). Obviously, Nuxalk and non-Nuxalk perceptions regarding the future for integrated education differed. One Nuxalk man in his fifties remembers attending BCE as a young student, and he still feels the hurt (both mental and physical) of being strapped by teachers for speaking the Nuxalk language. Another Nuxalk man who graduated from SAMS said of his local provincial school, "[It was] a damned lonely place to be" (*Coast Mountain News* 1987a, 1).

By 1967 a group of elders advised the elected band council to explore options for obtaining their own school. In pursuit of this goal, the council established an advisory board that eventually recommended the formation of a volunteer education committee. This committee was able to open the *Kii Kii Tii* Nursery School on the Bella Coola reserve as well as to create a home-school coordinator position. This post was established so that a Nuxalk person could act as a liaison between parents and their children's respective public schools. The committee also initiated fifteen-minute Nuxalk language classes in the public school. Interestingly, one Nuxalk man, remembering his own schooling experiences in the 1950s, when the Nuxalk language was repressed, was not pleased at the prospect of sharing his language with non-Nuxalk school children.

Although the band council and the education committee tried to work with provincial agents with regard to the development of future school sites in the valley, their attempts at involvement were rebuffed. As *Acwsalcta*'s computer teacher, who also acted as school historian, wrote: "It was reinforced that Nuxalk education needs would not be seriously addressed by non-Native organizations" (Tallio 1997, 3). The Nuxalk then turned resolutely inward for inspiration as to how to promote Nuxalk education and to foster strong Nuxalk identities.

The catalyst for the construction of their own school came in the spring of 1982, when overhead lights fell onto seven elementary school children at BCE. As the cultural coordinator and *Acwsalcta* mask, dance, and song

teacher explained, Nuxalk parents asked: "Why is this happening? The school up the valley has everything and BCE is dangerous ... We want to know what's happening. Where is the money going that is meant for our kids?" Although no one was severely injured, the lack of response from the authorities indicated to Nuxalk parents that they needed to make changes themselves. Thirty-eight Nuxalk families withdrew their children from BCE and the provincial public school system and began looking for someplace else to educate them (Tallio 1997, 3).[4]

The elders supported these parents' resolve to get their own school, and elder Margaret Siwallace[5] gave this future creation the name *Acwsalcta*, meaning "Place of Learning." The school's mandate was "the best of two worlds," suggesting the combination of Western academics and Nuxalk traditional knowledge. This hope, however, had to be translated into an actual curriculum, and a place had to be found to house the school's activities.

By September 1982 Nuxalk parents created a makeshift school in two already existing buildings: the cultural centre became the high school, and the old Indian agent house, dubbed "the red and white building," became the elementary school. High school students spent the mornings at SAMS and in the afternoons took correspondence courses at *Acwsalcta*, while students in kindergarten through Grade 7 attended classes all day at *Acwsalcta*. Gym was held every day at the Nuxalk hall. By 1986 50 percent of Nuxalk children attended *Acwsalcta* (in actual numbers: ninety full-time students, plus eighteen pre-K students for half a day) (*Coast Mountain News* 1986a, 1).

A non-Native teacher was hired to teach and develop a new Nuxalk-based curriculum. According to the cultural coordinator, who had been involved in the early stages of *Acwsalcta's* organization, he proved to be a committed and caring "godsend." Parents made the following demands: "We want some things different [at our school] – [we want the children to] learn new songs and dances." However, as the cultural coordinator also noted, "We weren't sure how to accomplish this task." This desire would prove to be both the impetus for developing their own school and a central difficulty. Selecting what Nuxalk content to teach and which educational methodologies to use became a significant source of contention. This initial hesitation about how to design a curriculum proved to be an enduring concern at *Acwsalcta*. Since the woman hired to be the first cultural coordinator did not know exactly how to accomplish this task, the school committee brought in an elder, Mabel Hall,[6] to help her. Mabel Hall proved to be a strong support: "She [Mabel Hall] was a big part of strength in our culture," remembers the cultural coordinator.

While the elders and cultural teachers developed a cultural curriculum that would work in conjunction with the Western academic subjects of English, math, social studies, and science, the band council worked to secure funding for a new building. Realizing that other band matters were

taking time away from this significant task, in 1985 they established the Nuxalk Education Authority. By this time the DIA had asked for a feasibility study for a Nuxalk-run school, which is ironic considering that the Nuxalk had been developing and running their own educational curriculum for three years! The Nuxalk responded with a document outlining costs for a new building. Approval was subsequently granted, and, by the end of 1985, *Acwsalcta* was put on a waiting list for DIA funding. According to the school historian, the Nuxalk Nation's proposal was so well organized that "*Acwsalcta* was bumped forward on the list" to first place (Tallio 1997, 4). Holding aloft the DIA approval document, the Nuxalk Education Authority chairperson rejoiced, "It has been a long, hard road, but worth it. We're moving in the direction we want to go ... This is a moment we will always treasure ... we will control our education by ourselves" (*Coast Mountain News* 1986b, 3). With unprecedented swiftness for a government project, groundbreaking began on 15 August 1986. In reference to *Acwsalcta*'s construction, the Nuxalk education administrator explained: "We started our own school because we felt we were losing our heritage and culture ... The only way we felt we could get it back was to reintroduce it through the education ... The provincial school system couldn't accomplish this goal ... Most of the young leaders in our community don't know how to speak the Nuxalk language, because we weren't given the opportunity to speak the language and practice the culture" (*Coast Mountain News* 1986a, 1). *Acwsalcta* was envisioned as the site for core cultural revival activities as well as the focus for the creation of a cohesive Nuxalk national identity.

In August 1986 construction began on the new building under the guidance of non-Native architect Luber Trubka of David Nairne and Associates and a Nuxalk project manager. It was located in Four Mile, another section of reserve land belonging to the Nuxalk Nation "up valley" from the Bella Coola reserve. *Acwsalcta* was designed to resemble a long house and was built of cedar planks and huge exposed beams. As the *Coast Mountain News* headline stated: "Design of School was a Community Effort." The article continued: "all [were] concerned that [the school building] have the right cultural atmosphere. The architect was hired for 'his sensitivity to the Nuxalk spirit'" (*Coast Mountain News* 1987c, 14). Covering 2250 square metres, *Acwsalcta* was to have nine classrooms in addition to a home economics room, an industrial education room, an art room and kindergarten built around a central gym, and a multipurpose area to be used as a library.

The school was constructed over thirteen months using a workforce that was 90 percent Nuxalk. Even before the school had opened its doors, learning was occurring for five Nuxalk carpenter apprentices who were part of the construction team (*Coast Mountain News* 1987d, 9). A symmetrical frieze of carved and painted animals in Nuxalk style runs along the school's front roofline. Protectively perching over the main entrance is a carved eagle,

whose wings are outstretched as though to embrace the community. It has a three-dimensional head that juts out assertively from its two dimensional body. The entire two-storied back wall of the school is covered in painted crests. A central Sun mask flanked by two images of the *Acwsalcta* school crest (a human face in profile) is joined below by two bird heads on either side of a killer whale. Inside, murals depicting the famous story of Raven bringing the sun to humans graces the library, perhaps equating the value of *Acwsalcta*'s teachings with the necessity of solar energy. A Nuxalk artist designed these carvings and paintings with the help of his brother. The murals were actualized with the aid of volunteers. The artwork serves to inspire the students to achieve the difficult goals of cultural education and preservation.

On 2 September 1987 a significant article appeared in the *Coast Mountain News*: "*Acwsalcta* Focus for Nuxalk Pride." The opening of *Acwsalcta* on 27 August 1987 was declared "a culmination of a dream first put forward in 1950 when Chief Sam Pootlass offered the provincial government land on which to build a secondary school" (*Coast Mountain News* 1987a, 1). There was a three-day celebration with speeches, dancing, and feasting. As the Nuxalk Education Authority chairperson had predicted thirteen months previously, *Acwsalcta* represented the "start of a new era ... Over the next ten years you'll see a community growing" (*Coast Mountain News* 1986c, 16). The sentiment most commonly expressed was that "young people" were "Bella Coola's number one resource" and that "great expectations [were] held for them" (Westdorp 1987, 3). Although Nuxalk differ on how best to educate their children, most agree about the need for local control over their children's education. One often hears the following statement: "Our children, grandchildren and children yet unborn are the leaders of the future."

Acwsalcta in 1997: The Play Potlatch

By the time I arrived in Bella Coola *Acwsalcta* was about to celebrate its tenth anniversary in the new building. The school planned a play potlatch, which, as mentioned, is a biennial event designed to teach the children how to host a potlatch. The 1997 theme was the commemoration of ten years of *Acwsalcta*'s school history. The fifth *Acwsalcta* play potlatch was held on 13 March 1997 in the school's multipurpose room.

During a pre-potlatch staff meeting, the cultural coordinator informed the teachers that they had to convey to the students that the potlatch is about building a name, telling a story, and healing. In Nuxalk, she said, the word is *lhm*,[7] which means "to stand," "to make a stand," or "showing." Previous play potlatches have honoured people who have contributed to *Acwsalcta*, have taught the students how to transfer or give a name, and have demonstrated how to memorialize the deceased.[8] Because most *Nuxalkmc* were not raised under potlatch law, the play potlatches emphasize preparation, purpose, and protocol.[9]

Attempts at Cultural Revival 1960s-80s

Due to the epidemics that decimated the Nuxalk population, the repressive anti-potlatch laws, and conversion to Christianity, most Nuxalk ceremonial behaviours had been halted by the 1920s. The Nuxalk consider the 1920s to the 1960s to be "the dark days of culture" (Birchwater 1997, 9). A Nuxalk elder recalled: "People were prosecuted for potlatching, and in Bella Coola most of the old masks were hidden away in an attic [sic]" (ibid.). By the 1960s sporadic attempts at cultural revival had occurred in Bella Coola. However, as one informant in her forties recollected: "At the time that we were trying to save the culture, we were rapidly advancing in modern stuff. [The culture] didn't play as significant a role as time went on."

In the early 1960s a singing society was formed under the auspices of the Bella Coola United Church Women's Guild (Kennedy and Bouchard 1990, 338). Led by elders Agnes Edgar, Dan Nelson Sr., Margaret Siwallace, and Felicity Walkus,[10] this singing society tried to encourage youth participation and eventually organized a dance troupe. They performed in competitions, for fundraising events, and for entertainment in many areas of British Columbia during the 1970s (Birchwater 1997, 9).[11]

A United Church youth group called Kairos, formed in 1967 by an enthusiastic minister, eventually became involved in learning Nuxalk dancing and singing. These Nuxalk youth were inspired to dance and wear button blankets at the celebration of Canada's centennial year in 1967. The Kairos group also worked to build the House of Noomst for youth activities. Opened in 1970, this long house-style structure featured a nine-metre high totem pole at its entrance (Meek 1970). In the late 1970s the House of Noomst became the site of a carving project funded by the Royal British Columbia Provincial Museum. Its purpose was to train Nuxalk mask carvers and to provide an opportunity for them to copy many of the Nuxalk masks in the museum's collection.

Even with these attempts at getting Nuxalk youth interested in cultural revival, many Nuxalk were not moved. When anthropologist Margaret Stott came to Bella Coola to study Nuxalk masked dancing in 1968-69, she witnessed a "lack" more than a "presence" of cultural knowledge. Although one informant, who as a child had been present during song practices in the 1960s, recalled that "the old people would always make a point to say connections in relation to the song," changes were occurring over traditional ownership of masked dances and songs. Those Nuxalk who still had masks in their possession (either through inheritance or through rediscovering old ones in caches in the woods), and who could find a knowledgeable elder willing to coach them in the corresponding dances, seemed to be given free reign to dance them. Stott (1975, 121) herself, after observing a performance of "Indian dances" presented for her benefit, wrote: "Some songs and dances seem now to have become communal property ... Thus it

appears that the notion of individual rights to ceremonial prerogatives has diminished, and what little remains of Bella Coola ceremonialism is kept alive through cooperation and group endeavor." Although some Nuxalk claimed ownership of masked dances or songs in the 1960s, the community as a whole seemed unconcerned with traditional Nuxalk law, which had recognized possession of status and property through public witnessing during potlatches or winter ceremonials. Consequently, during the 1960s and 1970s, there appear to have been many mixed messages circulating in Bella Coola with regard to the proper protocol for ownership of masks, dances, and songs, and with regard to whether permission to perform was an individual, family, or community decision.

It is generally agreed that potlatching had only been revived in Bella Coola in 1979 (Barker and Cole 2003, 24). The head hereditary chief believes his grandfather held the last official potlatch in Bella Coola in the early 1930s upon being warned that they had been declared illegal (*Coast Mountain News* 1986d, 1). Thus, much of contemporary Nuxalk "tradition" has been reconstructed through the memories of elders, ethnographic writings, and extant wax records and tapes recorded many years ago. *Acwsalcta* has inherited this legacy and has taken on the responsibility for healing the hurts of the past by consciously reviving Nuxalk cultural activities and training Nuxalk youth in the laws of the potlatch. Therefore, the objectives of the *Acwsalcta* play potlatch are extensive, and much depends on its continued success.

Participation Dilemmas

It was of paramount importance that the 1997 play potlatch go smoothly. Externally, it looked seamless, following the clear rhetoric of correct protocol, but in actuality many choices had to be made, which went unnoticed by the watching audience. These unvoiced decisions, although not obvious, played a crucial role in determining the end product.

For example, when planning the 1997 play potlatch the cultural coordinator worried about who was going to participate. Should all children regardless of age and previous effort in mask, dance, and song class be allowed to participate equally? Or should certain students be selected to dance, based on predetermined criteria? Should these criteria include skill with regard to singing or dancing, respect for Nuxalk culture, or pre-set age limits?

Traditionally, except for explicit children's dances, most Nuxalk dancing was done by experienced adults who were members of specific dance societies. Masked dances that represented supernatural creatures were reserved only for specially selected individuals; children and teenagers would not have been considered ready to perform such significant, spiritual roles. The cultural coordinator had to decide whether certain students were mature enough to take on the responsibility of dancing a specific masked dance. Mistakes were not considered to be fortuitous.

Another dilemma concerned whether she should emphasize family ownership and thus choose representatives from certain families to dance their property. Or should she allow all children to participate in the hope of fostering generic pride in being a member of the Nuxalk Nation? These were difficult decisions. The cultural coordinator did not want to discourage children from participating, though in the past not all families had been equally wealthy in rank and prerogatives. In the end, she chose a relatively democratic route: all children who attended *Acwsalcta*, regardless of past behaviour or interest, participated in the 1997 play potlatch, but those students who had shown special interest by going to after-school practice sessions were selected for the masked dances.

The Importance of the Emcee: Ownership Issues

At a Nuxalk event there is usually a master of ceremonies who ensures that each stage of the proceedings goes smoothly. During a potlatch it is the emcee's job to explain the "work" being performed. In the case of a song or dance, the emcee typically relates its origin story, thus publicly recognizing the source of the tradition and the family or individual who lays claim to it. In other words, it is the responsibility of the emcee to justify the appropriateness of the song/dance to the event in which it is performed.

During their mask, dance, and song class the students at *Acwsalcta* are taught that the singing of Nuxalk songs should only occur on certain occasions. The cultural coordinator cautioned her charges that, "as guardians of these songs [they had] to be able to sing them at the right times, but only at the right times."[12] The students must have specific permission from the song's owner (just as with a dance) to sing it, even during school practice. They are taught that learning and singing a Nuxalk song is a serious responsibility. The emcee's job of emphasizing the family-owned story accompanying each dance is critical because it recognizes ownership and the respect due to each performance. Not all Nuxalk songs or dances have a clear owner, but what *is* clear is that the Nuxalk think of songs and dances in the same way that they think of material art. Thus, there is the risk that someone might appropriate a Nuxalk song or dance without proper permission, just as there is the risk that a Nuxalk artist might use crest designs to which s/he doesn't have the right and then sell them.

Once, I witnessed the cultural coordinator acting the emcee by attempting to explain the meaning of each Nuxalk dance to guests over the din being created by distracted, inattentive *Acwsalcta* students waiting to perform. She warned the students that they had to learn what she was telling them about the dances because she would never write it down. She taught them that verbal storytelling is crucial to the preservation and proper etiquette of Nuxalk culture. Students were often requested to stand up and

take the role of emcee during mask, dance, and song class, thus receiving training in public speaking and in this crucial form of information transfer.

Tensions over Oral versus Written Forms of Education

At *Acwsalcta* there is a definite, yet unspoken, tension between Western and Nuxalk forms of education. Should Nuxalk children be taught their culture orally, as would have been done traditionally, or should they be taught with the written word? It is acknowledged that *Acwsalcta* students speak English as their first language and that the ability to read and write will be crucial to their getting work. However, some believe that putting the Nuxalk language in written form constitutes a threat to Nuxalk control over their culture. As already noted in Chapter 2, the very existence of a Nuxalk-English dictionary and grammar is upsetting to politically conscious Nuxalk who do not want their culture to be accessible to outsiders.

The cultural coordinator explained that, when she was first hired to teach the children Nuxalk culture, she wasn't sure how to proceed. She considered writing down the stories to show the students, but the elders objected, saying, "No, you can't do that! Think how our parents learned ... Write these songs [and stories] in kids' hearts and minds." Therefore, by the early 1980s, the elders were espousing a teaching model based on oral tradition rather than on the written word, thus emphasizing the difference between the Western and Nuxalk styles of education.

Recording Nuxalk songs, language, and dance steps in written form allows for a powerful kind of preservation – one that does not rely on the memories or actual presence of certain individuals. However, once a Nuxalk song is written down, a specific individual or family might lose control over who hears or sings it. The search for methods of cultural revival must balance preservation with privacy.

Eventually, the cultural coordinator, with the help of Mabel Hall and other elders fluent in the language, translated Nuxalk songs into English and Christian hymns into Nuxalk.[13] In order to ensure that this work would have a lasting effect on Nuxalk children's education, these transliterations and translations were written out and bound into songbooks. The ambivalence over written versus oral learning is expressed in the concern over the *Acwsalcta* songbooks. In many ways, these are cherished as essential educational tools. While cautioning the students in her mask, dance, and song class to respect the songbooks and to handle them with care, the cultural coordinator tried to teach them that reading was not the only method of learning. There was a fear that people were relying too heavily on these songbooks, with the result that, should they ever be lost, far too much would be lost with them.

In preparation for the 1997 play potlatch, the oral/written issue surfaced when a non-Native *Acwsalcta* school teacher asked a Nuxalk language teacher

to put together pamphlets containing Nuxalk words and their English translations. These pamphlets would then be used as giveaways. The language teacher appeared hesitant, as though recording Nuxalk in printed form might lessen the power of the words or the specialness of the language. Eventually, pamphlets that contained colours matched with their Nuxalk name were made to hand to play potlatch witnesses. The language teacher must have decided that these giveaways would prove to be educational, but she still felt uncertain about what would happen once this information was circulated outside the classroom and was out of her control.

Herein lies the bind of oral versus written education: while writing can preserve Nuxalk culture, it also leaves the Nuxalk vulnerable in that (1) they may come to rely on published texts in order to perform their culture and (2) they may lose control of their culture, which would suddenly become accessible to anyone who obtained one of these texts. On the other hand, it seems to me that relying on memory and oral tradition is more rhetoric than reality as school children did not appear to be interested in memorizing difficult Nuxalk songs in a language that they do not use in their everyday existence. These methodologies are still being debated because, as the methods of teaching Nuxalk culture become increasingly similar to the methods used to teach Western culture, the children, unlike earlier Nuxalk generations, are no longer learning by heart. While I was at *Acwsalcta* in 1997 any attempt to take the songbooks away from the students in mask, dance, and song class was met with disapproval by the students themselves. They said they relied upon the songbooks and could not sing without them.

Attitudes Change over Use of Western Technology

Another contested issue is the use of such Western devices as tape recorders, cameras, and video cameras. Many of the songs sung by the *Acwsalcta* students in school and at both play and regular potlatches come from old tapes made by Nuxalk elders. The Nuxalk use copies of tapes whose originals reside in museum or library archives. These tapes are viewed as valuable additions to the Nuxalk cultural canon because they provide access to songs and voices that have long been unheard or even forgotten. However, the contemporary use of tape recorders is often seen as a threat. With the renewed interest in reestablishing ownership of songs and stories, tapes are sometimes perceived as a threat to ownership. Certainly, whenever someone suggested that Nuxalk songs be recorded for sale to tourists, a common response was that Nuxalk culture should not be sold for profit or be placed outside Nuxalk control.

A former *Acwsalcta* graduate, cultural singer, and dancer said that only recently have the Nuxalk become strong enough to "bring out" old songs. For example, during the 1997 play potlatch one old song with an accompanying masked dance was "brought out" through the use of a recording made

by Nuxalk singers in the 1950s.[14] McIlwraith's (1992, 2:192, 239, 540-41) written description of this *kusiut* performance also served as a reference point for relearning the dance. The Cedar Softening Dance/Bark Pounding song was referred to as a "new-old style song/dance" because it had not been performed in many, many years and was in the process of being revived. It was a "traditional" Nuxalk song/dance, new to the living generations of Nuxalk who had never witnessed it. Its traditional family or individual owners had been forgotten.

The dance demonstrated the process of turning cedar bark into a usable material and referenced the absolute centrality of cedar bark to the life of the Nuxalk. The students practised repeatedly in order to learn the Nuxalk words to the song and the steps to the dance. As no specific masks for this dance had survived into the 1990s, the students made creative use of other masks that seemed to fit the dance's requirements. During the performance of this masked dance, an elder stood on stage to prompt the lead performer with the appropriate Nuxalk words as the latter had trouble memorizing them. The elders in the audience seemed joyful at seeing this new-old style song/ dance brought out again. In this case, Western technology and anthropological sources were held up as useful aids to cultural revival.

Changing Attitudes towards Photography

During the 1997 play potlatch, it was not permitted either to photograph or to videotape masked dances. The Nuxalk themselves do not photograph masked dances, and videotaping is only permitted for potlatch hosts (who want a personal record of the event) or in exceptional circumstances (e.g., when a dance novice receives express permission to videotape in order to learn a specific dance).

In the late 1990s one commonly heard that, because of their sacred nature, masked dances could not be photographed. However, I was told by a frequent non-Native visitor to Bella Coola that this was a relatively recent restriction. She recalled that, throughout the 1980s, the Nuxalk encouraged interest in photography because it was seen as an expression of interest in Nuxalk culture and as an aid to cultural preservation. So it would seem that attitudes and perceptions have changed with regard to what can be gained or lost via photography. I believe that the original motivation against photography had to do with the fear that a flashbulb in a darkened room would disorient the performer, whose vision was already limited by wearing a mask. The risks included missing a dance step, tripping, or even falling into a fire (Gillespie 1990).

It is possible that the relatively recent emphasis on the sanctity of masked dances is a resacralization, an attempt to return to a former way of being, and it is being manifested in a response to new types of recording devices. Or it may be a way to invoke the awe and discipline that many elders claim

they remember from their youth. Either way, the rule against photography points to the desire to keep these performances as sacred and as secret as possible. It also reflects the renewed interest in ownership of Nuxalk cultural content. This prohibition serves to promote the significance of these dances as, by refusing access to outsiders through photographs or videos, the Nuxalk are signalling the importance of their cultural capital. Defensive walls add value to what the Nuxalk own and control. Crucially, the timing of this prohibition coincides with the new Nuxalk interest in telling the international community about their fate as a colonized nation. This suggests that ownership of nationhood is promoted through declaring cultural patrimony as property.

Contested Ownership of Performance Prerogatives 1: Ladies' Dances and Songs

Tension over ownership and permission to perform lies just below the surface of many cultural events in Bella Coola and at *Acwsalcta*. No one would openly accuse another of theft, but many do question how songs and dances they remember as belonging to a certain person or a certain family have come to be freely performed by anyone. Ladies' dances, performed only by adult females, are made up of elegant moves complimenting specific songs. Although all female Nuxalk adults are permitted to dance ladies' dances and are encouraged to participate,[15] not all Nuxalk agree that these dances are common property.

With regard to ownership of one commonly performed ladies' dance,[16] a Nuxalk woman informed me that this was her dance and that she used to lead the dancing but had stopped because it felt like the students were learning it differently (by imitating the steps but not feeling the music or listening to the beat). Somehow her dance had been modified ("like it was put in a melting pot") as it became the property of the entire community.[17] This informant said that, in the past, there was more respect for family-owned dances and that only those specifically trained in a dance would be given permission to dance them. She believes that the current attitude is that all dances belong to the *Nuxalkmc*.

Another ladies' dance, often taught and performed at *Acwsalcta* by older high school girls, is performed to a specific song, which is acknowledged to be owned by an individual woman. This specific ladies' dance was nearly removed from the *Acwsalcta* dancers' repertoire because the cultural coordinator was informed, through an intermediary, that the owner of the song no longer wanted it to be sung by the *Acwsalcta* students (as was her right according to Nuxalk laws of ownership). However, upon hearing this, one parent declared: "It will die out if we stop singing it." The *Acwsalcta* art teacher and drummer for mask, dance, and song class agreed, saying: "If we

stop doing these things at school it will die out in a year – it won't take long. We have come far."

The cultural coordinator was put in an agonizing position. According to traditional Nuxalk law, she had to abide by the wishes of the owner of the song. The elders had told her she must work to make Nuxalk law the law in the valley. As a cultural teacher it was her responsibility to model appropriate Nuxalk respect and behaviour towards a song's owner. However, she believed that the owner herself was in fact not interested in preserving this particular song and would simply let it die out of the Nuxalk cultural canon. The bind was clear: break traditional law to ensure cultural revival or follow traditional law and lose one more piece of traditional culture.

One *Acwsalcta* student, who was very much involved in attempting to revive Nuxalk culture and who was a leader of the student body, commented repeatedly: "People are divided," and "I just want to stand behind if we can't all stand together." He warned that he would discontinue his involvement with the culture if the Nuxalk continued to fight among themselves. If the Nuxalk could not "all stand together" and agree upon how cultural revival should occur, then he would refuse to lead or even participate in it. These songs and dances represent human relations, and when ownership is in question, these relationships become entangled and are sometimes stretched to the breaking point. Eventually it was decided to use this song and its accompanying ladies' dance during the 1997 play potlatch unless the owner personally asked the cultural coordinator to stop its performance (which she did not).

Acwsalcta students did not seem to question their cultural teacher's decision to continue to teach the dance and to perform it during the play potlatch. This might reflect a move towards favouring national ownership of songs and dances over family or individual custodial ownership. This would have deep implications for cultural revival both at *Acwsalcta* and in the community as a whole. However, it is apparent that issues of ownership continue to simmer beneath the smooth exterior of celebrations of cultural perpetuation.

Contested Ownership of Performance Prerogatives 2: Masked Dances

The most respected Nuxalk dances are masked dances. In the past, masked dances represented specifically owned *kusiut* (secret society) or *sisaok* (chiefly, ancestral) privileges (Richardson 1982).

Kusiut privileges were owned by secret society members who had earned their membership either through meeting a supernatural being or through inheriting the right to represent an ancestor's meeting with a supernatural being. During winter ceremonials *kusiut* members enacted supernatural

beings coming down from above to visit an awe-struck, uninitiated Nuxalk populace. They wore masks that were carved specifically for a given dance and then burned them immediately afterwards so that the uninformed would not discover them.

Sisaok masked dances were passed on through family lines. Family chiefs acted as the masks' custodians and kept the heirlooms hidden in cedar bentwood boxes until they were needed. Performance of *sisaok* privileges occurred during potlatches and involved representing one's chiefly rank through having masked dancers depict family-owned origin stories (called *smayusta*). These masked dances might represent the animal cloaks worn by one's first ancestors, who came down from above as certain crest figures. The territory in which these ancestors landed would be owned by that particular family from then on. Other *sisaok* masked dances might depict supernatural powers that had been transferred to the ancestral family sometime in the past. The depiction of crest, *smayusta*, or supernatural powers became proof of ownership of land and resources as well as proof of the right to lead and assert political control over a certain territory.

By the 1920s the *kusiut* and *sisaok* societies had dwindled in significance. McIlwraith (1992, 2:260) writes that, in 1923-24, everybody, both young and old, belonged to a *kusiut* society, with the result that the awe of meeting supernatural creatures during a winter dance was not evident. Because *kusiut* privileges had become commonplace, everyone knew that they were representation rather than reality. By the time of my fieldwork in the 1990s few Nuxalk seemed to distinguish between *sisaok* and *kusiut* societies; in fact, the words seem to have fallen into disuse (except by those studying ethnographic sources).

By the 1990s most masked dances in the community's repertoire, commonly performed at potlatches and feasts held in Bella Coola, were believed to be part of a communal pool of Nuxalk cultural knowledge. Divisions between individual secret society masks and chiefly masks were all but forgotten. Typically, masked dances were performed by a group of *Acwsalcta* youth, sometimes joined by dancers from the preceding generation. If a family or individual claimed ownership of one of these dances or songs, then it was probably understood that they had given permission to the *Acwsalcta* youth dancers to perform it. Certainly the mask, dance, and song teacher emphasized to her students that proper respect must be shown to the lender's family or they could lose the right to use the dance or song. *Acwsalcta* students were trained in the fact that executing a family-owned dance or singing a song constituted a weighty responsibility. Other masked dances were less commonly performed in public, but when they were "brought out" they were usually performed by a representative of the family who owned the dance or who acted as custodian of its mask. What is danced and sung during a specific potlatch or feast depends on the net-

works of relationships of an event's host family. In the case of the 1997 play potlatch the host family was the school of *Acwsalcta*.[18]

As explained above, except for a few masked privileges that are still individually owned, most masked dances are recognized as owned by the Nuxalk Nation as a whole and are typically represented by the *Acwsalcta* youth dancers. But, as has been made clear, this solution is not equally accepted by all. I have also noted a distinct reawakening of interest in claiming ownership of specific Nuxalk prerogatives, whether they are songs, dances, or hereditary chieftainships. I worked in Bella Coola at a time when discourses around Nuxalk national identity were prevalent. The Nuxalk are trying to form themselves into a collective whole, represented by a Nuxalk national flag, and they are seeking to earn the right to self-determination within Canada. As I have explained in Chapter 2, many Nuxalk feel that, as they never signed a treaty with their colonizers, their inherent rights have, in effect, been stolen from them. As I have shown, a debate, sometimes vocal, but often sotto voce, involves the conflict between claiming all Nuxalk dance, song, and art as equally and collectively owned by the Nuxalk Nation versus returning to traditional Nuxalk law, which recognizes specific individual or family-owned prerogatives. For the non-Native world homogenous ownership of Nuxalk culture under the banner of a unified Nuxalk Nation could prove to be strong proof of Nuxalk self-autonomy; however, within the culture, pride is created through the strength of individual and family ownership. This essential conflict seems to be at the heart of the dilemmas facing *Acwsalcta* cultural teachers and the growth of the Nuxalk Nation as a whole.

Innovations: Cultural Change Is Cultural Tradition in Bella Coola

One must be reminded that, in order for innovation to occur, there must be a "tradition" against which to innovate. Innovation requires tradition because it is not distinct from it but, rather, part of how traditions grow.[19] As one high school student, who took a leadership role in organizing the 1997 play potlatch, assertively pointed out: "The only thing constant in Bella Coola culture is change!" He had read McIlwraith's two-volume ethnography on the Nuxalk and delighted in using it as a guide for planning the play potlatch. He also enjoyed adding new twists to these recorded ceremonial behaviours. Instead of being dispirited about filling in missing information in the written account, he relished the creativity involved in innovation. This student fully embraced a constructivist approach to culture change.

Innovative Tradition: Entrance Purification Dance

The Cedar Bough Dance, which comes first in any ceremonial agenda in Bella Coola, purifies the space for the events to follow. At the 1997 play potlatch the students paraded in a line around the room carrying a cedar

branch in each hand. These branches had been collected at sunrise while giving thanks to the trees. It is worth noting that this entrance dance is always accompanied by the song *Wayala*, given to the Nuxalk Nation by its composer *Ki-ke-in* (Ron Hamilton) of the Nuu-chah-nulth people. The emcee ritually recognized this gift from artist, poet, and song writer Ron Hamilton and thanked him for sharing his song.

The Cedar Bough Dance was followed by the Paddle Dance. Both these dances were executed with stately form and precision. They entail sweeping motions that signal the cleaning of the room and the arrival of the performers. During the Paddle Dance the high school students ceremoniously carried a lengthy log drum into the performance space. This was an inspirational modification, the brainchild of a creative *Acwsalcta* high school student and member of the student council. It was designed to heighten the meaning of the evocative events to come as the log drum doubled as a symbolic canoe. The canoe/drum was to be used as a percussion instrument by the high school singers, but first it functioned as a vessel to carry in the gifts to be given away at the conclusion of the potlatch. This variation invigorated the performance while, at the same time, reminding the students of the original meaning of their actions.

Innovative Tradition: Chiefly Dances and Their Modifications

As was standard at important Nuxalk events in the 1990s, male chiefs, wearing their chiefly headdresses, are called upon to dance to their specific chiefly song so that those present can honour them. Thus, the privilege of standing up and dancing, and being recognized by the audience, is a physical enactment of the chief's ability to guide the Nuxalk people into the future. The play potlatch follows the adult rule, which holds that a specific family's chief must be represented in song and dance. However, for every given "rule" of contemporary Nuxalk behaviour, there is an exception that has become commonplace and therefore "traditional." For example, there is a female elder who holds her deceased husband's family chieftainship along with her two sons. During potlatches and play potlatches she typically allows all Nuxalk children to dance with her in order to give them a taste for leadership and public performance. Although normally a chiefly dance would be performed only by the chief and perhaps his right-hand man, this elder's modification has become tradition in Bella Coola.

Innovative Tradition: Children's Dances

At the 1997 play potlatch a series of Nuxalk children's dances were performed. These dances are intended to be fun but they also serve a didactic function. The children are taught about plant and animal behaviour through enacting nature's cycles and/or through competitive games. In one dance, which focuses on a flower commonly referred to as Indian paintbrush, the

high school students planned to have the children dance with paper flowers in their hands (where previously they had danced empty-handed). Finishing the dance, they presented their flowers to the elders who were watching the performance. This innovation served to emphasize the respect paid to the elders, and all present were pleased with it.

Innovative Tradition: Gender Changes

Many of the masked dances were formerly performed only by men, but during my fieldwork the cultural coordinator considered allowing young women to learn these dances as well.[20] She justified this desire to change protocol by recalling a particular female elder who had danced a male masked dance in the past, perhaps because there were no men willing or able to do it. This precedent was important to the cultural coordinator, and she was eager to voice it during the play potlatch. Although in the end the female high school students who practised the masked dances did not perform them, the goal had been to create more positive relationships to Nuxalk culture by making them more accessible to young women.[21] These kinds of decisions regarding appropriate gender selection show how much is at stake in cultural revival. Each decision affects the future of Nuxalk culture, selecting some routes while discarding others.

Return to Tradition through Innovation: The Washing Ceremony

McIlwraith (1992, 2:262) writes that it was critical for a Nuxalk dancer not to make mistakes during a *kusiut* dance performance because a misstep during the representation of a supernatural creature could be dangerous and might expose the secret society. During the 1997 play potlatch an accident occurred. While enacting the Thunder Dance, considered the most important in the Nuxalk repertoire, a student performer fell off the stage. It was hardly the fault of the dancer because the mask he wore had only tiny eyeholes and he was following the sounds of a rattle shaken by another student to guide his movements. Besides which, the dancers were not used to performing on an upraised, small stage. As a result of his fall the dancer's grandmother and mother performed a washing ceremony following the masked dances in order to officially purify him of his mistake. The women gave a cheque for $100 to the school and had the dancer present his dance vest to another student. In this way, his mistake was erased, literally "washed away." This concern for doing it the "old way" is relatively new in Bella Coola, and it shows a conscious desire to recapture the ways of the ancestors in practising contemporary Nuxalk culture.

Secrecy versus Exposure: How Cultural Teachers Share Their Knowledge

Another problematic situation for Nuxalk cultural teachers concerns how

much knowledge to claim as their own, and when and where to share it. Cultural teachers get caught in a bind because while, on the one hand, keeping traditional Nuxalk knowledge to themselves can be perceived as a positive strategy for maintaining Nuxalk control of Nuxalk culture, on the other hand it can also be perceived as blocking cultural revival. Those who have Nuxalk cultural knowledge must carefully balance the agendas of secrecy and exposure. Too much secrecy can bring the charge of "hoarding knowledge," which, in turn, can lead to an accusation of trying to make oneself "large" by emphasizing one's own significance and status. However, too much sharing of Nuxalk cultural knowledge, especially with the wrong audience, can bring with it accusations of betrayal. For example, I was welcome to observe and even participate in Nuxalk language and mask, dance, and song classes, but if I took notes or seemed in any way to be recording cultural content or curriculum design, then the teacher appeared upset because I was exposing her to the risk of being criticized for allowing Nuxalk knowledge to pass into the hands of an outsider.

One Nuxalk language teacher was careful to say that her grandmother, from whom she had obtained her knowledge, was a "custodian" of Nuxalk culture but "not a claimant" and that she herself was also only a "keeper not an owner." She emphasized that she taught only Nuxalk children and that her knowledge was not for outsiders. She warned her elementary school students that they should not tell their stories to "white people" without first asking the elders' permission because otherwise they might be accused of selling Nuxalk stories for money. She cautioned that this would be the worst thing to do because "money disappears but our stories are forever."[22] In this way, she conveyed the fact that she was serving as a protector of Nuxalk knowledge in order to pass it on to Nuxalk children and that setting up walls against "cultural prostitution" did not make her a thief.

Work Accomplished by the Play Potlatch

The 1997 play potlatch ended with a friendship dance (in which all present were encouraged to participate) followed by giveaways. The *Acwsalcta* students had laboured for months preparing handmade gifts to give to their audience to thank them for witnessing the work of recognizing *Acwsalcta*'s tenth birthday. The gifts included drawings, pillows with the *Acwsalcta* school logo painted on one side, beaded jewellery, little plants, jars of jam and canned salmon, crocheted items, decorated wooden spoons, and plaques and calendars that listed Nuxalk words. Through these gifts members of the audience were acknowledged as having witnessed the creation and continuance of Nuxalk cultural revival. Giveaway objects found their way into homes throughout Bella Coola as mementos of this auspicious event.

Acwsalcta students, parents, and elders had differing beliefs about the play potlatch's success. These opinions partially stem from the difficult choices

made by the cultural teachers while planning the event but that went unrecognized in the final, seamless production. At a post-play potlatch recognition assembly held in *Acwsalcta*'s gym on 2 April 1997 the cultural coordinator told the students that the elders had said that what they were doing was making the name of their school and the names of their families good. "[The play potlatch] effort pleased the elders and made them smile ... We are strengthening our name," she said. When interviewing an involved *Acwsalcta* student after the play potlatch, she recalled: "The school was filled with spirit then. People still talk of that potlatch. It was cool."

However, when asked what he thought of the contemporary Nuxalk singing and drumming, an adult informant and former dancer responded that he "used to be involved with the culture, but not anymore." When he was involved the elders had led the singers, drummers, and dancers and they had been "real strict." They had disciplined the students. "You had to be clean of body, spirit and mind, no drugs or alcohol," he informed me. This informant felt that "there was no more discipline" and that anyone could participate "without being pure." He implied that he did not think the dancing and singing had any meaning anymore. He said it was now "just for show." Another informant, a Nuxalk woman in her forties, agreed with him: "If you ask the [Nuxalk] kids what the song and dance is about, they would say, 'I don't know – we just do it.'"[23] One Nuxalk student said, in reference to Harlan Smith's book of photos of Bella Coola life taken in the 1920s: "I wish we could be like that ... We're dying out. The culture is dwindling out." She added that today teenagers don't want to participate in the cultural revival of past Nuxalk practices. The youth think "it's crap" she said, adding that she was sorry to use that word.

Opinions seem divided on whether *Acwsalcta* can achieve its goal of getting children to feel pride in being Nuxalk and to learn their culture. Even with the dissenting voices, however, the 1997 play potlatch was able to accomplish its aims: *Acwsalcta*'s name gained status in the eyes of the community and other potlatch witnesses by being able to produce a successful event. The story of *Acwsalcta*'s creation was told and memorialized in written form, and Nuxalk youth continued the work of healing the past through trying to fill the holes in the "lost generations" who had not participated in Nuxalk culture making. During the 1997 play potlatch challenging decisions were made about how to proceed with cultural revival, and the event has proven to be a successful model for contemporary Nuxalk identity creation.

Conclusion

The establishment of *Acwsalcta* as a focal point for Nuxalk cultural revival can be viewed as an example of the switchback metaphor I have been employing with regard to Nuxalk national identity construction. In the 1997 play potlatch the tensions over which direction to take in order to create

strong youth leaders is evident. Cultural teachers and curriculum developers are caught between conflicting models of Nuxalk cultural education. Differing methods produce differing results, and consensus has not been reached. This has caused much consternation and difficulty at *Acwsalcta*. Many Nuxalk who choose to study to become teachers in their home town have left *Acwsalcta*, expressing a deep-seated frustration at being pulled apart by factions (i.e., national as opposed to family-based politics) or by disputes over ownership and educational epistemologies. They have to choose between the oral tradition and the written word, between using modern Western technology and not using it, between teaching collectively to all (thereby recognizing national possession) and emphasizing the old rules of Nuxalk ownership. Secrecy and exposure are always being balanced. Although the air in *Acwsalcta* can be filled with anxiety and disharmony, the halls are pervaded with hope because this school is the site of the creation of contemporary Nuxalk cultural identity. The teachers and students are moving forward to reach *Acwsalcta*'s stated goal: the creation of confident future Nuxalk leaders. This is an ongoing process and it will be constructed and debated endlessly; however, through this process a dream is being forged into a reality.

5
Physical and Figurative Repatriation: Case Studies of the Nuxalk Echo Mask and the Nuxalk Sun Mask

> Although the return of objects may be a fortunate homecoming, it is not always obvious where home is for collected objects.
>
> – James Clifford, *Routes*

For the Nuxalk, art serves as a materialized representation of selfhood in the process of being made, remade, and given renewed value. As noted in Chapters 2 and 3, many Nuxalk articulate self-identification via cultural objects by using words of loss. Owning Nuxalk property seems to go hand in hand with the fear of having it taken away, especially by non-Native outsiders. However, as suggested earlier, in a strange twist theft is an act of recognition signifying that what you have is valuable. For the Nuxalk, then, ownership is caught up with the threat of loss and entanglement with the non-Native value system of the Western art market.

The Nuxalk are also involved in the Western legal system, which supports non-Native ideas about ownership and defines what constitutes theft in a Canadian and international context. As we have seen in Chapters 3 and 4, one way the Nuxalk seem to be garnering strength to deal with threats of theft from the external world is by identifying themselves as owners of a national cultural patrimony. They present themselves cohesively as a *nation* of owners in contrast to their traditional mode of defining property as individual or familial.

In this chapter I look closely at two old Nuxalk dance masks, one an Echo mask and the other a Sun mask, in order to explore how ownership is established and sustained in relation to the Western art market and the Canadian legal system. My first case study, described in the prologue, tells a contemporary story about the sale of a Nuxalk Echo mask out of its community of origin and its eventual repatriation. The second case study describes Nuxalk responses to the display of a Nuxalk Sun mask in a museum exhibition. The first story depicts what I label a "physical repatriation," the

second what I label a "figurative repatriation." In the former, a cultural object actually returns to its place of origin; in the latter, a Nuxalk claim of ownership is established by means of feeling connected, taking responsibility for, and controlling the uses of a cultural object without legally owning it. Thus, the mask is metaphorically returned to its origins even though, physically, it remains in a foreign place, far from "home."

Each of these two case studies revolves around issues of Canadian patrimony and its entanglement with Nuxalk nationalism. The journeys of these objects allow us to investigate the ways in which Western and traditional Nuxalk systems of ownership work together to produce and validate Nuxalk national identity. In discussing these cases I articulate the differing strategies of physical repatriation and figurative repatriation in terms of how they affect cultural revival and the creation of a strong Nuxalk identity.

Positive Aspects of Commodification

Some think that indigenous art should not be sold outside of the community of origin (e.g., gii-dahl-guud-sliiaay 1995; Keeshig-Tobias 1997; Todd 1990). Many believe that Canadian laws fail to prevent the appropriation of indigenous art by the non-Native art market, which includes art dealers, non-Native collectors, and museums (Berman 1997; Coombe 1997, 1998; Messenger 1989; Napier 1997; Pask 1993; Strathern 1999; Thomas 1995, 1999; Ziff and Rao 1997). I question the commonly held assumption that selling Native art outside its community of origin inherently involves a loss and, instead, suggest that there may be something identity-affirming in having one's cultural objects recognized and valued by outsiders.

I conclude that commodification and/or cultural appropriation can spawn a renewed interest in cultural revival within the Native community from which the object originated. Through the appreciative eyes of outsiders, indigenous peoples can more clearly see the wealth of their own culture. The non-Native art dealer may have been correct when he told me: "Buying the object produces positive, creative, cultural awareness." Perhaps in the contemporary situation the Nuxalk need outsiders to firmly establish their identity.

Physical Repatriation Critiqued

A quote from the late Mohawk curator Deborah Doxtator frames my discussion of the repatriation of the Nuxalk Echo mask and the display of the Nuxalk Sun mask. During the 1994 symposium entitled "Curatorship: Indigenous Perspectives in Post-Colonial Societies," Doxtator (1996, 56-57) said:

> When people talk about repatriation, they seem to talk about it in terms of Native people backing up the trucks, taking everything out of the museums

and putting it all behind a little fence with a sign that says: "This is mine. You can't look at it. You can't see it." ... I don't mean ownership in that way – not as property you keep from other people, in that way of owning, because you can own things that way and still own nothing. What I mean is that you own the responsibility of who you are and what you belong to ... You have to own who you are because if you don't take the responsibility, somebody else will, and, when that happens, you end up having to live within the confines of what other people think your life should be.

Doxtator indicates that there are problems with the physical repatriation of objects.

In the United States the repatriation of indigenous cultural objects is legislated by the Native American Graves Protection and Repatriation Act (NAGPRA), Public Law 101-601, created in 1990.[1] In Canada the Canadian Museums Association and the Assembly of First Nations worked together to create a document outlining ethical guidelines for both Native access to museum collections and the repatriation of Native human remains and cultural objects. However, unlike the established repatriation law in the United States, this 1992 task force report, *Turning the Page: Forging New Partnerships between Museums and First Peoples in Canada* (Hill and Nicks 1992) was intended to be morally persuasive rather than legally binding.

Doxtator notes that, while the task force report calls for equal partnerships and co-management, Native people are only passive participants since responsibility and power remain with museums. Neither co-ownership nor a Native view of cultural property as inalienable are recognized in the task force document (Doxtater 1996, 63). Haida lawyer, gii-dahl-guud-sliiaay (1995, 199), also known as Terri-Lynn Williams, concurs, highlighting "the distinction made between existing legal rights and moral obligations in the *Task Force Report*. This distinction effectively preserves the presumption that First Nations lack title to cultural property and fails to reconcile the property concepts of First Nations with Western systems of laws. Until this reconciliation is done, new partnerships between museums and First Nations will not adequately address the questions raised by repatriation, since the basis of repatriation will remain firmly in the Western worldview." Both gii-dahl-guud-sliiaay and Doxtator point out that a significant problem with physical repatriation involves proving ownership of cultural property. According to whose definitions will this be determined? The Canadian legal system and Aboriginal traditional laws are often in disagreement over what constitutes ownership or proof of ownership. Both women suggest that one of the main problems with physical repatriation is the fact that the process occurs under the rubric of Western conceptions of ownership, framed within the Canadian legal system and British Common law, where objects are viewed as alienable property and can thus be relocated.

Repatriation means to restore or to return to one's native land or place of origin. This implies that, during repatriation, a material object physically moves from foreign land back to the land from whence it had been taken – in the hope of a complete restoration. However, as Doxtator's argument conveys, this literal return to a literal community may not adequately encompass a First Nations understanding of having responsibility towards an expression of self-identity. Because Native cultural objects come with complex histories, rights, and protocols, viewing them as mobile property does not recognize their potential as repositories of self-determination.

I believe that the desire that motivates repatriation is the desire to obtain the right to self-define as an individual and as a First Nation. Therefore, I would like to suggest that it would be fruitful to view repatriation as the act of claiming metaphorical territory via control of an object. This is accomplished when First Nations determine the terminology one uses to discuss their cultural objects, thus compelling the use of an Aboriginal conceptual system. Although ostensibly repatriation is about the return of an object to a specific place, it is also about being linked to an object and making a statement about who is in control.

The Case of the Nuxalk Echo Mask's Repatriation

In the sale and repatriation of the Nuxalk Echo mask, the main question for all involved was: Who owns the mask and did the person who sold it have the right to sell it? I suggest that ownership is a process, an activity among people, rather than a static relationship between people and objects. I dissect ownership by analyzing what I claim are the arbitrary categories of individual ownership, family ownership, and national ownership. Traditional and contemporary beliefs about ownership become snarled as the Nuxalk create strategies for claiming possession. I also show that an indigenous art object's status changes when it interacts with Canadian Western law, thus producing a new product.[2]

Problems with Physical Repatriation

The physical repatriation of cultural objects has been perceived as a panacea for the many ills of Native/non-Native relations, a way to erase the negative history of colonization, salvage anthropology, and museum collecting. It suggests that, if we could only find once and for all the original owner of a cultural object, then conflict would quietly go away; but we are learning that objects "sent home" do not end the trickiness of ownership issues. The story of the Echo mask shows the many different ways that ownership of an object can be perceived.

Under Canadian common law the Echo mask can be owned by an individual. The simple fact that the elder physically possessed the mask gave

her the right to turn it into a commodity and sell it in the art market. According to the art dealer and the secretary of the Canadian Cultural Property Export Review Board, the elder who sold the Echo mask believed that she was given a fair price and did not feel cheated, even though the art dealer was able to turn around and sell it for almost nine times what he had paid for it.

Traditional Nuxalk society was governed by two parallel social organizations: the *kusiut* society and the *sisaok* society. Under Nuxalk traditional law, the right to display the Echo mask was both a *kusiut* privilege and a *sisaok* privilege. In the *kusiut* society members owned the right to use the masked dance to represent their personal supernatural power figures. Echo was one of the figures in this type of dance. *Kusiut* privileges were handed down from individual to individual and became the exclusive property of the most recent initiate (McIlwraith 1992, 2:27).[3] For these reasons, under both Canadian and Nuxalk legal systems, ownership of the Echo mask can be considered an *individual* privilege.

However, one could also make the case that ownership of the Echo mask is a *family* privilege. Under Nuxalk traditional law the Echo mask is also a *sisaok*, or chiefly, prerogative (Boas 1898, 93; Kolstee 1982, 166; McIlwraith 1992, 1: 306, 323, 341; 2:274-75). It was said that Echo introduced himself to certain ancestral families when they came down from above and landed in the Bella Coola Valley. These families claimed possession of the specific land upon which they settled and also claimed possession of the right to display Echo (as their crest figure) at certain ceremonial events. The family collectively owned the origin story associated with meeting Echo. The Echo mask was a material representation of this story and could be danced by members of the family if given permission to do so through family consensus. The mask was held in trust by the eldest male member of the family, or chief, who would inherit custodial rights in the name of his entire family.

To complicate this intricate web of ownership claims, the Echo mask can also be owned by a *nation*.[4] When the Nuxalk band council sued the art dealer in court it publicly claimed that the Echo mask was the cultural property of the Nuxalk Nation. The elected band chief declared in court that the Nuxalk elder did not have the right to sell the mask because it was owned by the Nuxalk Nation as a whole and, therefore, could not be sold by any one individual. Indeed, as already noted, claiming national ownership of cultural property, whether material arts, land, or resource rights, has become a political strategy among First Nations peoples. National ownership claims allow First Nations groups to represent themselves as homogenous bodies, united in the desire for the return of national property, as opposed to family ownership claims, which are perceived as possibly divisive and are less easily understood by a non-Native audience.

Interestingly, to further complicate the matter of who owns the Nuxalk Echo mask, one could claim that Canada views the Echo mask as *its* national property. The Canadian Cultural Property Export Review Board denied the mask an export permit in 1996 because it "is of such a degree of national importance that its loss would significantly diminish the national heritage." This claim is very similar to the Nuxalk Nation's claim – that of cultural patrimony.[5] I might add that Canada's position was not in opposition to that of the Nuxalk Nation's. Recognition of a Nuxalk mask as Canadian cultural property helped the Nuxalk Nation gain the time and funds to claim the mask as Nuxalk cultural property.

What is significant here is that, during this process, the status of the mask's legal ownership changed from individual/family ownership to national ownership, which led the Nuxalk to present a unified front in spite of the fact that, behind the scenes, a battle was going on over who owned this mask within Bella Coola. The Canadian Cultural Property Export and Import Act facilitated its return, but this did not restore the original status of the mask. What it did was create a space for a settlement to be reached between the art dealer who bought the mask, the Nuxalk Nation who wanted it returned, and the Canadian Heritage Department, which guided the negotiations, granted the Nuxalk cultural centre institution status, and offered the funds to help buy the mask back. The Echo mask's sale out of the Bella Coola Valley actually forced the Nuxalk to work together for its return, seeking a new solution to what had previously been a very difficult situation among Nuxalk individuals and families.

In this case the Echo mask clearly did not revert to an original way of being but, instead, absorbed new ways of perceiving ownership. Under the supervision of the Nuxalk band council and elected chief, ownership shifted from the individual/family to the nation. The Echo mask's status changed because of its involvement with multiple systems of thought. The mask was "wrapped" (Jonaitis 1992, using Jameson's 1991 epistemology) in layers of interpretation as it moved through time and into different situations. During this "wrapping" process the mask gained new meanings as it interacted with Western art dealers, collectors, museum curators, scholars, the Canadian legal system and even the media. Because the mask's status changed during the process of its commodification, it cannot be "unwrapped." The Echo mask's meaning now encompasses its journey out of the valley and through the Western art world, the Canadian legal system, and back to the Bella Coola Valley.

Equally important is the fact that the mask's journey and tortuous negotiations through Canadian law have changed how it is displayed by the Nuxalk. The bank building in which it is housed is not on the Nuxalk reserve but, rather, on the non-Native side of the town of Bella Coola. A large part of the traditional significance of the Echo mask involved its unveiling during spe-

cific ritual contexts, so being always accessible to outsiders' eyes is contrary to its original raison d'être. The label the Echo mask bears in the bank display case renders the story of its sale and return integral to the way it is presented by the Nuxalk. It now functions as motionless treasure fixed under glass. With all its mouths on display simultaneously, it cannot enact its various voices one by one and so does not fulfill its performative capabilities.

Because cultural objects are often not returned to their original owners but are instead returned to the First Nation, the authorization of their display and use remains a contested domain. The Native community continues to wrestle with the implications of the change in ownership. In November 2001 I attended a potlatch in Bella Coola where Echo appeared for the first time since 1995. I was curious to know whether the repatriated Echo mask would be danced and by whom. The mask used, however, was a newer copy of the returned mask. The fact that the Nuxalk do not appear to be dancing using the repatriated Echo mask suggests that they perceive this older mask to be an heirloom – something that needs to be carefully preserved and not submitted to the rigours of a ritual dance performance. This might reflect the rules of the federal Department of Heritage and the Canadian Cultural Property Export Review Board, which state that the Nuxalk Nation must keep the Echo mask within what is termed a "safe" location. It implies that the Nuxalk are being cautioned to follow a Western style of conserving and preserving objects rather than a Nuxalk style of "cultural perpetuation" (giidahl-guud-sliiaay 1995).

However, treating the mask as a "museum object" allows the Nuxalk to avoid deciding who would perform the dance if the mask were to be used ritually in a potlatch. Thus the Nuxalk were able to sidestep the complex issue of who had authority over the old Echo mask. While on the surface the Nuxalk appear to have resolved their internal differences, when I asked various Nuxalk how they felt about the Echo mask's new location and new status as nationally owned, many hesitated to respond. Others neither affirmed nor criticized the mask's new status. I believe that this ambivalence relates to the fact that many Nuxalk feel caught between their loyalty to their families and their loyalty to the Nuxalk Nation.

From this perspective, the Echo mask's physical repatriation appears unsatisfactory because it did not resolve control issues: the Nuxalk must still worry about the future status of the mask and who has the right to dance it. The elected band chief told me that the repatriated Echo mask is now under the stewardship of the elected band council, which follows the mandate of the voting Nuxalk Nation. This is a democratic decision-making system that relies on a quorum of voters, and it is a radical alternative to the former system, in which either a secret society initiate decided when the mask would be danced or a family, under the guidance of a hereditary chief, selected someone to represent its crest figure.

Another problem arising from physical repatriation is that First Nations must become adept at arguing their ownership in Western terms if they want objects returned to them – a zero-sum game in which one side wins possession and another side loses possession. This creates a paradoxical situation because First Nations have been trying to teach the West that relationships to cultural objects are not about object ownership per se but, rather, about an *inalienable* connection between objects and their custodians (something not encompassed by Western legal ideas about ownership).[6]

Ironically, the Nuxalk were forced to use the Canadian legal system in order to claim that the elder did not have the traditional right to alienate the mask because, according to Nuxalk traditional law, it could not be owned but merely held in custody. They were compelled to use the foreign concepts of Canada's court system in order to cite a Nuxalk principle, only to have the mask's status changed from family owned to nationally owned upon its return. Doxtator would view this strategy as being counter to the goals of repatriation as it does not maintain an Aboriginal conception of ownership.

Ownership Validated through External Recognition

It seems that a definitive statement concerning ownership makes no sense. Perhaps ownership is a process rather than an absolute relationship. Since it appears impossible to ever conclusively determine ownership it is appropriate to explore the various ways in which ownership is validated. How does an object gain value in the eyes of its owner? What strategies allow various groups to gain recognition of ownership from others?

Georg Simmel (1978, 63) suggests that value is never a quality of the object but, rather, is a judgment upon the object that emanates from persons not things. He also says that possession is not just an economic fact (54-55). In other words, value does not come from the object or from the money invested in buying it but, rather, from the recognition and legitimization that people grant to the object. "For many individuals, property does not fully gain its significance with mere ownership, but only with the consciousness that others must do without it" (Simmel 1950, 332). Thus, ownership is never created in a vacuum. The owner requires external recognition in order to appreciate what he or she owns. For this reason, in the case argued here, the key to ownership is display. The Nuxalk tradition clearly views ownership in this light. It was never enough to simply own a mask, wrap it up in cedar bark, and tuck it away in a cedar box. Nuxalk social convention demanded that the mask be ritually displayed during a potlatch or winter ceremony. This was a public way of validating claims to ownership. Public approval also brought recognition of the privileges attendant with the mask, whether these were land ownership, resource-gathering rights, or social authority. Merely having a mask in one's physical possession was not

enough to establish ownership. If outsiders witnessed a mask being danced and its song sung and, in this context, accepted food and gifts, then they were publicly declaring that they agreed with the family's claim to ownership of the mask and all its resulting rights.

Because, for the Nuxalk, ownership requires external validation, there is always a concomitant risk of theft. Exposing one's property to foreign eyes means that outsiders will know that it exists; the resulting knowledge is beyond the control of the owner. In the past the display of *sisaok* and *kusiut* privileges to outside visitors during a potlatch risked not only the physical theft of the mask through a raid but also the chance that a witness would remember the dance danced, the song sung, and the explanatory story told and then have a mask made and claim the privilege to display it as their own.

Nowadays, Nuxalk people complain about the risk of being bombarded by requests from art dealers to buy their old masks. For this reason many are fearful of admitting that they have masks tucked away in their attics or hidden under their beds. As noted in Chapter 3, selling cultural objects out of the Bella Coola Valley is not just perceived as a means of generating income but also as a "selling out" of one's culture. Some Nuxalk see this as "cultural prostitution," a betrayal of national culture, and believe that it undermines Nuxalk cultural identity.

While there are many risks to ownership, there are also many positive sides to it. When ownership is displayed the owner gains recognition through external validation. Some Nuxalk perceive the copying of Nuxalk art styles by outsiders as a compliment – one that increases the value of Nuxalk art. The copy becomes proof of the value of what the Nuxalk display. The Nuxalk gain political leverage when they use material culture to prove their national identity to British Columbia and Canada. Handler (1988) made a similar point when he showed that "having a culture" became the twentieth-century requisite for proving collectively that one is a nation with a valid identity.[7]

Summary of Echo Mask Case Study

The Nuxalk repatriation of the Echo mask can be read in numerous ways. From one perspective, the physical return of this mask can be celebrated because the Nuxalk Nation worked together to return a vital, sacred mask to the community. It sought a new solution to what had previously been a very difficult situation among Nuxalk individuals and families. The Nuxalk displayed a unified front to the rest of the world, solidly representing Nuxalk national identity. The Echo mask's physical repatriation has mobilized renewed community interest in Nuxalk culture and has provided a venue within which the Nuxalk people can unite under a common banner as a nation rather than as a group of quarrelling extended families. Some informants

even told me that the elder might have sold the Echo mask in order to alert the Nuxalk to what they could be losing – a wake-up call of sorts to emphasize the importance of Nuxalk culture. Needless to say, the Echo mask's function is now very different from what it was before it was bought and sold out of the valley.

From another perspective, this case can be read as a failure to untangle the dilemma of ownership and, therefore, serves as evidence for my claim that ownership can never be completely resolved. Thus, physical repatriation should not be viewed, as has traditionally been the case, as a complete reversion to an original way of being. The physical repatriation of the Nuxalk Echo mask did not result in the erasure of its commodification and sale. The Nuxalk will continue to wrestle with the implications of Nuxalk national ownership of the Echo mask, and they will be required to make decisions about how it will be used or displayed. Clearly, physical repatriation is not as straightforward a process as it is often assumed to be.

Figurative Repatriation

The story of the Echo mask brings us back to Doxtator's point that First Nations need to take responsibility for their identities. They cannot allow themselves to use foreign concepts, such as Canadian law regarding alienable property, to make repatriation claims because, when they do so, they perpetuate the colonization process through which First Nations were named, categorized, and then controlled by outsiders. Doxtator makes a plea for repatriation but only when the terms of argument are Aboriginal and where the object is perceived as absolutely inalienable. As Clifford (1997, 212) aptly observed, many Native groups do not desire physical possession of their material property but, rather, an ongoing connection with and control of it.

For the remainder of this chapter I focus on what I term "figurative repatriation" as a possible alternative to this impasse. I refer to the idea that Nuxalk leaders and artists can regain control of their material cultural objects by exhibiting politicized artworks in Western spaces, thus displaying metaphorical acts of self-definition. I argue that figurative repatriation requires interactive spaces outside of Native territory so that messages of Native control and ownership can be heard, seen, and witnessed by non-Native audiences.

As I have argued, repatriation should not be thought of as a zero-sum game, where First Nations communities win and museums and Western communities lose. Native and non-Native people are not really in conflict over a non-renewable resource. Contemporary First Nations artists are producing the cultural objects needed to keep Aboriginal traditions and cultures alive and flourishing. Many First Nations people point to a lack of

respect on the part of non-Native people, to the latter's failure to recognize that they have survived and endured Canada's assimilationist history.

Gloria Cranmer Webster, the first director of the U'mista Cultural Centre in Alert Bay, stated that the Kwakwa̱ka'wakw Nation does not need their cultural objects to be repatriated in order to dance them since they have artists making new material for the spiritual health of the community. They need objects repatriated "to rectify a terrible injustice which is part of our history" (Webster 1995, 141). If repatriation is to occur, then First Nations need to have the non-Native public hear this message. This would enable First Nations to take responsibility for their culture and how it is defined. Once the complexities and limitations of the physical repatriation of objects are understood, then figurative repatriation can be appreciated as a way of fostering intercultural relationships and of achieving self-determination.

Museums are a prime location for this kind of conscious act. Clifford's (1997, 191-92) notion of the "contact zone" (borrowed from Pratt 1992) recognizes museums as meeting places where transcultural processes happen. While acknowledging that museums "make borders" he also sees museums as potential sites for "border crossings" (Clifford 1997, 204). These border crossings are not comfortable or easy, but he encourages us to "work within these entanglements rather than striving to transcend them" (213).

The Case of the Nuxalk Sun Mask's Display

In the case regarding another old Nuxalk cultural object, a Sun mask, the Nuxalk never sought physical repatriation; instead, the display of this mask functioned as a form of figurative repatriation. This mask was at the centre of a major advertising campaign for the Vancouver Art Gallery's Down from the Shimmering Sky: Masks of the Northwest Coast exhibition held in the summer of 1998. Based on attendance records (Sterngold 1998, E1), this was one of the most successful shows in the Vancouver Art Gallery's history. It was also a well publicized exhibition, covered in multiple newspaper articles that appeared in the Vancouver area and as far afield as Toronto and New York City (Fournier 1998a, 1998b; Goodman 1998; Gustafson 1998; Milroy 1998; Scott 1998; Sterngold 1998; Van Evra 1998; Varty 1998), not to mention displayed on the ubiquitous ten-foot high posters at bus stops in Vancouver's main thoroughfares. Vancouver and British Columbia were proud to host such a blockbuster show. Many of the masks on display were borrowed from countries around the world and had not been seen in Canada for upwards of 100 to 200 years. Their return to their place of origin, even if temporary, was heralded as triumphant, a display of Canada's pride in its material heritage. As Peter Macnair, the former curator of the ethnology department of the Royal British Columbia Museum in Victoria (and one of the three curators for this exhibition) stated, "The idea of a homecoming ...

strengthened the show and underscored the sense of a strong and living tradition with deep roots in the Indian [sic] imagination and local trade" (Milroy 1998, C10).

The Vancouver Art Gallery wore a banner the size of a small building, with only three-quarters of the face of the Nuxalk Sun mask emblazoned across its black background, suggesting that the show was so big and of such importance that the sign could not entirely contain the face of the mask. One art critic noted "the spectacular Nuxalk Sun Mask ... used as the exhibition's signature image" (Milroy 1998, C10). The Nuxalk must have enjoyed the fact that their mask was chosen to represent the contents of the show, that it was recognized as *the* most beautiful, evocative piece and so was used to attract people to the exhibition.

The Sun mask represents the Nuxalk supreme deity *Senx*. Boas recorded that *Senx* lived in the upper edge of the Sky World, in a house called *Nusmata*, meaning "the place of origin of myths and legends" (Macnair 1998, 96; Richardson 1982, 21; Seip 1999, 276). The Sun has "ultimate power" (Macnair 1998, 96) and is considered to be one of the "rulers of mankind [sic]" (Boas 1898, 30, quoted in Seip 1999, 278). It sent to earth four supernatural carpenters, who created the *Nuxalkmc* and the environment in which they live. The Sun mask would have been worn by a dancer during a potlatch or it might have been used as a theatrical prop "rigged to move across the rear wall of the ceremonial house to indicate the daily passage of this celestial power" (Macnair 1998, 96).

Interestingly, this specific Sun mask has been copied in two-dimensional and three-dimensional form by contemporary Nuxalk artists in Bella Coola. A Nuxalk artist in the early 1980s designed a Sun mask painting to be part of the giant mural on the back wall of *Acwsalcta* (Bella Coola's band-run school [see Chapter 4]). The Sun mask has also been used in numbered silkscreen prints and as a model for a carved cedar mask created in the early 1990s (see Chapter 3). This design has also been stenciled onto T-shirts sold in Bella Coola to *Nuxalkmc* and tourists alike. The Nuxalk Sun mask's replication in various forms speaks of the importance of old Nuxalk designs to today's *Nuxalkmc*. The sun is recognized as the crest of all contemporary Nuxalk, regardless of other personal or family crests. In fact, the sun crest is depicted on the Nuxalk national flag (see Chapter 6).

The specific Nuxalk Sun mask used in the Vancouver Art Gallery exhibition was collected by Boas and Hunt in 1897 for the American Museum of Natural History and has been an important part of that museum's Bella Coola display for over 100 years.[8] Curator Macnair (1998, 192) estimates that the mask was made in approximately 1870. It was loaned to the Vancouver Art Gallery by the American museum for this exhibition.

A band councillor for the Nuxalk Nation was photographed unveiling the mask when it arrived in Vancouver from New York City, and this picture

appeared in the *Province* on 14 May 1998. This councillor was described as a contemporary Nuxalk mask carver who carves only for ceremonial occasions, not for sale (Fournier 1998a, A13). His willingness to be associated with the display of this mask signalled his acceptance of its public display. Interestingly, this councillor is quoted as saying: "If they hadn't been stolen and kept by museums, we'd never have them today" (ibid.). The councillor's ambivalence cuts to the heart of the matter: the Nuxalk were previously exploited, but despite this they are pleased that museums took care of their masks so that they are able to see them today.

The exhibition planning committee consulted with representatives from eleven Northwest Coast First Nations in order "to ensure that the privileges and rights associated with individual masks are appropriately protected, that permission to exhibit and document the masks has been granted and that the masks are displayed and represented in a manner that acknowledges their social and ceremonial meaning" (Grenville 1998, 15). This was a groundbreaking protocol, especially considering that most of the masks came from international museum collections rather than from First Nations.[9] Members of the Nuxalk Nation must have been glad that their permission was sought regarding the public display of their masks. It seems clear that the band councillor's support of the Vancouver Art Gallery exhibition demonstrated that a number of influential Nuxalk saw value in presenting an important aspect of their culture to a non-Nuxalk public.

I was excited to discover, in photographs taken by a friend during a fall 1998 Bella Coola potlatch that I was unable to attend, that a full-size advertisement from the Vancouver Art Gallery exhibition had been included as part of the ceremonial screen behind which dancers dress and undress during their performances. I do not know whether this particular Sun mask traditionally belonged to the family that used it in their potlatch, but I surmise that the hosting family was claiming it in the name of the Nuxalk Nation as a whole.

I do know that the family hosting this potlatch did so in order to publicly unveil new masks made by their carvers. These new masks were copies of older masks that had been in museums for so many years that most Nuxalk were not familiar with them. These new masks could only be made after the Nuxalk Nation received photographs of them from museum collections in the United States and Canada. After interviewing a Nuxalk artist and band councillor, Lisa Seip (1999, 284-85)[10] writes: "Developing a dialogue with museums is important for the *Nuxalkmc* as they strive to revitalize their ceremonies. The ceremonial items in the collections of museums serve as a valuable resource base for artists when creating new masks and exploring the art styles used in the past." This cooperation signals the importance for the Nuxalk of maintaining working relationships with museums holding Nuxalk materials.

Both the display of the Sun mask in Down from the Shimmering Sky and the Nuxalk use of the exhibition's poster strongly suggest an intercultural process of identity production. Through the Vancouver Art Gallery exhibition and the Nuxalk potlatch, the Sun mask increased its value to the Nuxalk. It can be argued that the Nuxalk Sun mask's exposure to a public outside Bella Coola functioned as an act of figurative repatriation. In this case, it would seem that cultural revival was better served by displaying the Sun mask in a Western museum than at home in Bella Coola.

Controversies over Display

Down from the Shimmering Sky did not quiet all controversies, however. At its opening, Native dancers performed masked dances for a non-Native, museum-going public. While some First Nations organizers and performers were excited about sharing their ceremonial wealth with a larger audience, others appeared hesitant or even unhappy.[11] There was a subtle undercurrent of discontent – an implication that these dances were private and sacred and should only be revealed in the big house, the venue appropriate to Northwest Coast ceremonial events. However, Kwakwa̱ka̱'wakw chief, trained dancer, and co-curator of the exhibition, Robert Joseph, commented: "When I was a little boy, we got together with the old chief and closed the door and let no outsiders in the Big House ... No cameras, no recorders. But those doors have opened somewhat to outsiders, as long as they are respectful ... How will people respect us if we don't tell them about who we are?" (Sterngold 1998, E2). In this statement Joseph acknowledges the changes that have occurred regarding the exposure of First Nations ceremonies to outsiders, and he recognizes the need to display his culture's traditions in order to gain understanding and respect from non-Native people.[12]

The tension beneath the surface of Down from the Shimmering Sky is quite common in First Nations communities in British Columbia. First Nations struggle to establish a balance between exposing their culture and, at times, denying access to it. This negotiation of access is at the very heart of what museum exhibitions can accomplish. When a First Nation refuses a museum-going public the right to view an important dance mask or to understand its secret meaning, then it is clear that limits have been reached and that translation is denied (Townsend-Gault 1997, 153). This is what Charlotte Townsend-Gault refers to as a "no-go zone" (personal communication 1998). I argue that this boundary-marking activity is a means by which First Nations assert their responsibility for their cultural property while taking control of their Native identity. In the same vein, when First Nations allow their cultural patrimony to be put on exhibition, they are participating in the process of validating their culture.

Performing Figurative Repatriation

Clifford and Myers both ask why a Native group might want to perform its culture for outsiders beyond the boundaries of its home: "Why would tribal people be eager to dance in New York or London? ... Why play a game of self-representation?" (Clifford 1997, 200) Clifford argues that public performance may bring "empowerment and participation in a wider public sphere as well as commodification in an increasingly hegemonic game of identity ... For what exceeds the apparatus of coercion and stereotype in contact relations may perhaps be reclaimed for current practice in movements to expand and democratize what can happen in museums and related sites of ethnomimesis" (ibid.). Myers (1994, 693) probes further:

> The questions that ought to be asked about the politics of current forms of Aboriginal cultural production are whether and to what extent local (community-based) social orders are defining themselves – their meanings, values, and possible identities – autonomously in relation to external powers and processes; whether and how they are transformed in relation to new powers and discourses; and how or whether what had been local meanings are now being defined dialectically (or oppositionally) with respect to discourses available from the larger world. That is, our interest in such events ... should be a closer examination of cultural mediation as a form of social action in uncertain discursive spaces, of unsettled understandings, in short, of "culture-making."

Thus, the act of display in non-Native venues, in spite of fears that it will reduce cultural meaning, gives value to what is on display. The ability of First Nations to act as gatekeepers allows them to control how they are received. In this way, they set the terms of the exchange (what Myers refers to as "cultural mediation"). This, I argue, is the process of figurative repatriation. Myers (1994, 694) recognizes "the sincerity and purpose of the Aboriginal participants to make something of themselves and their cultures known, to 'objectify' themselves not only as a type of people, but also as worthy of international attention and respect."

In a parallel example, Judith Ostrowitz explores what the Kwakwaka'wakw gained from performing their ancestral dances at the opening of the exhibition Chiefly Feasts: The Enduring Kwakiutl Potlatch, held at the American Museum of Natural History in 1991. There existed the possibility that the Kwakwaka'wakw might perceive the exposure of sacred, ceremonial dances to non-Native eyes as inappropriate. In reality, however, the participants saw it as an opportunity to assert their cohesive national identity in an international, public venue. Ostrowitz (1999, 103) concludes: "The dances were not supposed to validate the name of a single high-ranking host. They

were intended to be diplomatic, a communally sponsored event requiring a public display of cooperation among various Kwakwa̲ka̲'wakw people from different families and villages. The program was meant to give the audience a good time, but it also provided an abbreviated model for idealized pot-latch protocol to non-Native observers, functioning in a didactic manner for the public presentation of contemporary, and in this case, unified, Kwakwa̲ka̲'wakw identity." Beneath the veneer of unified national identity, however, various Kwakwa̲ka̲'wakw individuals and families vied to validate their own reputations. While this may not have been apparent to non-Native spectators, the Kwakwa̲ka̲'wakw used this larger stage to make asser-tions to one another about their own authority. In other words, the Kwakwa̲ka̲'wakw converted the status created in this museum-arena into a declaration of their right to make culture.

Summary of Sun Mask Case Study

While not all Nuxalk approve of ceremonial dance masks ending up in pub-lic displays,[13] or the use of sacred dances to open museum exhibitions, it is important to acknowledge that acts of cultural affirmation can occur in the alien spaces of Western museums. Many Nuxalk travelled to Vancouver to attend the Down from the Shimmering Sky exhibition. Through their pres-ence, they metaphorically declared their control of this territory. The Nuxalk band councillor did this in another venue when he reminded newspaper readers that his cultural patrimony has been stolen, even if "legally" bought by museum collectors and/or art dealers. In other words, he used the press and the exhibition to point out problems with Western ways of acknowl-edging ownership and to offer, instead, his view of Nuxalk cultural heritage as inalienable property.

After interviewing the Nuxalk elected band chief, Seip (1999, 284) re-ported: "The *Nuxalkmc* would like to establish a relationship with museums and to be consulted about how objects from their culture are displayed and presented to others." The Nuxalk produce their own national identity by presenting their cultural property to non-Nuxalk in identity-affirming ex-hibitions. They do this in the hope that non-Native museum visitors will learn about Nuxalk culture. As gii-dahl-guud-sliiaay (1995, 1888-89) has said: "From a First Nations perspective, development of respect for First Nations culture is the principal area of concern; it should exceed the con-cern accorded to science or 'cultural preservation.'"

Conclusion

Because ownership among the Nuxalk is a process that requires public dis-play in order to gain external validation, we can view the selling of Nuxalk art objects as potentially redemptive with regard to Nuxalk cultural iden-tity. It is for this reason, as argued more extensively in Chapter 3, that I wish

to rehabilitate commodification and to protest that selling an object does not necessarily result in cultural appropriation, rupture of cultural knowledge, or loss of positive self-growth.

Physical repatriation, although inspiring for cultural revival projects, does not resolve the dilemmas of ownership, which force the Nuxalk to work within a non-Native system of laws and to speak in non-Native vocabularies. I suggest that figurative repatriation enables the Nuxalk to gain control of their cultural patrimony and to claim inalienable ownership in transcultural spaces without the requirement of physical repatriation. Contemporary Nuxalk identity is strengthened in the exchange between Native and non-Native people, often via objects that focus dialogue or that serve as flashpoints for argument and reaction. No matter how difficult these contested social relations, the display of Nuxalk artworks in non-Nuxalk settings functions to create contemporary Nuxalk identity.

6
Theft Inside and Out: The Making of a Theory

Acwsalcta Students at the American Museum of Natural History

In June 1998 I arranged to be in New York City to meet a group of Nuxalk students at the American Museum of Natural History. This was a monumental trip in the lives of these teens from Bella Coola, filled with excitement and novel opportunities. Organized by two non-Native *Acwsalcta* teachers, fundraising for this journey had lasted for over a year and was augmented with a grant from the Bella Coola band office.[1] The main reason for making this journey was to view the Bella Coola collections in Franz Boas' famed Northwest Coast Hall at the American Museum of Natural History. The students were planning to videotape their visit to the museum in order to bring the collection back, at least visually, to the Nuxalk community.[2] The Nuxalk contingent, which met me at the 77th Street entrance west of Central Park, had already experienced the typical sight-seeing adventures of tourists in the Big Apple – an all-day bus tour through various neighbourhoods, a trip up the World Trade Center Towers, a search for discount shopping, and seeing a Broadway musical.

The social studies teacher who led the group had tried to contact the curator of North American ethnology at the museum in order to arrange a behind-the-scenes tour of its extensive Northwest Coast collections. Not aware of museum protocol, the teacher phoned the museum's general information line about the proposed trip rather than writing to the anthropology department. Her call was shunted off to visitor services, which arranges group tours. As a result, upon arriving at the museum, the Nuxalk contingent was treated as just any group of visitors instead of being given the recognition and respect it might have received had the curator of North American ethnology been alerted to its arrival. Additionally, the group members, not understanding that the admission fee was voluntary, paid the full suggested price, a heavy financial burden for them. These misunderstandings are typical when visitors from rural communities expect the same level of support in urban settings that they would expect to offer to a group

visiting their own community. This deficiency in communication reinforces the feelings of appropriation experienced by First Nations people, who are prone to feel slighted and excluded by Western museums.

As soon as they entered the museum the Nuxalk teens walked into the dark and somber Northwest Coast Hall. Their attention was immediately drawn to the dusty Bella Coola case, where masks, headdresses, cedar-bark rings, secret whistles, and fishing hooks and nets were on display. Ironically, the crowning piece of the museum's collection, the Nuxalk Sun mask, was absent, having already been sent to the Vancouver Art Gallery. Even with this gap, the students appeared impressed by the pieces, announcing in quiet voices that they had never seen some of the types before and that "they look[ed] really old." One student asked me the names of the artists who had made these objects. I had to tell her that Boas had not collected their names when he amassed these objects in 1897. In accordance with the anthropology of his time, he was interested in presenting whole cultures rather than individuals. His purpose was to present a "complete" collection of Nuxalk artifacts and their matching stories: the names of the individual artists were irrelevant.

A student's eyes fell on an Echo mask, and she commented that its appearance was different from that of the one she knew back home. Another student, upon seeing a Thunder mask, asked me if I had seen the new one that had been carved for the *Acwsalcta* school. Apparently it was "awesome" and she knew the name of the artist. Another student was impressed by the cannibal bear outfit. As they viewed the exhibit the students began singing parts of Nuxalk songs and expressed feelings of homesickness. Clearly, they were reacting personally to the objects, trying to fit them into what they knew about their lives back in Bella Coola.

Amid the excitement, there was ambivalence: happiness at being able to see these objects, which had been preserved in the museum setting, and anger that they were here and not in Bella Coola. A student announced loudly that they should break in and steal these objects back in order to bring them home! At the end of their visit he repeated this desire, whispering to a teacher that he wanted help to break in at night and take the masks back. This sentiment appropriately expresses Nuxalk feelings towards museum collecting practices. In their minds, whether paid for or not, these artifacts were inalienably Nuxalk, had been stolen from the nation, and belonged at home. I would not hesitate to suggest that this group of *Acwsalcta* students saw themselves as emissaries sent from Bella Coola to claim what was theirs.

Theft as Valuation

Annette Weiner (1992) writes about "inalienable possessions," objects that must be kept while given, that must remain permanent while circulating.

For example, via exchange Trobriand Islander's *kula* bracelets and necklaces gain a history, a meaning, and an aura of ever-increasing value. Weiner also asserts that, although such *kula* objects gain value through being traded away, *because* they are so valuable individuals try not to part with them. I wish to build upon this paradox with respect to the dichotomy of theft and ownership. It is not new to suggest that these are two parts of the same whole: without the risk of theft ownership cannot exist; without possession theft has no meaning. Yet in this scenario theft is viewed as *removing* something valued from its owner. I would like to suggest that theft, in certain cases, actually *creates* value.

In addition to Weiner's paradox of keeping while giving, ownership entails yet another paradox, that of secrecy and exposure (Nooter 1993; Weiner 1992, 26). For a possession to have value in social life it must be recognized, but in this recognition comes the risk of theft (see Chapter 5). This risk is part of the cachet of ownership. If someone does not know you own something, then what, beyond use-value, is the point of ownership? As Weiner so aptly explains, "The possibility of loss ... is so paramount to an inalienable possession's uniqueness that the more the possession grows in importance, the greater the threat of its loss" (94-95). Conversely, once stolen, the value of a possession increases.

From this perspective, crying theft or appropriation forces the listener to recognize that what one had possessed is indeed valuable. This makes the crier an agent in the creation of his or her own status in the eyes of others and is key to the creation of an empowered Native identity.[3] Thus, below the surface of Nuxalk claims of ownership of appropriated property lies an implicit strategy for gaining increased external recognition of the value of their culture and identity. This interpretation may sound incendiary to the Nuxalk as it suggests that the theft of objects and cultural knowledge can be viewed positively in the present. Yet, in a cautious and qualified way, this contention is indeed central to my thesis.

In what follows I examine ideas about theft that are commonly voiced in Bella Coola. I identify two strains of discourse: one concerning theft *internal* to Bella Coola (i.e., practised by Nuxalk upon Nuxalk), the other concerning theft *external* to Bella Coola (i.e., practised by non-Nuxalk upon the Nuxalk Nation). I explore how and why these two types of theft and their associated rhetoric diverge.

Internal Theft: When Nuxalk Steal from Nuxalk

Theft is a common occurrence in Bella Coola. "Breaking and entering" (B&E) on the part of Nuxalk youth is on the rise (*Coast Mountain News* 1998). Indeed, I witnessed a B&E in progress in July 1997, and victims told me about several others when I lived in the community. Thanks to my close involvement with teenagers at *Acwsalcta* I came to understand the reasons

behind this increase in theft. Teens told me that they were bored and that they often turned to alcohol and drugs for entertainment. One can only assume that house robberies occur because those who perpetrate them are looking for excitement, need cash to buy alcohol and drugs, and/or lack alternatives to stealing (such as jobs or educational opportunities). Adults in the community often complain about the inability of parents and guardians to control their children. Parents are asked by the authorities to be aware if their teenager has objects of value for which s/he cannot account, though they don't often comply. Due to the small size of Bella Coola, youths do not have very far to roam and, as a result, are usually caught when the RCMP ask members of their peer group who committed the crime. Arrests are often made so swiftly that people are able to recover their stolen objects.

Teenagers who are arrested and charged with theft must await the arrival of a travelling judge, thus their case often takes months to resolve. There seems to be little fear of punishment as young thieves are typically placed on probation and may also enjoy the attention they receive. However, repeat offenders are sent out of the valley for various lengths of time to various juvenile detention centres. Because of this, I found that Nuxalk community members were loath to inform on Nuxalk youth, fearing the loss of teenagers to the non-Native judicial system – a situation that I imagine is eerily similar to the loss of three generations of Nuxalk children to the residential school system described in Chapters 2 and 4. Thus, as the Nuxalk are well aware, the structure of the judicial system ensures that reporting theft within the community will only bring about *more* theft, and this of an even less desirable nature: the dislocation and banishment of Nuxalk children by non-Native authorities.

A number of adult members of the community viewed teenage theft as a result of a lack of respect for the belongings of others. For example, one Nuxalk artist worried that someone would steal his carving tools from his studio. In one discussion with me he equated teen theft of property with a lack of respect for how hard one must work to earn things in life. This artist believed that young artists, who are beginning to succeed at selling their artwork, need to be taught the value of tools as well as the laborious process of how to reinvest one's earnings in order to build up equity. As an artist, he carefully funnelled the profits he earns from his art back into buying tools and materials, which further augmented his skill. A cycle involving reinvesting in one's labour and gradually increasing one's understanding of one's art derives both from one's culture and from one's tools (as well as from maturity and professional success).

This idea of a building up of emotional and material equity through a cycle of hard work and ownership of things both tangible (such as tools) and intangible (such as culture, artistic skill, and spiritual understanding) relates interestingly to the words of another informant, a middle-aged Nuxalk

woman. She explained that young people who do not recognize family ownership of traditional dances have no respect for their culture or for those around them. If a child owns her/his own blanket, then s/he respects it, but this would not be the case if s/he were just wearing someone else's.[4] For these adults and others in the community, the escalation of thefts by youth signals a lack of respect for self, culture, and others.

The Circulation of Capital: Adult Fundraising and Theft

Overall, the continual circulation of money in Bella Coola is central to how life there is experienced. At any given time most people in Bella Coola are poor, but individual groups possess thousands of dollars gleaned from fundraising. This may be the result of a pre-European contact system in which material resources were redistributed to members of the community as needs arose in exchange for the public recognition of chiefly ownership – a system that functioned exceedingly well within a non-literate culture. Or, as Carol Stack suggests in her seminal work *All Our Kin* (1974), the constant circulation and sharing of goods and cash through the community may have arisen as a social safety net, the result of an inadequate amount of resources stretched to meet the needs of too many people.[5]

How often cash is in fact raised in Bella Coola never ceased to amaze me. On any given day, multiple fundraisers occur simultaneously, and large amounts of cash are accumulated. Bake sales, garage sales, soup and sandwich events, and fifty-fifty split tickets are common in Bella Coola. The latter involve the winner splitting the profit with the fundraiser. The daily bingo game is sponsored by a different fundraising group each night and provides an opportunity for yet another group to sell snacks. Fundraising benefits are held for: families needing money to travel to Vancouver to be with loved ones who are in hospital; basketball teams desiring new uniforms or money to travel to Native conferences in Bella Bella or Prince Rupert; political groups wanting to raise awareness about logging practices or environmentalism; church societies needing to acquire a new building; and student groups planning trips to Disneyland or Native youth conferences. One can even fundraise for oneself by selling cookies or bread door-to-door for pocket money.

It is an ongoing joke in Bella Coola that certain Nuxalk are "bad with money" and should not be left too long holding cash belonging to a fundraising group. Such individuals may even alert others to this fact by calling them up and saying, laughingly, "Come over and take this money, because you know I'm not good with numbers!" Bingo is often mentioned as a way of making or losing money. Money seems to burn a hole in many people's pockets. This kind of talk, although light-hearted, dovetails with the recurrent problem of theft. Teenagers are not the only thieves in Bella Coola. There are adults who, suffering from alcohol addiction, gambling

debts, or general poverty, steal as a way to survive. Keeping money with its rightful owner(s) is no easy task in a community where so few inhabitants use a bank account regularly and where almost nobody has an automated banking machine card or a credit card.[6] When transactions are all in cash, and cash is in short supply, some of that money is bound to "go missing."

Responses to Theft within Bella Coola

In the case of internal theft, the person whose property is taken rarely points to a thief but, rather, proclaims that something has been stolen. One common way of expressing this is to say that an object "grew legs." This allows the victim to leave the robber out of the conversation and to place the focus firmly on her/himself. By refraining from directly naming and confronting a suspected thief, the victim can vent feelings of indignation and elicit the sympathy of others while, at the same time, avoiding the dangers of gossip and factionalism in a small community where everyone knows everyone else.

Often a passive statement such as "my [object stolen] grew legs" was accompanied by the observation that: "somebody must have really liked my [blanket, regalia, tools, carving, etc.]," implying that the thief could not help but steal such an evocative, tempting (or theft-worthy!) object. This was frequently followed by an expression of hope that the object would find its way back to its original owner. In addition to "growing legs," other expressions are used to suggest that objects "leave home" of their own accord. For example, one Nuxalk artist, a painter, once remarked that, while he did not mind giving his artwork away to his adopted mother, he did not like it to be taken from her. "It has a way of leaving the house," he commented.

In other instances objects were returned to their owners; for example, the *Acwsalcta* art teacher's "lost" ceremonial dance apron and blanket "came back to him." When he attended the First Salmon Ceremony at the Bella Coola River in May 1997 he saw a young man wearing his apron. He approached the youth and told him he could keep the apron if he told him where the blanket was. A few days later the youth arrived at the art teacher's door and handed him a bundle that, as expected, contained both the blanket and the apron. Pleased at the return of his "lost" possessions, the art teacher did not pursue the incident further.

In another case, the mask, dance, and song teacher told me of an old silver bracelet that had apparently been stolen from her. She went into town expressly to find it and saw what she believed was her bracelet on another woman's wrist. To keep from being accused of theft, the latter had "told stories" surrounding its origin. Given the situation, the cultural teacher did not accuse the woman of taking her bracelet but explained that if she was supposed to have the bracelet back it would manage to find its way home to her. And she continued to pray for its return.

I was surprised by the Nuxalk acceptance of petty theft as part of daily life. I never heard of a parent who punished a child for stealing or of an adult chastised for losing money that had been fundraised. This fits with Nuxalk traditional assumptions that someone who does ill by another will eventually get their just rewards (McIlwraith 1992, 1:698). There also seemed to be a general air of unconcern, probably stemming more from a feeling of joint culpability than from frustration at the inability to stop theft. From a Nuxalk perspective we were all part of the system in Bella Coola that produced theft. Victims should not invite thieves to steal by improperly leaving possessions unprotected. Even though this attitude was more tacitly understood than verbally expressed, the general feeling of culpability allowed guilt to be shared.

Although the examples of theft I have so far presented depict this act in a negative light, there is another perspective. As a number of informants pointed out, stealing can be a form of praise. For example, one Nuxalk artist interpreted the theft of one of his paintings from his cousin's car as a compliment and viewed it as a legitimization of his status as a painter. Similarly, in an example of symbolic theft, another Nuxalk artist often related stories about how others had been inspired by his work to copy his designs. Where some artists, Native or non-Native, might perceive this to be a violation of unwritten copyright, this artist explained that being copied from is also a form of flattery. He didn't worry, he said, because he doubted that anyone could copy his style exactly. These anecdotes highlight the fact that, while some Nuxalk see theft as something negative, others do not.

External Theft: Nuxalk Accusations of Cultural Appropriation

In contrast to internal theft, external theft brings about direct accusations of cultural appropriation. Without doubt this is a result of over 100 years of Nuxalk losing cultural and material objects, land, autonomy, and children to the non-Native world. While internal accusations of theft are dealt with in a Nuxalk manner, external accusations of theft are dealt with through both the Canadian court system and Western museum logic, as is evident in the case of the Nuxalk Echo mask. It is understandable that the Nuxalk would use Western systems in order to gain retribution for theft by non-Native outsiders. However, this strategy implies far more than mere compliance with an external methodology. The Nuxalk could turn to the local, Bella Coola-based RCMP to trace theft by outsiders, but they rarely do so; instead, they make their arguments in the larger provincial, federal, and even international arenas. I believe that the data show that accusations of theft on a national and international scale constitute a strategy that returns far more to the Nuxalk than the objects stolen. Much more than money is at stake when accusations of cultural appropriation are made; money, after all, is replaceable and can always be earned, raised, or borrowed.

From the perspective of many Nuxalk, powerful feelings of having been exploited by outsiders – who take, borrow, copy, and sometimes buy without permission – converge and give rise to accusations of expropriation. But the situation is complex. Permission to buy, view, copy, take, or use Nuxalk objects may be given to outsiders by *some* Nuxalk and denied to them by others, thus creating an often vexing situation for everyone involved. I argue that prevalent accusations of appropriation are not made solely with the aim of gaining recognition for an individual's victimhood; rather, they are active claims for recognition of what the Nuxalk struggle constantly to possess – a contemporary Nuxalk national identity. What on the surface may seem to be simply a desire for the return of what has been stolen is, in reality, an opportunity for the Nuxalk to emphasize the value of their national identity through their cultural property.[7]

I have already given examples of Nuxalk accusations of cultural appropriation. Given the historical context of external theft detailed in Chapter 2, it is not surprising that the Nuxalk continue to be cautious with regard to their dealings with non-Nuxalk. In Chapter 3 a hereditary chief argued that selling art is akin to "cultural prostitution." In his view, when one sells art or stories, or when outsiders copy them, something is lost to the Nuxalk Nation. However, he also saw Nuxalk culture as inalienable: as a renewable, essential entity that bubbles forth from the Nuxalk themselves. When viewed in this way the fear of loss is lessened. What the anthropologist comes away with is a strong sense of ambiguity: the Nuxalk are thought to possess a "culture" that, on the one hand, can never be lost, yet, on the other, is vulnerable to theft should outsiders learn of its existence. In Chapter 5 ambiguity was also evident in the words of the band councillor, who validated nineteenth-century museum collecting for its role in preserving Nuxalk culture and, at the same time, labelled it as "stealing."

Here I want to turn to another example of an accusation of appropriation in Bella Coola. This involves the display of the Nuxalk flag by non-Native environmental groups. While working to defend traditional Nuxalk land from clear-cut logging on the part of International Forest Products (Interfor), the House of *Smayusta* (the seat of hereditary chiefly leadership) joined forces with the Forest Action Network (FAN) and Greenpeace. The House of *Smayusta*, originally created as a cultural centre, believes that it is its responsibility to protect Nuxalk lands, although some in Bella Coola do not appreciate its political activities. In spite of this opposition, the House of *Smayusta* invited FAN and Greenpeace to work with it to protect what these environmental groups dubbed the Great Bear Rainforest. Specifically, they were acting to protect an area sacred to the Nuxalk in the South Bentinck Arm portion of their traditional territory, known as the Talyu Hot Springs. With this in mind, in 1994 the House of *Smayusta* granted these groups the right to display the Nuxalk Nation's flag.

The flag had been designed and inaugurated as the Nuxalk Nation's official emblem during the 1989 *Acwsalcta* play potlatch, where the head hereditary chief proclaimed: "Since we have our own ways, culture, songs, and dances, we have to have our own flag, our own identity. It is only right" (Schooner 1989, 13). This flag bears the Sun crest because it is believed that "the One who gave birth to the *Nuxalkmc* was from the sun" (ibid.).

Granting permission for environmental groups to fly the flag was strenuously contested in both printed and verbal form by the elected band chief and council and many other Nuxalk (Pootlass 1997). Some felt that the environmental groups, being outsiders, had their own agendas, which differed from local ones. Others, whose family members were loggers, felt that their livelihood was being threatened. The elected band council took the position that it was not necessary to work with outside environmental groups to protect Nuxalk lands, which, it insisted, was its responsibility. The elected band chief stated: "We will speak for the environment and do not want outside groups doing it for us or attempting to represent what they believe to be our interests. The protesters are not welcome in our territory" (Feinburg 1997, 8). The environmentalists were accused of appropriating Nuxalk symbols for their own purposes. This concerned some Nuxalk to such an extent that a protocol agreement was signed between the Oweekeno of Rivers Inlet, the Kitasoo of Klemtu, the Gwa'Sala-'Nakwaxdaxw of Port Hardy, and the Nuxalk on 4 July 1997, stating that "any special interest environment group cannot use crests, totems, dances, songs, or other symbols of First Nations culture for the purposes of representing First Nations support of their cause without the expressed consent of the respective First Nation" (*Coast Mountain News* 1997, 3).

Art Market Fears and Ambivalence towards Tourism

Today tourism and the sale of Nuxalk art are central points of contact involving the exchange (or sharing) of cultural objects between the Nuxalk Nation and outsiders. There is much disagreement within the Nuxalk community regarding how these exchanges should be interpreted and mediated. Some Nuxalk fear that bringing tourists to Bella Coola will diminish cultural revival since tourists have the monetary means to purchase Nuxalk objects and remove them from the valley; others see the marketing of their culture to tourists as providing publicity as well as economic opportunity for the Nuxalk Nation. Thus, for some, selling, sharing, or displaying constitutes loss, while for others it does not.

When Nuxalk artists sell their work they not only think about the immediate profit of the sale, they also think about whether the buyer will resell their work for a significantly higher amount. Thus, Nuxalk artists experience high levels of anxiety over intermediaries (art dealers, gallery owners) and the amount of money they could potentially lose through their busi-

ness dealings with them. One Nuxalk artist I know seemed to be happier selling his paintings for $100 each to Nuxalk or tourists in Bella Coola rather than to risk exploitation at the hands of a non-Native art dealer who promised to pay him $500 per painting. The artist was concerned that he might be "cheated" by the art broker, whom he feared would sell his paintings in Vancouver for $1,000 to $1,500 each.

From a Western art market perspective, a mark-up of 100 to 200 percent is not viewed as exploitation and is, in fact, common practice. Galleries that sell Northwest Coast contemporary art in Vancouver and Victoria typically buy artwork outright from Native artists,[8] with the result that only the art gallery carries the risk that a piece will not sell. This is a different arrangement than is standard for non-Native artists who consign their work to art galleries. In the latter scenario, if the piece sells, the profit is split fifty/fifty.[9]

As dealers and gallery owners explain, they are the ones who must bear the expense of living in urban Vancouver, which is far more costly than living in rural Bella Coola, along with the obvious overhead costs of running a gallery (which includes, of course, their own time and labour). Plus there is the fact that dealers and gallery owners have something else of value to sell to artists: a much wider access to customers, especially those with money, than rural artists could ever hope to have. Viewed from their perspective the mark-up seems reasonable rather than exploitative. Nonetheless, Nuxalk fear and hostility is also reasonable, given the outside world's very real historical exploitation of the Nuxalk Nation as well as the present-day power imbalance between non-Native art dealers and Nuxalk artists, who lack the experience, education, and cultural capital of the former. Add to this the fact that, if a Nuxalk artist were cheated, he or she would not likely be able to afford expensive urban lawyers or the expenses of travelling to Vancouver to have her/his day in court.

This fear of theft in relation to contact with Western art dealers is not unfounded, as the Harrington Art Gallery case attests. As noted briefly in Chapter 1, in May 1994 the Harrington Art Gallery in Vancouver held an exhibition and sale of Nuxalk art entitled Valley of Thunder: Art of the Nuxalk Nation from Bella Coola, BC. Unfortunately, after selling two pieces of artwork the gallery's finances collapsed and it declared bankruptcy. Rather than remunerating the artists, the gallery's owner used the money generated from the sales to pay creditors, reinforcing the idea that involvement with outsiders results in theft and exploitation.

A long history of exploitation and a dearth of money for legal fees are not the only factors that discourage the Nuxalk from dealing with the non-Native art world. As the Nuxalk students' visit to New York shows, there is also the serious matter of cultural mistranslation with regard to the interactions between rural Nuxalk and non-Native, urban institutions. From the perspective of art dealers and gallery operators, art is a business and is

associated with specific Western conventions including: keeping to dead-
lines, delivering works of art at regular intervals, maintaining an agreed-
upon art style, and possessing the subtle elements of Bourdieu's cultural
capital (e.g., exhibiting "correct" [i.e., non-Native] forms of speech, physical
carriage, cultural knowledge, style of dress, etc.). When Nuxalk artists fail to
adhere to deadlines, fail to produce art on a consistent, predictable sched-
ule, and present themselves in ways that make interacting with them un-
comfortable for non-Native people, urban art dealers experience frustration
and anger and may choose not to sell their work.

From a Nuxalk perspective, urban, non-Native modes of self-presentation,
as well as non-Native attitudes towards money, making profit, keeping ap-
pointments, and meeting deadlines – in short, non-Native notions of "pro-
fessionalism" – seem equally rash and confusing. In Bella Coola life is
slow-paced.[10] There is the expectation that people will come and go when it
is convenient for them to do so and as events arise. This relaxed, flexible
approach to life is widely shared in the valley, and, over time has become
the only way of being that makes sense to the inhabitants. In addition, it
tends to make life pleasant; at the very least, the relaxed atmosphere causes
few problems in a small town where many people do not have nine-to-five
jobs and where everyone knows that, if the person you had an appoint-
ment to speak with on Tuesday does not show up, then s/he will be easy
enough to track down (or will certainly turn up by Wednesday or Thurs-
day). Many of the artists with whom I spoke indicated that their art, not the
profits that might be gained from its sale, is their central concern. Whereas
the driving force behind the Western art market is a quest for profit. And
this can be disturbing for both Native and non-Native artists alike.

Not everyone in Bella Coola eschews selling their art to outsiders. One
Nuxalk carver is sometimes criticized for selling his art out of the valley to
non-Native people. Although he is Nuxalk, at times he is accused of stealing
Nuxalk culture by selling his art to outsiders, which many consider a form
of betrayal. Consequently, he must weigh these accusations against his need
for money to feed and take care of his family, and also against his convic-
tion that the selling of Nuxalk-style art to outsiders is a good thing – some-
thing that empowers the community by validating the Nuxalk Nation as a
whole. Like those of his accusers, the feelings of this artist regarding Nuxalk
art and culture run deep. He explained that, first and foremost, he must
know what the art means to him as a Nuxalk. Towards this end he strives to
understand what he is taking from his community in order to know how to
give back to it – a perspective I explore in greater depth in the last chapter.
As he told me, "If you know where you have been, you can see clearly
where you are going."

The issue of the Nuxalk Nation's cultural insularity and ambivalence re-
garding contact with outsiders also arises in relation to tourism. During a

discussion on the subject, one Nuxalk woman, a teacher's aid at *Acwsalcta*, stressed that Nuxalk youth need to interact more with the outside world in order to gain knowledge of life beyond the valley. She viewed this inter- action practically, seeing it as a way for youth to gain access to better jobs both within the valley and beyond it through gaining a wider knowledge of the world. At the same time, she spoke of a need to intensify young people's knowledge of Nuxalk culture and Nuxalk past by returning lost cultural objects to the valley and building a museum in Bella Coola to house them. And she hoped tourists would follow the objects to the valley.

In opposition to the general perception in anthropological literature that tourism is to be distrusted because of its potential to dilute indigenous cul- ture by removing it (Errington 1998; MacCannell 1992; Root 1996; Smith 1989), this woman argued that, assuming the objects' return and an inten- sification of cultural revival among the Nuxalk, Bella Coola should open itself up to *more* tourism. Her reasoning for increased contact was twofold: on the one hand, for Nuxalk youth to be successful they need access to tourists, who would bring them increased exposure to the outside world; on the other hand, the learning process is mutual. In an odd reversal of value that seems to occur in Bella Coola (and elsewhere), she told me that the Nuxalk don't always appreciate what they *do* have. Only after outsiders come to Bella Coola to learn about and appreciate Nuxalk culture do the Nuxalk see their wealth clearly. In her view, outside admiration and interest allows for the success of Nuxalk cultural revival. She argued that the key to ensuring the creation of a strong Native identity does not involve the Nuxalk refusing or limiting outside contact but the reverse. This woman's views were echoed by another Nuxalk woman, who told me: "Tourists visit Bella Coola and see all the beauty in the valley. They see a place surrounded by breathtaking snow-capped mountains, cedar trees with branches that serve as footing and nests for bald eagles, and the Bella Coola River rich in salmon. In this way, outsiders see the wealth that local people take for granted." She concluded that "it takes outsiders to see wealth," implying that, through the fresh vision and open reception of tourists, the Nuxalk might better be able to value what they have.

Conclusion: "It Takes Outsiders to See Wealth"

This kind of thinking allows us to view art buyers and Nuxalk participation in the Western art market as aiding the Nuxalk in the construction of their own identity. Similarly, when a Nuxalk woman tells me that many outsid- ers have wanted to buy her old bracelet but that she would never sell it, she is demonstrating a secure sense of self through her refusal to do as others wish, while at the same time being assured by outsiders of the value of the object she possesses. Thus, what exists is a two-way process of identity con- struction. In short, if outsiders want Nuxalk culture, then Nuxalk culture is

worth having and holding onto. Conversely, this Nuxalk woman might not have valued her old bracelet so much if others had not wanted it too. This is not to say that other Nuxalk coveting and appreciating the bracelet does not give it value, but certainly the bracelet and, by extension, Nuxalk culture gain when non-Nuxalk covet it as well.

This example leads to the point with which I began this chapter: the First Nations of British Columbia gain from claiming to be victims, not just tangibly in the form of treaty remuneration for the theft of land, sovereignty, and dignity, but intangibly in the form of recognition. Interestingly, the Nuxalk have always known this, for potlatches have always flirted with the idea of revealing and keeping secrets. In the traditional potlatch ceremony objects are presented to the community for recognition and validation, which serves to increase their value. At the same time, the fact that some knowledge is kept hidden serves to highlight its value as something to which only certain individuals may be privy. The Nuxalk continue this strategy today in new ways, notably by claiming the external appropriation of knowledge and objects that should have been kept secret or have remained in the valley.

Weiner (1992) writes of inalienable objects, objects that cannot be given away completely but that must be traded in order to gain value. The Nuxalk too are caught in the paradox of having inalienable possessions that gain value through transaction. Proof of the value of Nuxalk culture is found in the fact that others not only covet Nuxalk art, song, dance, and stories but that they also buy or steal them and take them away. I believe that this adds value to Nuxalk culture and enhances the strength of Nuxalk national identity. It is this play of alienability and inalienability, of walking this treacherous line of keeping while giving, gaining while being stolen from, that strengthens the contemporary Nuxalk sense of self. Interestingly, this dovetails with Weiner's argument that social life requires the outward appearance of ṣtasis in order to obscure the fact that life is characterized by constant change, which leads ultimately to death (which is feared). Thus, material objects gain value because they are powerful symbols of permanence. This is because they cannot die, because they live on even with the passing of many generations of owners (Weiner 1992, 8).

I wish to conclude this chapter by focusing on the bright side of art, cultural revival, and life in Bella Coola. Although I listened to Nuxalk concerns about the theft of Nuxalk culture, property, and identity, I also heard a softer voice. This voice came from many Nuxalk and said, "Letting out brings return." As one informant told me, recalling the advice of his elders: "Give away your last dollar and it will return double." This is the flip side of another sentiment I often heard expressed in Bella Coola: "If you take, you must re-establish the balance by giving back." This voice suggests that, if you give, then you will receive. In other words, to truly have, one must let go – a theme I develop in my concluding chapter.

7
Conclusions: Articulating Nuxalk National Identity

I use the metaphor of switchbacks in order to avoid the thoroughly problematic language of hybridity, which "becomes a condition which serves to reinforce the notion of a static and unequal set of power relations where one (marginalized) group reacts to the culture of another group in political dominance" (Brah and Coombes 2000, 12). I have two reasons for choosing this metaphor in order to reflect upon the contemporary situation of Nuxalk identity production. First, the idea of switchbacks alludes to travel, acknowledging that people and cultural groups are always moving, both diachronically through history and synchronically through space, as they wind back and forth across culturally divergent ways of being. Clifford (2001) in searching for a more nuanced and non-reductive vocabulary with which to elucidate contemporary indigenousness, offers the idea of "indigenous commuting" – a dialectic that attempts to encompass both "dwelling and travel" or "roots and routes." He evokes an "indigenous cosmopolitanism" that maintains a sense of belonging to one's home. He asks: "How should differently positioned authorities (academic and nonacademic, Native and non-Native) represent a living tradition's combined and uneven processes of continuity, rupture, transformation, and revival?" (480). Using Stuart Hall's articulation theory, Clifford suggests that indigenous peoples choose particular elements of their past and present in order to build their future. This concept of articulation "evokes a deeper sense of the 'political' – productive processes of consensus, exclusion, alliance, and antagonism" (473). The "switchbacks" metaphor tries to convey this idea of indigenous identity's being produced in the present through real-life choices, or "articulations," decided during "commuting" back and forth across difficult territory rife with "historically imposed constraints" (478).

My second reason for selecting switchbacks as a metaphor involves the terrain of the Bella Coola Valley itself, with its steep and treacherous slope (known as "the hill"), which one must travel in order to get there. During my fieldwork it occurred to me that physically traversing the precarious

zigzags along the mountainside offered an apt metaphor for how Nuxalk national identity construction is currently being navigated through art and cultural revival. As I argue throughout, identity and its material embodiment, the production and possession of objects, are not created on only one side of a boundary between "us" and "them"; rather, identity and ownership are constantly being fashioned and valued via the recognition on the part of outsiders that Nuxalk heritage is worth having and owning. As many Nuxalk told me with regard to the physical beauty of their valley as well as with regard to their culture and art: "It takes outsiders to see our wealth." Thus, I argue that identity creation, particularly surrounding the act of Native cultural revival, does not occur in a vacuum; rather, it occurs in a process that involves a "switchback" relationship between First Nations people and the world outside their local communities.

In a similar vein, Crosby has argued that Native identity is forged in a crucible of interaction with outside others, who make contradictory demands upon Native people. She asserts that First Nations people have found it so difficult to voice their identity because the available terminology has, in fact, silenced them:

> Clearly, there has been little room in this *legal* "narration of nation" for positioning aboriginal nationhood as Homi Bhabha describes, "in *media res* [with] history ... half-made because it is in the process of being made; and the image of cultural authority ... ambivalent because it is caught, uncertainly, in the act of composing its powerful image" (Bhabha 1990, 3). Obviously Aboriginal and Canadian governments have different political agendas and goals. Yet the interests of opposing political groups, in this context, share what is recognizable in the production of a fixed hybrid form (seamless linear histories leading to intact traditional institutions), whose "ambivalence" is found in the gap between its referents in Native societies in fact and within the abstract discourse of "authenticity" in Western historicizing. (Crosby 1997, 26)

Crosby observes that both Native and non-Native groups have adopted the readily recognizable fiction that Native identities are essential and fixed, defined as "traditional," unchanged forms that replicate some "authentic" past. Native peoples accept this fiction in order to empower themselves vis-à-vis non-Native society, while the latter accepts it as part and parcel of a continuing historical stance of condescension. Underlying Crosby and Bhabha's words is a critique of the acceptance of static identity itself.

Crosby proceeds to articulate two binary Native ways of being that have been established and imposed, albeit unconsciously, by the non-Native world. On the one hand, Native peoples can opt for an identity that attempts to resurrect what are deemed to be historically accurate, or "authentic,"

cultural forms. Should this path be chosen, cultural revivalists are expected to tangibly embody the lifestyles, thoughts, and behaviours of "traditional Indians" of the North American past. This path, however, is not only undesirable; it is impossible to follow because all Native people live within contemporary, non-Native-dominated societies that are vastly different from the worlds inhabited by their ancestors. Yet many believe that, in order to be heard and recognized by the non-Native mainstream, they must adopt this "traditional Indian" stance. On the other side of the equation, should Native people eschew the mantle of the easily recognizable "authentic Indian" and choose to live and give voice to a Native identity consonant with life in the contemporary social milieu, they then run the danger of *not* being heard – or worse, of becoming invisible, of being decried as not really Native. Given these opposing, impossible options, First Nations peoples manoeuvre between the two as they adopt the stance of the "traditional" Native in certain circumstances and the stance of the "non-traditional" in others. (Crosby 1997). I label this strategy "self-objectification" and examine it as potentially advantageous for Nuxalk identity politics (see Chapter 3).

Overall, Crosby's argument runs parallel to my own claim that the back and forth movement involved in Native identity creation implies that Native identity itself cannot be understood in static, essentialized terms. Past anthropologists viewed Native cultures as "things" that were precise and contained, able to be captured, catalogued, and placed in a museum case (Fabian 1983; Kuper 1999). In opposition to this view, I argue that Native culture and identity is a fluid dance, constantly being debated by First Nations people who, perhaps ironically, make use of the image of the essentialized "Native" of anthropologists' tales – but only in part, and only to the extent that it serves ends that they themselves choose.

Rosemary Coombe, anthropologist and legal scholar, also underscores this tension between the oppositional identities that have been foisted upon Native peoples. Coombe argues for switching back and forth between tactics and cultural tropes. This movement constitutes identity creation, and it does not assume the existence of a static, reified Native identity. Focusing on the Canadian legal system and Native claims of ownership of land and material culture, she writes: "First Nations peoples may well be compelled to articulate their claims 'in a language that power understands,' but in the *substance* of their claims they contest the logic of possessive individualism, even as they give voice to its metaphors. Engaging in 'double-voiced rhetoric,' they appropriate and subvert these metaphors through the character of the claims they make" (Coombe 1997, 91). Coombe suggests that, even though Native ownership claims cannot be seamlessly inserted into systems of Western legal logic, Native peoples use these terminologies in order to be heard by the non-Native world (see also Berman 1997; Pask 1993; and Spencer 2001 regarding how First Nations ownership issues are at variance

with Western law). Coombe, borrowing from Macpherson (1962), describes this Western system as "possessive individualism," which finds expression in such things as copyright and cultural property law. Her use of the term "double-voiced rhetoric" suggests, as I have, that Native strategies for dealing with the non-Native world involve oscillating between opposing cultures and systems.

Figurative repatriation is one tactic available to First Nations, enabling them to refuse Western terminology that doesn't fit with Native ideas, such as that of inalienable cultural property. This is admirably performed by the Nuxalk Sun mask (see Chapter 5). Yet figurative repatriation can only be accomplished on foreign terrain – that of the museum or other transcultural, public spaces of display. This strategic act requires the presence of non-Native audiences to ensure that messages of Native control and ownership can be heard, seen, and witnessed by non-Native people. Thus, refutation of non-Native claims to ownership of Native cultural objects is found in interactive spaces that are sites for the creation of empowering social relations.

I contend that it is through this movement between two different lines of rhetoric that contemporary Nuxalk identity is created and sustained. In other words, identity creation can be viewed metaphorically as a process involving switchbacks and the interrelationship between insiders and outsiders, between the proverbial "us" and "them."[1]

Switchbacks and Nuxalk Cultural Expression

The oscillating action of switchbacks lies at the very heart of the events and emotions experienced both by myself in the field and by the inhabitants of Bella Coola as they negotiate the complexities of life in the postcolonial age. In this section, I highlight a number of switchbacks that involve processes that ultimately result in identity creation. Identity involves a sense of being and knowing one's place in the world, and it derives from a multiplicity of actions, interactions, and material signifiers. In this book I have chosen to focus on the production, display, possession and loss of art forms and art objects (e.g., masks, music, dance, jewellery, carvings) that are central to identity construction in Bella Coola and, hence, to First Nations cultural revival, because they are perceived as the tangible building blocks of this process. Just as identity emerges from the back and forth motion of the switchback metaphor, so too do art education, sale, production, display, valuation, and the like.

I have addressed a number of core issues surrounding Nuxalk art, beginning with the question of whether Nuxalk identity is better served by the sale of art within the Bella Coola Valley to other Nuxalk or outside the valley to non-Native people. As noted in Chapters 3, 5, and 6, there is no simple answer to this question. Opinions differ among individuals and fac-

tions within the community, ultimately giving rise to yet another example of the switchback metaphor.

Other core issues illustrating the trope of switchbacks in relation to art appear in Chapters 1, 3, and 5. In Chapter 3 I raise the problem that Nuxalk artists face when they are caught between accepting formalized, academic rules for the "authentic" production of "traditional" Northwest Coast and Nuxalk national art, on the one hand, and choosing a contemporary style on the other. Many Native artists have found themselves shunted into accepting artistic models designed by museum curators, art historians, or anthropologists. If they refuse to follow the "traditions" as recorded by non-Native academics, then they are labelled "inauthentic" and no longer deserving of the appellation "Native artist." On the other hand, if they slavishly follow the dictates of scholarship regarding what defines "authentic" Northwest Coast art, then they become vulnerable to accusations of being mere copyists (Graburn 1993).

As noted in Chapter 1, Northwest Coast art has historically been presented as fitting a bell curve, which maps the birth, apex, and nadir of its narrowly defined style. Art collected at the turn of the twentieth century has been held up as "classic" Northwest Coast art, rarely superseded by artists of today. This bell curve subsequently forces contemporary Native artists onto its downward slope. Should they deviate from rules of authenticity, then the art they produce becomes further invalidated. There are no parallel rules of cultural style for contemporary, non-Native artists who are vested with the right to create art in a style of their own choosing. Ultimately, this scenario forces Nuxalk artists into following the switchback model as they swing back and forth between both sides of this no-win situation (i.e., between following the "authentic" Northwest Coast/Nuxalk style and claiming an individual style). While limiting, this switchback strategy nonetheless allows them to chart a course forward through essentialist discourse and stagnating definitions.

Another central issue involves cultural education at *Acwsalcta* and the dilemma facing Nuxalk cultural teachers regarding how best to teach Nuxalk art and culture. Chapter 4 explains the anxiety of teachers and administrators. The main points of tension to emerge concerned conflicting methods of education (e.g., Western versus Nuxalk systems of ownership, the use of oral versus the use of written materials). Again, no resolution has been achieved, and teachers are left to struggle with their desire to pass on Nuxalk culture in a historically accurate way while recognizing that students would be denied access to that same culture if forced to rely solely on oral methods of learning. Also, it became clear that, should the *Acwsalcta* staff decide to respect the Nuxalk custom of private ownership of cultural material, then in many cases the very material that they wish to teach has to be kept from students.

In Chapter 6 I investigate the murky space between selling and stealing Nuxalk cultural productions, and I discuss how the Nuxalk have traditionally perceived commercialization and commodification as negative actions involving victims and victors. However, rather than assuming that cultural appropriation is theft, pure and simple, with no beneficial consequences, I posit that it can be viewed as part of the activity of cultural revival and that it can be seen as strengthening Native voices. The experience of cultural appropriation helps to enhance Native recognition of their own culture. Nicholas Thomas (1999, 141) expresses this well: "If appropriations do have a general character, it is surely that of unstable duality. In some proportion, they always combine taking and acknowledgment, appropriation and homage, a critique of colonial exclusions, and collusion in imbalanced exchange." He continues: "The heat of the debate arises from the fact that what is laudable interest in indigenous art from one point of view is unsanctioned borrowing, an act of theft, from another. Appreciation and appropriation have been intimately connected and are essentially double-sided processes. By definition, their values are unstable" (158).

A central tenet of this book is that the act of theft can be interpreted as a serpentine process that fits the switchback trope. In the same way that a Nuxalk artist can view imitation of his or her style as a compliment, accusations of cultural appropriation can be heard as something more than claims of theft. Such accusations, so often voiced by the Nuxalk and other indigenous peoples, can be seen as an assertion of the desire to be recognized as owning valuable cultural patrimony. Thus, rather than solely assuming their stance as victim, these accusations also affirm their right to be recognized as owners of contemporary identity.

Similarly, in Chapter 5 I show that selling the Echo mask out of the Bella Coola Valley ultimately added value and prestige to the mask and, by extension, to the Nuxalk Nation as a whole. Indeed, the dialectic journey of the Echo mask, as it made its way from devalued to revalued art object, can also be seen as a switchback. The Sun mask's transformation from Nuxalk ceremonial regalia to museum masterpiece to proof of Nuxalk national identity similarly embodies this validation process. All of these examples return us to the powerful switchback metaphor, which expresses the complex experience of contemporary First Nations peoples as they strive to create viable Native identities.

Ascending the Mountain: Taking While Giving Back

Taking while giving back is another facet of life in the Bella Coola Valley. Indeed, as time went on, I discovered another side to Nuxalk fears about theft – the one that shares freely, that gives willingly. When I volunteered at *Acwsalcta* I was impressed by the fact that all the children told me about

giving their art projects away. The recipients were mostly parents or relatives, but they also included friends and teachers. I asked, reflecting my own possessive tendencies, whether it was difficult to give away that which one had made with one's own hands. The children unanimously answered, "No."

One high school girl explained the act of giving quite clearly: "It's like if you took a picture of yourself. Would you keep it and hang it on the wall? I wouldn't!" Her declaration was simple, yet it revealed much. It illuminated the meaning behind another act I often witnessed in Bella Coola: that of people giving photos of themselves to their friends, something which I had always thought strange. In my experience people give away photos *of their friends* as gifts, returning them to the person who was photographed. In Bella Coola, however, it was the opposite: one always gave away photos of oneself. What was the meaning of this, I wondered? I believe this student was trying to explain to me that it is a far more significant act to give away a piece of oneself than it is to give back a piece of a friend. It seems to me that one risks much by sharing a representation of oneself, which may, after all, be criticized or rejected. This high school student continued, "Isn't it far more powerful to give something away than to keep it?" As other Nuxalk told me, "Why would you keep a photo of something you already have [in this case, yourself!]?"

The young student explained more, this time in relation to creating art: "If I made a painting, I saw it all come together. It won't be so beautiful. But if you give it away, they [the receiver] won't know how it came together." With this she implied that the painting would seem more beautiful to those who did not know the process of its creation.[2] By extension, her words validate the perception that it is often through outside eyes that the Nuxalk are able to appreciate their own culture.

Through their actions, the high school boys in art class said much the same thing. Often they became frustrated with a painting and would tear it up or threaten to do so – an act the art teacher discouraged. However, if a painting made it to the final stages, then the boys knew that the mistakes they had made would not be noticed by outside buyers. When they had completed a painting, they often commented that it was "not too shabby" or "good enough," implying that their buyers would value the paintings. This attitude illustrates my claim that selling or giving artwork away has the potential to increase its worth. An outsider's guileless appreciation can add value to a piece of art. By "value" I do not refer solely to money but, rather, to something less tangible – to beauty recognized, culture admired, identity noted.

In June 1995 I witnessed a cultural exchange between Nuxalk youth and a group of young Native drummers from Ottawa who were known as the Spirit Singers. After music, dance, and food had been shared, a young hereditary

chief stood up to thank the visitors for the gift of their songs and the healing messages of cultural perpetuation that came from their presence and performance. Unexpectedly, he took off his ritual regalia – a black poncho-like shirt bearing his own personal crest in appliquéd red wool, which had been made expressly for him by a loving family member – and gave it to the leader of the visiting drumming group. The Nuxalk who watched this presentation gasped in astonishment and approbation. They recognized the power of his action for not only did it honour and display respect for their guests, but it also emphasized the strength and integrity of the giver. His confidence in who he was was reflected in this act of generosity: by giving away such a vital symbol of his Nuxalk identity, he highlighted the significance of Nuxalk culture and of all *Nuxalkmc*.

Weiner's work on inalienable possessions in the Trobriand Islands also elucidates this type of exchange. The giving away of material objects is not solely motivated by a search for instrumental (economic) power but also by the desire to possess a universally validated and recognized identity. This phenomenon is widespread at *Acwsalcta*. *Acwsalcta* students are clearly aware of the problems faced at the school (e.g., the lack of participation and general disorganization in play potlatches and other ceremonies, the difficulty students have remembering Nuxalk words to songs, uncoordinated or badly learned dance steps, and improperly drawn formlines), and it is often only after an external audience (whether Nuxalk or non-Nuxalk) has witnessed their artistic and cultural efforts that they are able to recognize the importance and value of what they have produced. The students' products (whether material object or performance) function in much the same way as do the inalienable possessions of the Trobriand Islanders for, although they may be given away or sold, they are not alienated from those who created them. Both the students and the Trobriand Islanders gain by viewing their creations through the gaze of others.

Another high school student spoke to me about the importance of passing on culture, explaining that cultural activities, like those at the school, must be continued. Further, he stressed that it is everyone's collective responsibility to do this: "It's like money; it goes through one pocket to another pocket." Provocatively, his money analogy demonstrated that he saw money not as something that should be retained but, rather, as something that should be shared. This student's opinion echoes the suggestion that commodification (i.e., the selling of cultural products) can be viewed as strengthening Nuxalk culture rather than as contributing to its breakdown.

This idea was also voiced by a Nuxalk artist who sees his art as a personal journey that is made more valuable by sharing it with others. Over and over again this man spoke to me of the need for balance in art and life. Whenever he partakes of the shared Nuxalk art tradition he gives back to his community (i.e., by carving dance masks for *Acwsalcta* or donating his time

teaching). This balancing act is required of both Nuxalk artists who sell their art and non-Native anthropologists who write about Nuxalk life. Balance. If you take, give back. A seemingly simple equation.

The Anthropologist's Place in Switchbacks

My time spent in Bella Coola prompted me to ask myself, "How can my writing not be perceived as an act of theft?" Many people in Bella Coola were concerned that I would take from them, ultimately profiting (e.g., by writing a book and/or gaining high-paid employment). In this way, I could be labelled a thief. However, returning to the message of the artist above, everyone takes, and it is each person's responsibility to give back. Balance. As time went on, I began to perceive my relationship with the Nuxalk in this light. I gradually began to accept and understand the Nuxalk view that one can and should keep while giving. In terms of my query about how I could give back, I began to see things from a Nuxalk perspective: my access to knowledge was made possible when I understood that the Nuxalk could keep while giving; that is, that they could share their knowledge with me (and hence risk a loss of control and power) and that, in exchange, they could eventually *retain* control of their identity through my validation of their ownership of Nuxalk culture.

As for my own role as thief/external validator, I can only recognize the ambiguous place of the ethnographer in contemporary Native society. In Bella Coola I was seen by some as someone who benignly appreciated, by others as someone who would potentially appropriate. I found myself, by virtue of being an outsider, a lightening rod for accusations of theft. On the other hand, I also conceived of myself as a conduit, as someone who focused interest on cultural revival and struggles of Native ownership. I realize, as do the people cited above, that I will never completely be either one or the other. My presence in Bella Coola as a researcher will always be an ambiguous one, and there is no single person there who can grant me the right to write about Bella Coola. In sum, the anthropologist's only way out of the double bind we create when we strive to represent others is to understand the switchback process – what Marilyn Strathern (1999, 130) cautiously labels "a constant inventiveness."[3] I, too, am entangled within this system of creating contemporary identity. I owe a debt to the Nuxalk for sharing with me their culture and trusting that my reception of it would entail respect rather than theft, that my writings would transmit some of their cultural capital and their concerns about how to convey their cultural patrimony.

Native peoples have claimed their right to be undefined, their right not to follow essentialist anthropological proscriptions in order to be authentic. Their right to be undefined, however, is also a right possessed by the ethnographer. Ownership is never constituted by the singular but, rather,

by people involved in historically contingent relationships within circumstances that are tactically and/or politically mobilized. Just as the Nuxalk use non-Native constructions of their traditions or Western legal categories to define themselves (self-objectification), ethnographers can make space to write about others who are not them.

The Power of the Nuxalk Nation

A scenario I witnessed many times during my stay in Bella Coola might clarify my point regarding ownership and multiplicity. In the house where I stayed while living in Bella Coola, I witnessed a daily ritual that I could not at first understand. The head of our household, a man in his fifties, would hold his two-year-old granddaughter while the girl's mother would point to her father and say, over and over again, "My dad." The baby girl would begin to cry, her assurance that she was the centre of her grandfather's attention shattered. The adults just laughed and repeated the action with the daughter hugging her father for emphasis. At first I thought it was cruel to taunt the little girl about the fact that her grandfather loved others as well as herself, but I learned to see it in a new light. They were teaching her that she did not have complete ownership of anything, not even her grandfather's love. They were also demonstrating to her that, although her grandfather might love others, there would always be space in his heart for her. This familial scene was repeated over and over, and I witnessed it with other grandchildren as well. It spoke to me of my own assumptions about ownership. Ownership, I began to understand, can never be complete. Ownership in Bella Coola is a complex claim, involving much more than the person or persons who assert it. It is a process of events involving witnesses and, as such, it is often fraught with contention and counterclaims.

Throughout my research I observed instances of ownership being stated and contested, and I began to realize that these are powerful declarations about identity. Identity is built from the joining of person and object, each of which shores up the other. Nuxalk identity is constantly created via the interchange between people over ownership of an object's title, not necessarily over its actual physical possession. As Strathern (1999, 18) writes: "Property as a relation has long been central to anthropological theorising ... Like art, property is a reification of a person's capacity to act." Just as ownership can never be total, so Nuxalk production of their own identity can never be total. Instead, they grasp opportunities where they can and move back and forth along a metaphorical hill, which moves both into and out of the Bella Coola Valley.

The following words aptly illustrate my concluding point. One Nuxalk man told me that few people realize the strength of his nation. The Nuxalk Nation, he explained, was known all over the world, primarily because its

art resided in foreign places such as Germany, New Zealand, New York, and Hawaii. He observed that it is because outsiders own Nuxalk art and recognize Nuxalk culture and nationhood that the Nuxalk are now powerful. Thus, that which has left the valley has returned something greater in its stead.

Notes

Prologue

1 *Coast Mountain News* is a bi-monthly publication local to the Bella Coola Valley. At times it has been called the *Coast Mountain Courier*, but since it did not consistently keep this name I refer to it as *Coast Mountain News* throughout.

2 Money was probably also an important factor. I was told by the art dealer that the elder sold the mask after her husband died and probably needed what, to the Nuxalk, would be a large sum of money. Although I wrestled with interviewing the elder who sold the mask, I decided her actions indicated that she no longer wanted to be implicated in this issue. I determined that the most ethical stance would be one that respected her privacy and her choice to have no further involvement with the mask. Therefore, I can only guess at her motivations. What I write is the product of the supposition of individuals who know her better than I do.

3 One Nuxalk person told me that another family claiming ownership of the Echo mask had commissioned a copy to be made by a non-Native Seattle-based artist named Lalooska, now deceased.

4 My knowledge of the movements of the Echo mask comes from piecing together documents, newspaper articles, and interviews with certain key players. I interviewed Phil Hobler, then chair of the archaeology department at Simon Fraser University, whose museum had been offered the chance to buy the mask in order to prevent its export from Canada. I also interviewed the expert examiner in the case, Alan Hoover (the then manager of the anthropology department of the Royal British Columbia Museum); David Walden, secretary to the Canadian Cultural Property Export Review Board; the art dealer, Howard Roloff, at his home in Victoria, British Columbia; and the then elected band chief of the Nuxalk Nation. In addition, I spoke with various relatives of the elder who sold the mask and other Nuxalk who had connections to the mask.

5 This means "thank you" in Nuxalk.

Chapter 1: Introduction

1 The term "First Nations" implies indigenousness and refers to the fact that the Nuxalk and other indigenous peoples possessed the land before European colonization. It is generally accepted as a properly respectful term by the Aboriginal peoples of Canada, who previously had been termed "Indian" or "Native." The noun form of the term "First Nation" also implies a sense of political identity equivalent to the sovereignty of nations such as Canada or the United States.

2 Button blankets are made to be worn on ceremonial occasions. Crest designs are depicted in appliquéd cloth, outlined buttons, sequins, or paint and identify the wearer's family and, thus, social identity. Contemporary button blankets come in many forms, from a traditionally designed wool blanket worn around the neck and shoulders to a vest or poncho-like garment. They can be adorned with ermine skins, deer hooves, or folded metal lids to

emphasize the movements of the wearer and to make an emphatic sound in order to gain attention.

3 This country is also filled with First Nations communities, some recognized as reserves, others not, but many do not appear on maps of the area. This perpetuates the idea that the Chilcotin is "empty," a "western frontier" in need of settlement, civilization, and resource extraction (Furniss 1999).

4 Since 1995 more and more of Highway 20 to Bella Coola (the Freedom Highway, as it is dubbed by locals) has been paved, making a significant difference in ease of travel.

5 Famed Anthropologist Franz Boas wrote upon his first trip into the Bella Coola Valley in a letter dated 21 July 1897: "Finally, about three miles from the Bella Coola River the valley narrowed into a gorge. We left it and rode along the northern side of the mountain until we arrived at the foot of the pass which leads into the Bella Coola Valley. There we made camp, about 4,000 feet high. In the evening it poured, and the wind blew so hard it threatened to blow our tents away. How happy I was when the sun shone again the next morning and the wind abated. In two hours we reached the summit of the pass. The trail went across snow-fields and meadows. We saw right before us the most beautiful mountain country. Deep in the valley was the Bella Coola River, and we rode slowly toward it along the side of the mountain. The view was gorgeous. There were steep mountaintops with huge glaciers, and in the valley a sea of clouds through which one could see the river. The landscape was magnificent ... Then came the descent, which was easy all the way. In four hours we descended about 5,000 feet and found ourselves in a completely different climate. It was warm and humid, and we were surrounded by the dense forests of the coast" (Rohner 1969, 214).

6 "Oolichan," or "eulachon," is the Chinook term for candlefish, a type of fish in the smelt family. In the Nuxalk language it is called *sputc*. Oolichan are prized by the Nuxalk because they are rich in oil (16 percent) and can be rendered into a luxury condiment eaten with dried berries, salmon, and potatoes or used as a valuable trade commodity.

7 Clifford (1991, 226) makes a parallel observation when he describes what "tribal institutions" and locally based artists must do when "they aspire to wider recognition, to a certain national or global participation. Thus a constant tactical movement is required: from margin to center and back again, in and out of dominant contexts, markets, patterns of success ... On the one hand, then, no purely local or oppositional stance is possible or desirable for minority institutions. On the other, majority status is resisted, undercut by local, traditional, community attachments and aspirations. The result is a complex, dialectical hybridity."

8 Linda Tuhiwai Smith (1999, 1), a Maori and academic researcher, succinctly and aptly describes the general indigenous response to being the subject of research: "The word itself, 'research,' is probably one of the dirtiest words in the indigenous world's vocabulary. When mentioned in many indigenous contexts, it stirs up silence, it conjures up bad memories, it raises a smile that is knowing and distrustful."

9 For example, in the summer of 1995 one Nuxalk woman told me that, because of the political split, she usually goes directly home after work and stays there, not talking to her neighbours or socializing the way she used to. She tries to stay out of it. Her philosophy is not to get involved with what she can't change, and her job, federally funded, mandates that she remain neutral, so if someone asks her opinion she tells them it would jeopardize her job to say anything. But she still says that one is nervous not knowing what side people are on, although the sides are pretty clear if you know everyone. It may not be apparent to outsiders but people are nervous around each other. She told me she never knows when someone will ignore her.

10 The Department of Indian Affairs' full title is actually the Department of Indian Affairs and Northern Development (DIAND), but it is often referred to as DIA for short. This ministry was created in October 1966. Between 1950 and 1966 the Indian Affairs branch of the federal government was administered through the Department of Citizenship and Immigration. Between Confederation in 1867 and 1950 Indian affairs was administered by many various departments: the Department of Secretary of State Canada (1867-73), the Department of the Interior/Superintendents General of Indian Affairs (1873-1935), and the Department of Mines and Resources (1935-50).

11 An Indian agent was the on-site administrator for the Department of Indian Affairs. He was a non-Native man who lived on reserve and whom the Indian act provided with extensive powers to ensure the protection of his wards – "status Indians." He decided who was worthy of government aid in the form of food, clothing, and/or shelter. Many Nuxalk, especially those who only spoke the Nuxalk language and could not read or write English, were afraid of the Indian agent because of the control he had over their and their children's lives (Fournier and Crey 1997, 54). There was an Indian agent in residence in Bella Coola from 1910 to 1979. From 1875 to 1908 the Bella Coola band was administered from afar by the Department of the Interior, first via the Victoria Superintendency (1875-83) and later via the North West Coast Agency (1883-1908) (Prince 1992, 56, 198; Wild 2004, 229, 233).

12 With the election of a new chief in 2001 some of the factionalism has abated. There is more cooperation between the elected chief and council and the hereditary chiefs, although residues of the political divisions still exist.

13 Most Nuxalk travel outside Bella Coola with some frequency, typically visiting cities in British Columbia (such as Williams Lake, Kamloops, Prince George, or Vancouver) as well as less populated areas (such as Rivers Inlet, Bella Bella, or Port Hardy). A smaller percentage of Nuxalk travel to such destinations as California, Hawaii, Germany, and New Zealand.

Chapter 2: History of Bella Coola

1 This identification with the Salish-speaking peoples to the south and east is resoundingly rejected by most Nuxalk because it conflicts with their beliefs about how they came to the Bella Coola Valley.

2 The word *Nuxalkmc* (pronounced *new-hulk-um*) refers to the Nuxalk people.

3 The store was a Hudson's Bay Company (HBC) post from 1867 to 1882 and was then bought by former HBC factor John Clayton, who ran it until his death in 1910.

4 I am echoing Clifford (1991, 247): "I want simply to make visible to outsiders the complexity that is hidden behind words such as local, tribal, and community. For it is too easy to speak about 'local history,' 'the tribe,' or 'the community' as if these were not differently interpreted and often contested." Clifford is pointing out that behind these strategically wielded terms are a plethora of meanings, yet they are often deployed as though they are monolithic. The Nuxalk also do this with regard to their use of named units.

5 This is the Canadian federal police force.

6 The Kwakwa̱ka'wakw are also known as the Kwagiulth Nation, although in the early academic literature they were referred to as the Kwakiutl.

7 "Food fisheries" is a designation of the Indian Act, which was passed in 1876 and made all "status Indians" wards of the Canadian government. These people were to be managed through the auspices of the Department of Indian Affairs.

8 The Nuxalk 1995 Communal Fishing Licence from the Department of Fisheries and Oceans allows for fishing only from Sunday at 1800 hours to Thursday at 1800 hours from 30 May to 31 December. The licence also limits what kind of gear can be used and where in the river fishing can occur.

9 See note 6, chap. 1.

10 The Nuxalk Nation submitted a land claim to the federal government in 1972 after working with elders to establish territories and place-names. This was not responded to until 1992, when the provincial government finally agreed to settle the entire British Columbia land question. However, as already discussed, the Nuxalk have decided not to participate in this process.

11 In 1883 the visiting Methodist missionary Reverend William Henry Pierce estimated that the population was "200 wholey pagan" (Pierce 1933, 44).

12 The last residential school in British Columbia did not close until 1984 (Fournier and Crey 1997, 61).

13 Alcoholics, who need money to buy more alcohol, have been responsible for selling much Nuxalk material culture out of the valley. In this way, the Euro-Canadian introduction of alcohol to the Nuxalk created a double theft, taking both people and objects.

14 B. Phillip Jacobsen was the same Jacobsen who spurred the migration of the Norwegian religious group to Bella Coola.

15 A ritual prompter was a Nuxalk who was supposed to remember the words to songs so that, if the singers forgot the words, then he could prompt them orally. Traditionally, this person would have to memorize the canon, but McIlwraith took written notes to aid his memory.

16 Cliff Kopas, a prominent member of the non-Native community in Bella Coola, owned a large store there that sold Native art as well as books, clothing, fishing gear, toys, and household goods. The Kopas store is still there and is owned and run by Kopas' son-in-law.

17 I use this Nuxalk person's real name to honour the deceased and because he is a well-known author.

18 Out of sixty-four Nuxalk objects in the Museum of Anthropology's collection, seventeen (mostly masks) were previously owned by John Clayton and were said to have been "gathered in 'trade' through the family store between 1890-1910" (Museum of Anthropology acquisition files).

Chapter 3: "Selling Out" or "Buying In"?

1 Marcia Crosby (1997, 30) warns that relying on categories such as "lover/hater," "oppressor/oppressed," traditional/assimilated," or "reserve/urban," which are "reductive or populist difference(s) as a tool for empowerment ... will eventually turn inward, dividing and disempowering [her] own history, and the places/people [she is] trying to support."

2 Aaron Glass (1999, 9) states: "By the 1980s and 90s ... the postmodern or constructivist turn in the social sciences suggested that culture itself is best characterized as performance, thereby challenging the classical notion that rules and systems and structures underlie the stability or coherence of cultures."

3 This term comes from Arthur Mason (1996, 2002). See note 11, chap. 3.

4 Although the Canadian Inuit igloo trademark example comes from a 1975 tourism magazine, the use of indigenous trademarking as a marker of authenticity is growing globally. See Julie Hollowell (2004) and Terre Janke (2003) for developments in the United States, Australia, and New Zealand.

5 Virginia Dominguez (1994, 53) is concerned that, when culture is objectified, it is separated out from other arenas of politics and economics and is thus easily judged. She suggests that non-European peoples are evaluated as inferior when their cultures are objectified and compared to European cultures.

6 Anthropologists working in the South Pacific have long noticed this trend towards self-objectification. See Hanson (1989), Keesing (1989), Linnekin (1992), and Thomas (1992).

7 I use the masculine pronoun because I do not know of any female artists doing this sort of production; however, a man's wife or female partner will often be in charge of selling his manufactured T-shirts for him.

8 A family member who performs a dance during the potlatch puts on a button blanket and, occasionally, a dance apron. Sometimes the mass-produced item is removed, other times it is worn beneath the hand-made regalia.

9 It is quite conceivable that other types of items will be given away in the future (such as canvas tote bags, posters, buttons, etc.). Each family wants its potlatch giveaways to be unique so that they will be remembered.

10 Many people in Bella Coola and beyond wear crest T-shirts that they have received from potlatches that were not their own, thus providing advertisement for successful potlatch-hosting families.

11 During his fieldwork on Kodiak Island Arthur Mason noted that the Alutiiq placed designs from local petroglyphs on indigenous buildings, T-shirts, and posters. Though there is no archaeological evidence that the contemporary residents of Kodiak Island have any relation to the people who carved these petroglyphs, the carvings were accepted and made to stand in for Alutiiq identity because the people "bought into" the idea that these designs could and should do so (Mason 1996, 2002).

12 Phillips' (1998, 261) research on tourist art production in the northeast of North America lends support to my argument: "In designing arts for sale, Aboriginal artists performed many small acts of cultural translation. And in wearing these objects, in placing them in their homes, non-Native consumers also enacted a ritual of indigenization. The cultural

validity of Native tourist art derives precisely from its location at the meeting point between Native and non-Native worlds. These objects authentically express the processes of cultural accommodation each group made to the other."

13 I am indebted to Thomas Miller for this important observation.

14 'Ksan style is taught at the Kitanmax School of Northwest Coast Art in Hazelton, British Columbia. It is a version of the Git'ksan Northwest Coast art style, which is not surprising as this is a Git'ksan-run school. However, since the school was founded in 1970 and some of its teachers have been Haida or non-Native, the 'Ksan style is something that developed without conscious intent. I know of at least two Nuxalk artists who studied at the Kitanmax School.

15 Some Nuxalk artists only create when they need money. Other Nuxalk often refer to these people as "Friday-afternoon artists" because they work to earn money for the weekend.

16 See also Brian Wallis (1991) who, in his seminal article "Selling Nations," details how blockbuster exhibits and culture festivals are propaganda whose purpose is to bring economic opportunities to nations that promote themselves through displays of art and heritage in the United States.

17 Ferry (2002, 338) would call these "patrimonial strategies."

18 The example subject is male because the majority of carvers in Bella Coola are male.

19 Marilyn Strathern (1988, 1999) and Alfred Gell (1998) have made crucial contributions to the thesis that art is an extension of the self.

20 The Nuxalk use the phrase "new/old" to describe any ethnographically recorded tradition, whether song, dance, or mask, that had been forgotten but that is currently being reclaimed through conscious cultural revival.

21 This same artist has also told me other stories of artworks he attempted but that, for various reasons, did not come out "right"; however, his "mistakes" were clearly important lessons, which he brought with him to his next creations. I did not find all Nuxalk artists to be so resilient. Some seemed easily defeated by artistic problems and stopped production when they encountered difficulties.

22 Hegel recognizes this unobtainable human desire for absolute knowledge and human perfection (Miller 1987, 9), which I equate with returning to an image of stability (such as that produced by nostalgia).

23 I say this even though I am aware that there will always be those in Bella Coola who do not agree with me.

Chapter 4: Privileged Knowledge versus Public Education

1 A play potlatch is organized both for entertainment and for educational purposes. In pre-contact Bella Coola parents would host potlatches for their male children and encourage them to give away small gifts. It was a humorous event, done, according to McIlwraith (1992, 1:288-91) to counteract the seriousness of the men's potlatches but also to teach children to attend to gift exchanges and debt repayment. Now *Acwsalcta* has taken over this task. It organizes a play potlatch every two years to teach the children the procedures and protocols of this important ritual. Children are the main performers and creators of the giveaways. See Codere (1956) for a description of a Kwakwaka'wakw play potlatch.

2 He subsequently married a non-Native woman, moved off reserve, and gave up his chieftainship, eschewing most Nuxalk ways.

3 I use personal names to honour deceased individuals whose memory is significant to the Nuxalk.

4 The *Coast Mountain News* reports that fifteen Nuxalk families withdrew their children from public school in 1981. By 1982 fifty families had sent their children to *Acwsalcta* (*Coast Mountain News* 1987a, 1).

5 Margaret Siwallace was given an honorary doctorate of letters by the University of British Columbia in 1985 in recognition of her work towards Nuxalk cultural preservation. See also note 3, chap. 4.

6 See note 3, chap. 4.

7 The Nuxalk use the word *lhlum* to refer to a potlatch. According to linguist H.F. Nater's (1990, 62) Nuxalk-English Dictionary *lhlm* means "to give a feast or to potlatch."

8 In 1989 the first play potlatch honoured both the original mask, dance, and song teacher and the art teacher, while naming each of the *Acwsalcta* classrooms; in 1991 the second play potlatch honoured the Nuxalk Education Authority chairperson; in 1993 the third play potlatch honoured the elder and cultural teacher Mabel Hall; in 1995 the fourth play potlatch memorialized a former student, Cassandra (Tallio) Pootlass.

9 Potlatch law is the expression of the economic, political, and social rules that governed Nuxalk society. The potlatch, as a ceremonial complex, made visual Nuxalk expectations of behaviour. Thus, participating in potlatching assured that Nuxalk followed the appropriate societal rules. The potlatch embodies a different system for motivating correct behaviour than does the Canadian legal system, but the outcome is similar in that the individual is encouraged to follow the societal will.

10 See note 3, chap. 4.

11 One female informant in her forties recalled a late 1960s celebration of Mackenzie Day, which marked Sir Alexander Mackenzie's reaching the Pacific in 1793. The Nuxalk re-enacted their part in welcoming Mackenzie by dressing up in button blankets and other regalia, feasting, singing, and dancing. Then she reported that "politics got involved" because some Nuxalk did not want to celebrate the arrival of European explorers. Indian Days replaced the Mackenzie Day celebration. During Indian Days people fundraised for the church. They would pay two dollars per head to view Indian dancing. She recalled that, in the late 1960s, there was a very strict dress code and very clear rules of behaviour. The announcer for these events spoke in Nuxalk, which was then translated into English.

12 For example, the *Acwsalcta* youth singers were counselled that they could only sing a chief's song for that chief, not for another person.

13 I was informed by a hereditary chief that the Nuxalk youth singers have their songs and songbooks only because certain elders sat down with the cultural coordinator to listen to old tapes and to translate them. This was necessary because, since the early 1980s, these songs were no longer in the Nuxalk repertoire and had been all but forgotten.

14 The tape of Nuxalk singers was made in 1956 by painter and amateur ethnographer, Mildred Valley Thornton (author of *Indian Lives and Legends*).

15 During the 1997 play potlatch, female high school students were required to wear skirts and button blankets while dancing the ladies' dances. They were joined by some adult females from the audience.

16 I have purposely not used the actual name of the song, the dance, or the owner in order not to embarrass anyone or lay claim to knowledge I have not been granted the permission to relay. I am more concerned with the tensions revolving around ownership of specific songs and dances than I am with which specific songs and dances are being contended.

17 I have never heard an emcee announce that this dance was individually owned.

18 There are a number of different types of Nuxalk dances: chiefly dances, children's dances, ladies' dances, men's dances, masked dances, and dances for everyone. At every potlatch and play potlatch a variety of these dances are performed. The hosting family makes the selections. They often work in coordination with a cultural teacher, who guides the *Acwsalcta* school dance troupe. Individuals who own masked dances may also offer to perform them, or someone who organizes the event may request a specific dancer to perform.

19 Bruce Grenville (1998, 16), the senior curator of the Vancouver Art Gallery, aptly notes: "To embrace tradition is not necessarily to reject innovation or experimentation."

20 Changing gender roles is not unheard of in Bella Coola. It is understood that traditionally only men sang during potlatches (as evidenced by McIlwraith's 1920s ethnography), but it was female elders who kept the singing going in the 1960s. Too many men had died, and it seems that the women were the most determined to save the songs. Now anyone can sing in Bella Coola, and singer's gender is not an issue.

21 The only reason these women did not perform the masked dances was that they were not in Bella Coola during the 1997 play potlatch but in Bella Bella attending another potlatch. In a November 2001 potlatch there was a crossing of traditional gender roles. I witnessed a woman publicly participate in the typically all-male Bow Dance and another woman don a Thunder mask and, to the shock of some of the Nuxalk audience, perform in this most important masked dance.

22 Thus much trust was placed in my own character when I was allowed, as an outsider and an anthropologist, to participate in mask, dance, and song class and to eventually write about *Acwsalcta's* undertakings.

23 This Nuxalk woman is a blanket maker. She told me that, at one point, she considered giving up making blankets because she thought the significance of the blanket was being abused. She had been taught it was to be used for ceremony and dancing, but she perceived that now it was being used symbolically, to represent protest and to express anger, and, as she proclaimed, "That is not what blankets should be used for!" Blankets should not be worn in defiance but in pride of heritage. However, she changed her mind about refusing to make new blankets because she thought about her mother's blankets, which were still around. Her mother had wanted her blankets to be passed on after she was gone, and this informant wanted to reinforce the continuity of the act of blanket making.

Chapter 5: Physical and Figurative Repatriation

1 If Native human remains or cultural objects of Canadian origin exist in US museum collections, then NAGPRA does not require museums to alert Canadian First Nations of their existence. So repatriation does not get legally initiated in this way. Although there have been cases of Canadian Native human remains and cultural objects being returned to Canadian First Nations, these have occurred through initial requests stemming from the First Nations themselves. For example, the recent repatriations of Haida skeletal remains from the American Museum of Natural History and of Kwakwaka'wakw regalia from the National Museum of the American Indian were both accomplished due to the perseverance of the Canadian First Nation rather than the force of US law.

2 Chris Steiner (2001, 219-21) analyzes the case study of Brancusi's "Bird in Space," which, under the Tariff Act, 1922, was denied art status. This occurred in 1928 at the US border, the reason being that the act viewed the bronze sculpture as a manufactured item and thus as neither original nor art. The ensuing court case is evocative of the Echo mask's situation: "I suggest that the classification of objects at the interstitial nodes of national borders provides a unique opportunity to witness a highly politicized form of categorization and the emergence of definitions of value out of the very liminality engendered by transit and passage across formal boundaries" (212). Steiner also notes that, "at each point in its movement through space and time, an object has the potential to shift from one category to another and, in doing so, to slide along the slippery line that divides art from artifact from commodity" (224).

3 Usually an initiated member would pass a *kusiut* privilege to her/his offspring or other near relative; however, there are recorded examples of even slaves being given *kusiut* privileges (Richardson 1982, 36).

4 Interestingly, McIlwraith (1992, 2:385) discusses a category of Echo stories that reflect neither *kusiut* nor *sisaok* categories of ownership but something more like "ancient lore," which is owned by everybody: "These do not belong either to individuals or to families, consequently they are more widely known than allegedly historical accounts which are the personal property of social groups." Included in this category are a couple of Echo and Raven stories (405-8).

5 I make this argument, although David Walden, in a phone interview, did not agree that this was the motivation of the Canadian government as represented by the Canadian Cultural Property Export Review Board. Walden, the secretary of the board, emphasized that the term "Canadian" in Canadian cultural property functions only as an adjective, as in "cultural property from Canada," and does not mean that the property is any less Nuxalk because it was not given an export visa.

6 The Canadian Task Force Report is not specific about the procedures and protocols for repatriation. The recommendations only suggest that each case be evaluated on its own merits. While this flexibility could be seen as indicating a potential openness, many First Nations people appear frustrated at being forced to make their arguments in language that museums understand (i.e., that of proving ownership according to the Canadian legal system). As well, it must be remembered that the task force recommendations only apply to cultural objects in museum collections and not to those bought by individuals in the

"free" capitalist market. As has been demonstrated by the Echo mask case study First Nations can make use of the Cultural Property Export and Import Act, 1977; however, this act was not designed to protect indigenous cultural property but, rather, to keep Canadian national property within Canada's borders. First Nations don't always find out about objects leaving the country unless they operate a federally recognized museum or cultural centre. The Canadian court system is always an option but of course requires that First Nations speak the language of laws and lawyers (although this is beginning to change, with the 1997 Supreme Court decision on the appeal of *Delgamuukw v. The Queen*. This decision urges Canadian judges to treat Native oral history as being just as valid as that depicted in written documents [Culhane 1998]).

7 The edited volume, *Archaeology under Fire: Nationalism, Politics and Heritage in the Eastern Mediterranean and Middle East* (Meskell 1998a) makes parallel points. The various chapters suggest that "symbolic capital" produced by archaeologists is used to create national identity (Bailey 1998, 96; Kotsakis 1998, 54), although often the interpretation of past material culture is contested in political power plays (Meskell 1998b, 2). Ian Hodder (1998, 135) aptly notes that we should not view arguments over the interpretation of archaeological sites as binaries, such as secular versus sacred or Western versus the Orient. In the case of Catalhoyuk in Turkey, Islamic fundamentalists are fighting to stop the promotion of the site for global tourism as well as to purge the secular commercialization of the Mother Goddess figures found there. Hodder views Catahoyuk as "involved in a global process of interpretation" (138), much as I argue that the Nuxalk are involved in contested, global processes in which they must balance secular and sacred concerns.

8 Aldona Jonaitis used it on the cover of the American Museum of Natural History's Northwest Coast art collection catalogue: *From the Land of the Totem Poles: The Northwest Coast Indian Art Collection at the American Museum of Natural History* (1988).

9 In her exhibition review, art critic Sarah Milroy (1998, C10) pointed out: "One may wait a long time to find an exhibition of First Nations art whose process has been so open and diplomatically astute. The organizers have worked in concert with representatives of the 11 major nations of the Northwest Coast, meticulously clearing the rights to exhibit objects that are repositories of ancestral history and inherited oral tradition."

10 Archaeologist Lisa Seip wrote her master's thesis on Nuxalk masks in 2000 (see Chapter 2). As part of her research, she photographed all Nuxalk masks being held in museum collections in North America and put this compendium onto a CD-ROM. This CD-ROM is now available to the Nuxalk Nation. Artists are especially keen to have access to these images.

11 One journalist reported: "The show has helped open up some of the innermost recesses of Indian [sic] culture to the world, an achievement that has stirred some controversy within the Native communities of British Columbia. The opening ceremony for the exhibition last month in the court in front of the gallery, for example, included a dance that had previously been performed only on ceremonial occasions before an Indian audience. Some of the masks in the show, particularly those of mythical cannibal beings, are regarded as so sacred by some Indians of the region – tribes like the Haida, Nuxalk, Tsimshian, Tlingit and Heiltsuk – that they argue they should not be put on public display at all" (Sterngold 1998, E1-2).

12 As the then director of the Vancouver Art Gallery, Alf Bogusky said, "Museums are places of reconciliation. Or at least they should be" (quoted in Milroy 1998, C10).

13 Recall the various responses to the Harrington Gallery exhibition Valley of Thunder: Art of the Nuxalk Nation from Bella Coola, BC, discussed in Chapter 1.

Chapter 6: Theft Inside and Out

1 One of the *Acwsalcta* teachers was convinced the group received the grant of Cdn$4,000 from the Bella Coola band office because they intended to view the Bella Coola collection at the American Museum of Natural History.

2 Many Nuxalk artists expressed interest in seeing this video, believing it to be the best alternative to viewing these objects at the museum.

3 On the Northwest Coast inalienable possessions such as coppers or crests have always been about displays of power and authority. Coppers are shield-shaped objects hand hammered

out of copper. They are owned by chiefs of elite families and are displayed during pot-latches as proof of high status and great wealth. They act somewhat like Trobriand *kula* bracelets and necklaces. In the past, in order to depict excess riches, a chief might cut off pieces of his copper to give them away to his guests during a potlatch; or in extreme cases, he might throw the entire copper into the ocean or into a fire in order to demonstrate that he is so wealthy that he can afford to destroy an object of great value.

4 Each student at *Acwsalcta* must make his/her own dance blanket in home economics class. Although the design may be commissioned, each student machine sews his or her own blanket and then hand sews material appliqués and buttons onto the back. For youth with short attention spans, the long hours and concentrated work that goes into making a button blanket provides them with a visceral way of learning the significance of this personal regalia.

5 I thank Louisa Cameron for this analysis and reference.

6 Lack of access to an automated banking machine card or credit card is more a symptom of poverty than a cause, but being forced to use only cash leaves a Nuxalk person more vulnerable to theft since dollar bills cannot be traced to their original owner.

7 Handler (1988) makes a similar argument for the creation of Quebecois national identity in his seminal work *Nationalism and the Politics of Culture in Quebec* (see Chapters 3 and 5).

8 This is beginning to change as successful Northwest Coast artists realize the benefits of consigning their art work: more control of pricing; more likelihood that a gallery will be able to afford sponsoring an exhibition; and generally more awareness about how the Western art market works.

9 It is common for a non-Native artist to sign a contract agreeing to be represented by only one gallery. This gallery will then be responsible for marketing the artist and displaying his or her artwork in gallery exhibitions. However, often Northwest Coast artists create masks and other regalia for family and friends to use during potlatches. For this reason, it is not possible to make an exclusive arrangement with Native artists who carve or paint for spiritual purposes as well as for economic ones. I thank Gary Wyatt, co-owner of the Spirit Wrestler Gallery in Vancouver, for this observation.

10 A notable exception is when salmon or oolichan are running in the Bella Coola River and Nuxalk work long days fishing, cleaning, smoking, or canning fish. Artists also quicken their pace in carving or painting as potlatches and other ceremonies loom.

Chapter 7: Conclusions

1 James Fernandez (2000, 133) refers to this as "peripheral wisdom," by which he means the way marginalized groups create their identity through permeable, fuzzy boundaries between the centre and the periphery.

2 This echoes Miller's (1987) sentiments, citing Hegel's belief that artists feel connected to the objects they create but perceive them as flawed (see Chapter 3).

3 Marilyn Strathern (1994, 12; 1999, 135) cautions that merely describing contemporary cultural identity as constantly inventive does not free us from the problems of inequality between the marginalized and those at the core: "Yet there is no refuge for the anthropologist in the idea of hybrid networks and impure cultures either. These do not, of themselves, indicate a symmetrical, sharing morality. They are not of themselves the resistant, transgressive stands they might seem; not the revitalised assembly or parliament of things Latour so freely imagines. For neither a mixed nature, as such, nor an impure character, guarantees immunity from appropriation. On the contrary, the new modernities have invented new projects that forestall such imaginings."

References

Alland, Alexander, Jr. 1977. *The Artistic Animal: An Inquiry into the Biological Roots of Art.* Garden City, NY: Anchor Books Anchor Press/Doubleday.

The American Heritage Dictionary of the English Language, ed. William Morris. Boston: Houghton Miffin Company, 1981.

Appadurai, Arjun. 1986. "Introduction: Commodities and the Politics of Value." In *The Social Life of Things: Commodities in Cultural Perspective,* ed. Arjun Appadurai, 3-63. New York: Cambridge University Press.

–. 1990. "Disjuncture and Difference in the Global Cultural Economy." *Public Culture* 2 (2): 1-24.

Bailey, Douglas W. 1998. "Bulgarian Archaeology: Ideology, Sociopolitics and the Exotic." In *Archaeology under Fire: Nationalism, Politics and Heritage in the Eastern Mediterranean and Middle East,* ed. Lynn Meskell, 87-110. London and New York: Routledge Press.

Barker, John. 1992. "Introduction: T.F. McIlwraith and the Nuxalk (Bella Coola Indians)." In *The Bella Coola Indians,* ed. John Barker, ix-xxxvii. Toronto: University of Toronto Press.

Barker, John, and Douglas Cole, eds. 2003. *At Home with the Bella Coola Indians: T.F. McIlwraith's Field Letters, 1922-24.* Vancouver: UBC Press.

Barman, Jean, Yvonne Hébert, and Don McCaskill, eds. 1987. *Indian Education in Canada.* Vol. 2: *The Challenge.* Vancouver: UBC Press.

Barth, Fredrik. 2000. "Boundaries and Connections." In *Signifying Identities: Anthropological Perspectives on Boundaries and Contested Values,* ed. Anthony P. Cohen, 17-36. London and New York: Routledge Press.

Barton, Adriana. 2001. "Fly-By Culture." *Vancouver Magazine,* March: 24-30.

Benjamin, Walter. 1968. "Theses on the Philosophy of History." In *Illuminations,* trans. Harry Zohn, 253-64. New York: Shocken Books.

Berlo, Janet. 1992. "Introduction: The Formative Years of Native American Art History." In *The Early Years of Native American Art History: The Politics of Scholarship and Collecting,* ed. Janet Berlo, 1-21. Seattle and London: University of Washington Press.

Berman, Tressa. 1997. "Beyond the Museum: The Politics of Representation in Asserting Rights to Cultural Property." *Museum Anthropology* 21 (3): 19-27.

Bhabha, Homi. 1990. "Introduction: Narrating the Nation." In *Nation and Narration,* ed. Homi Bhabha, 1-7. New York: Routledge Press.

Bierwert, Crisca. 1999. *Brushed by Cedar, Living by the River: Coast Salish Figures of Power.* Tucson: University of Arizona Press.

Birchwater, Sage. 1993. *Ulkatcho Stories of the Grease Trail.* Anahim Lake, BC: Ulkatcho Culture Curriculum Committee.

–. 1997. "The Women Lead the Way to Native Cultural Revival." *Coast Mountain News,* 25 September: 9.

Boas, Franz. 1898. "The Mythology of the Bella Coola Indians." *Memoirs of the American Museum of Natural History* 2 (1): 25-127.

–. 1955. [1927]. *Primitive Art.* New York: Dover Publications.

Bourdieu, Pierre. 1984. *Distinction: A Social Critique of the Judgement of Taste,* trans. Richard Nice. Cambridge: Harvard University Press.

–. 1990. *The Logic of Practice,* trans. Richard Nice. Stanford: Stanford University Press.

–. 1993. *The Field of Cultural Production,* ed. Randall Johnson. New York: Columbia University Press.

Boyd, Robert T. 1990. *Demographic History, 1774-1874.* In *Handbook of the North American Indians.* Vol. 7: *The Northwest Coast,* ed. Wayne Suttles, 135-48. Washington: Smithsonian Institution Press.

Bracken, Christopher. 1997. *The Potlatch Papers: A Colonial Case History.* Chicago and London: University of Chicago Press.

Brah, Avtar, and Annie E. Coombes, 2000. "Introduction: The Conundrum of 'Mixing.'" In *Hybridity and Its Discontents: Politics, Science, Culture,* ed. Avtar Brah and Annie E. Coombes, 1-16. London and New York: Routledge Press.

Canadian Press Release. 1996a. "Court Blocks Artifact Sale: Nuxalk Band Seeks Buyer to Keep Ceremonial Mask in Canada." *The Globe and Mail,* 4 July: C1.

–. 1996b. "Injunction Blocks Sale of Famed Mask to Chicago Resident." *The Times Colonist,* 3 July: D10.

Carlson, Keith Thor, ed. 1997. *You Are Asked to Witness: The Sto:lo in Canada's Pacific Coast History.* Chilliwack: Sto:lo Heritage Trust.

Clifford, James. 1988. *The Predicament of Culture: Twentieth-Century Ethnography, Literature, and Art.* Cambridge and London: Harvard University Press.

–. 1991. "Four Northwest Coast Museums: Travel Reflections." In *Exhibiting Cultures: The Poetics and Politics of Museum Display,* ed. Ivan Karp and Steven D. Lavine, 212-54. Washington and London: Smithsonian Institution Press.

–. 1997. *Routes: Travels and Translation in the Late Twentieth Century.* Cambridge and London: Harvard University Press.

–. 2001. "Indigenous Articulations." *Contemporary Pacific* 13 (2): 468-90.

Clifford, James, and George E. Marcus, eds. 1986. *Writing Culture: The Poetics and Politics of Ethnography.* Berkeley and Los Angeles: University of California Press.

Coast Mountain News. 1986a. "Acwsalcta School Soon to Realize Twenty Year Dream." *Coast Mountain News,* 3 December: 1, 3.

–. 1986b. "Nuxalk Band Gets Official Approval for $3.7 Million School." *Coast Mountain News,* 17 October: 3.

–. 1986c. "Official Groundbreaking Ceremony for Acwsalcta on August 15, 1986." *Coast Mountain News,* 27 August: 1, 16.

–. 1986d. "Potlatch Tradition Revisited by Nuxalk." *Coast Mountain News,* 19 November: 1, 7-8.

–. 1987a. "Acwsalcta Focus for Nuxalk Pride." *Coast Mountain News,* 2 September: 1.

–. 1987b. "The Bella Coola Valley, 1894: Here Come the Norwegians." *Coast Mountain News,* 28 October: 8-9.

–. 1987c. "Design of School Was a Community Effort." *Coast Mountain News,* 2 September: 14.

–. 1987d. "Nuxalk Band School a 'Top Quality Job.'" *Coast Mountain News,* 19 August: 9.

–. 1990a. "Acwsalcta Does Student Exchange with Joe Duquette High School of Saskatoon, Saskatchewan." *Coast Mountain News,* 3 May: 1, 6, 15.

–. 1990b. "A History of Logging in Bella Coola." *Coast Mountain News,* 14 June: 3, 10.

–. 1991a. Little Mingling between Lower Bella Coola and Upper Bella Coola." *Coast Mountain News,* 25 November: 8-9.

–. 1991b. "Looking Back at Hagensborg Mercantile." *Coast Mountain News,* 25 November: 8-9.

–. 1997. "Four First Nations Sign Protocol Agreement." *Coast Mountain News,* 17 July: 3, 16.

–. 1998. "Bella Coola RCMP 1997 Year End Report." *Coast Mountain News,* 29 January: 3.

Codere, Helen. 1956. "The Amiable Side of Kwakiutl Life: The Potlatch and the Play Potlatch." *American Anthropologist* 58: 334-51.

–. 1966 [1950]. *Fighting with Property: A Study of Kwakiutl Potlatching and Warfare, 1792-1930*. Seattle: University of Washington Press.

Cole, Douglas. 1982. "Franz Boas and the Bella Coola in Berlin." *Northwest Anthropological Research Notes* 16 (2): 115-24.

–. 1985. *Captured Heritage: The Scramble for Northwest Coast Artifacts*. Seattle and London: University of Washington Press.

–. 1991. "Tricks of the Trade: Some Reflections on Anthropological Collecting." *Arctic Anthropology* 28 (1): 48-52.

Cole, Douglas, and Ira Chaikin. 1990. *An Iron Hand upon the People: The Law against the Potlatch on the Northwest Coast*. Vancouver/Seattle: Douglas and McIntyre/University of Washington Press.

Coombe, Rosemary J. 1997. "The Properties of Culture and the Possession of Identity: Postcolonial Struggle and the Legal Imagination." *In Borrowed Power: Essays on Cultural Appropriation*, ed. Bruce Ziff and Pratima V. Rao, 74-96. New Jersey: Rutgers University Press.

–. 1998. *The Cultural Life of Intellectual Properties: Authorship, Appropriation, and the Law*. Durham and London: Duke University Press.

Crosby, Marcia. 1997. "Lines, Lineage and Lies, or Borders, Boundaries and Bullshit." In *Nations in Urban Landscapes*, ed. Faye Heavy Shield, Shelley Niro, and Eric Robertson, 11-30. Vancouver: Contemporary Art Gallery.

Cruikshank, Julie. 1995. "Imperfect Translations: Rethinking Objects of Ethnographic Collections." *Museum Anthropologist* 19 (1): 25-38.

Culhane, Dara. 1998. *The Pleasure of the Crown: Anthropology, Law and First Nations*. Burnaby: Talonbooks.

Culler, Jonathan. 1981. "Semiotics of Tourism." *American Journal of Semiotics* 1 (1/2): 127-40.

Danto, Arthur. 1988. "Artifact and Art." In *ART/Artifact: African Art in Anthropology Collections*, 18-32. New York: The Center for African Art.

Davis, Philip W., and Ross Saunders. 1980. "Bella Coola Texts." *Heritage Record*, 10. Victoria: British Columbia Provincial Museum.

–. 1997. "A Grammar of Bella Coola." *Occasional Papers in Linguistics*, 13. Missoula: University of Montana.

Dickie, George. 1989 [1977]. "The New Institutional Theory of Art." In *Aesthetics: A Critical Anthology*. 2nd ed., ed. George Dickie, Richard Sclafani, and Ronald Roblin, 196-205. New York: St. Martin's Press.

Dominguez, Virginia. 1986. "The Marketing of Heritage." *American Ethnologist* 3: 546-55.

–. 1994. "Invoking Culture: The Messy Side of 'Cultural Politics.'" In *Eloquent Obsessions: Writing Cultural Criticism*, ed. Mariana Torgovnick, 237-59. Durham and London: Duke University Press.

Doxtator, Deborah. 1996. "The Implications of Canadian Nationalism for Aboriginal Cultural Autonomy." In *Curatorship: Indigenous Perspectives in Post-Colonial Societies*, Canadian Museum of Civilization, Mercury Series, Canadian Ethnology Service Paper 8, 56-76. Ottawa: National Museums of Canada.

Duff, Wilson. 1992 [1969]. *The Indian History of British Columbia*. Vol. 1: *The Impact of the White Man*. Anthropology in British Columbia, memoir no. 5. Victoria: Royal British Columbia Museum.

–. 1981. "The World Is as Sharp as a Knife: Meaning in Northern Northwest Coast Art." In *The World Is as Sharp as a Knife: An Anthology in Honour of Wilson Duff*, ed. Donald N. Abbot, 209-24. Victoria: Royal British Columbia Museum.

Errington, Shelly. 1998. *The Death of Authentic Primitive Art and Other Tales of Progress*. Berkeley, Los Angeles and London: University of California Press.

Ettawageshik, Frank. 1999. "My Father's Business." In *Unpacking Culture: Art and Commodity in Colonial and Postcolonial Worlds*, ed. Ruth B. Phillips and Christopher B. Steiner, 20-29. Berkeley: University of California Press.

Fabian, Johannes. 1983. *Time and the Other: How Anthropology Makes Its Object.* New York: Columbia University Press.

Feinburg, Jennifer. 1997. "Summer Heats Up with Another Blockade of King Island." *Coast Mountain News*, 19 June: 1, 8.

Fernandez, James. 2000. "Peripheral Wisdom." In *Signifying Identities: Anthropological Perspectives on Boundaries and Contested Values*, ed. Anthony P. Cohen, 117-44. London and New York: Routledge Press.

Ferry, Elizabeth Emma. 2002. "Inalienable Commodities: The Production and Circulation of Silver and Patrimony in a Mexican Mining Cooperative." *Cultural Anthropology* 17 (3): 331-58.

Fisher, Robin. 1992 [1977]. *Contact and Conflict: Indian-European Relations in British Columbia, 1774-1890.* 2nd ed. Vancouver: UBC Press.

Fournier, Suzanne. 1998a. "Ancient Sun Mask Will Shine on Big VAG Show." *Province* (Vancouver), 14 May: A13.

–. 1998b. "Natives Want Stone Masks Returned." *Province* (Vancouver), 4 June: A22.

Fournier, Suzanne, and Ernie Crey. 1997. *Stolen from Our Embrace: The Abduction of First Nations Children and the Restoration of Aboriginal Communities.* Vancouver and Toronto: Douglas and McIntyre.

Furniss, Elizabeth. 1999. *The Burden of History: Colonialism and the Frontier Myth in a Rural Canadian Community.* Vancouver: UBC Press.

Geertz, Clifford. 2000. *Available Light: Anthropological Reflections on Philosophical Topics.* Princeton and Oxford: Princeton University Press.

Gell, Alfred. 1998. *Art and Agency.* Oxford: Oxford University Press.

George, Kenneth. 1999. "Introduction: Objects on the Loose." *Ethnos* 64: 149-50.

gii-dahl-guud-sliiaay. 1995. "Cultural Perpetuation: Repatriation of First Nations Cultural Heritage." In *Material Culture In Flux: Law and Policy of Repatriation of Cultural Property* (theme issue), *University of British Columbia Law Review*: 183-202.

Gillespie, Tracey. 1990. "Opening Ceremonies at Nutl'l." *Coast Mountain News*, 4 October: 1.

Glass, Aaron J. 1999. "The Intention of Tradition: Contemporary Contexts and Contests of the Kwakwa̲ka̲'wakw Hamat'sa Dance." MA thesis, Department of Anthropology and Sociology, University of British Columbia.

Goldman, Irving. 1940. "The Alkatcho Carrier of British Columbia." In *Acculturation in Seven American Indian Tribes*, ed. Ralph Linton, 333-89. New York and London: D. Appleton-Century Company.

Goodman, John. 1998. "Invitation to the Dance." *North Shore News*, 5 June: 15, 28.

Graburn, Nelson. 1993. "Ethnic Arts of the Fourth World: The View from Canada." In *Imagery and Creativity: Ethnoaesthetics and Art Worlds in the Americas*, ed. Dorothea S. Whitten and Norman E. Whitten, 171-204. Tucson and London: University of Arizona Press.

Greenblatt, Stephen. 1989. "Towards a Poetics of Culture." In *The New Historicism*, ed. H.A. Veeser, 1-14. New York and London: Routledge Press.

Grenville, Bruce. 1998. "Introduction." In *Down from the Shimmering Sky: Masks of the Northwest Coast*, ed. Peter L. Macnair, Robert Joseph, and Bruce Grenville, 14-16. Vancouver: Douglas and McIntyre.

Gustafson, Paula. 1998. "Exhibition Looks History in the Face." *The Georgia Straight*, 28 May-4 June: 59.

Haberland, Wolfgang. 1987. "Nine Bella Coolas in Germany." In *Indians and Europe: An Interdisciplinary Collection of Essays*, ed. Christian Feest, 337-74. Aachen: Herodot, Rader-Verl.

Haig-Brown, Celia. 1988. *Resistance and Renewal: Surviving the Indian Residential School.* Vancouver: Tillacum Library.

Hall, Jenny. 1991. "Lily-Brown-Patrick Squash Memorial Potlatch." *Coast Mountain News*, 17 October: 8-9.

–. 1995a. "Nuxalk March in Protest of Motel Fence." *Coast Mountain News*, 2 February: 1, 3, 11.

–. 1995b. "Protestors Block Interfor Road Construction at Fog Creek." *Coast Mountain News*, 14 September: 1.

Halpin, Marjorie. 1994. "A Critique of the Boasian Paradigm for Northwest Coast Art." *Culture* 14 (1): 5-16.

Handler, Richard. 1986. "Authenticity." *Anthropology Today* 2: 2-4.

–. 1988. *Nationalism and the Politics of Culture in Quebec.* Madison and London: University of Wisconsin Press.

Handler, Richard, and Jocelyn Linnekin. 1984. "Tradition, Genuine or Spurious." *Journal of American Folklore* 97: 273-90.

Hans, Lorraine. 1997. "History of Education in Bella Coola." In *Nuxalk College Focus on ECE* (Bella Coola), 7 April, p. 4.

Hanson, Alan. 1989. "The Making of the Maori: Culture Invention and Its Logic." *American Anthropologist* 91: 890-902.

Haug, W.F. 1986. *Critique of Commodity Aesthetics: Appearance, Sexuality and Advertising.* Cambridge: Polity Press.

Hawker, Ronald W. 2003. *Tales of Ghosts: First Nations Art in British Columbia, 1922-61.* Vancouver and Toronto: UBC Press.

Hill, Tom, and Trudy Nicks, eds. 1992. *Turning the Page: Forging New Partnerships between Museums and First Peoples.* Report of the Task Force on Museums and First Peoples. Ottawa: Assembly of First Nations and Canadian Museum of Civilization.

Hilton, Susanne F. 1990. "Haihais, Bella Bella, and Oowekeeno." In *Handbook of the North American Indians.* Vol. 7: *The Northwest Coast,* ed. Wayne Suttles, 312-22. Washington: Smithsonian Institution Press.

Hobler, Phillip. 1990. "Prehistory of the Central Coast of British Columbia." In *Handbook of the North American Indians.* Vol. 7: *The Northwest Coast,* ed. 298-305. Washington: Smithsonian Institution Press.

Hobsbaum, Eric, and Terence Ranger, eds. 1983. *The Invention of Tradition.* Cambridge: Cambridge University Press.

Hodder, Ian. 1998. "The Past as Passion and Play: Catalhoyuk as a Site of Conflict in the Construction of Multiple Pasts." In *Archaeology under Fire: Nationalism, Politics and Heritage in the Eastern Mediterranean and Middle East,* ed. Lynn Meskell, 124-39. London and New York: Routledge Press.

Hollowell, Julie. 2004. "Intellectual Property Protection and the Market for Alaska Native Arts and Crafts." In *Indigenous Intellectual Property Rights,* ed. Mary Riley, 55-98. New York and Oxford: Altamira Press.

Holm, Bill. 1965. *Northwest Coast Indian Art: An Analysis of Form.* Seattle: University of Washington Press.

Jackson, Jean. 1989. "Is There a Way to Talk about Making Culture without Making Enemies?" *Dialectical Anthropology* 14: 127-43.

–. 1995. "Culture, Genuine and Spurious: The Politics of Indianness in the Vaupés, Colombia." *American Ethnologist* 22 (1): 3-27.

Jameson, Frederic. 1991. *Postmodernism, or, the Cultural Logic of Late Capitalism.* Durham, NC: Duke University Press.

Janke, Terre. 2003. *Minding Culture: Case Studies on Intellectual Property and Traditional Cultural Expressions.* Geneva: World Intellectual Property Organization.

Jonaitis, Aldona. 1988. *From the Land of the Totem Poles: The Northwest Coast Indian Art Collection at the American Museum of Natural History.* New York/Vancouver and Toronto: American Museum of Natural History/Douglas and McIntyre.

–. 1992. "Franz Boas, John Swanton, and the New Haida Sculpture at the American Museum of Natural History." In *The Early Years of Native American Art History,* ed. Janet Catherine Berlo, 22-61. Seattle/Vancouver: University of Washington Press/UBC Press.

Jonaitis, Aldona, and Richard Inglis. 1994. "Power, History and Authenticity: The Mowachaht Whalers' Washing Shrine." In *Eloquent Obsessions: Writing Cultural Criticism,* ed. Marianna Torgovnick, 157-84. Durham and London: Duke University Press.

Karp, Ivan, and Steven Lavine, eds. 1991. *Exhibiting Cultures: The Poetics and Politics of Museum Display.* Washington and London: Smithsonian Institution Press.

Kasfir, Sidney Littlefield. 1992. "African Art and Authenticity." *African Arts* 25 (2): 41-53, 96-97.

Keane, Webb. 2001. "Money Is No Object: Materiality, Desire, and Modernity in an Indonesian Society." In *The Empire of Things: Regimes of Value and Material Culture*, ed. Fred R. Myers, 65-90. Santa Fe/Oxford: School of American Research Advanced Seminar Series/James Currey.

Keddie, Grant. 1993. "The Victoria Smallpox Crisis of 1862." *Discovery: Friends of the British Columbia Museum Quarterly Review* 21: 6-7.

Keeshig-Tobias, Lenore. 1997. "Stop Stealing Native Stories." In *Borrowed Power: Essays on Cultural Appropriation*, ed. Bruce Ziff and Pratima V. Rao, 71-73. New Jersey: Rutgers University Press.

Keesing, Roger M. 1989. "Creating the Past: Custom and Identity in the Contemporary Pacific." *The Contemporary Pacific* 1 (1/2): 19-41.

-. 1994. "Theories of Culture Revisited." In *Assessing Cultural Anthropology*, ed. Robert Borofsky, 301-9. New York: McGraw-Hill, Inc.

Kennedy, Dorothy I.D., and Randall T. Bouchard. 1990. "Bella Coola." In *Handbook of North American Indians*. Vol. 7: *The Northwest Coast*, ed. Wayne Suttles, 323-39. Washington: Smithsonian Institution Press.

King, Jonathon C.H. 1986. "Tradition in Native American Art." In *The Arts of the North American Indian: Native Traditions in Evolution*, ed. Edwin Wade, 65-92. New York: Hudson Hills Press.

Kinkade, M. Dale. 1991. "Prehistory of the Native Languages of the Northwest Coast." In *Proceedings of the Great Ocean Conference*, vol. 1: 137-58. Portland: Oregon Historical Society Press.

Kirk, Ruth. 1986. *Wisdom of the Elders: Native Traditions on the Northwest Coast*. Vancouver: Douglas and McIntyre.

Kirshenblatt-Gimblett, Barbara. 2001. "Reflections." In *The Empire of Things: Regimes of Value and Material Culture*, ed. Fred R. Myers, 257-68. Santa Fe/Oxford: School of American Research Advanced Seminar Series/James Currey.

Kolstee, Anton F. 1982. *Bella Coola Indian Music: A Study of the Interaction between Northwest Coast Indian Structures and Their Functional Context*. National Museum of Man, Mercury Series, Canadian Ethnology Service Paper 83. Ottawa: National Museum of Man.

Kopas, Cliff. 1970. *Bella Coola*. Vancouver: Tenas Tiktik Publishing.

-. 1992 [1950]. "Bella Coola Experiment Leaves It to the Kids." *Coast Mountain News*, 25 June: 6-7.

Kopytoff, Ivor. 1986. "The Cultural Biography of Things: Commoditization as Process." In *The Social Life of Things: Commodities in Cultural Perspective*, ed. Arjun Appadurai, 64-91. Cambridge: Cambridge University Press.

Kotsakis, Kostas. 1998. "The Past Is Ours: Images of Greek Macedonia." In *Archaeology under Fire: Nationalism, Politics and Heritage in the Eastern Mediterranean and Middle East*, ed. Lynn Meskell, 44-67. London and New York: Routledge Press.

Kuhn, Ryan. 1997. "Sacred Echo Mask Returns to Bella Coola." *Coast Mountain News*, 18 December: 1, 3.

Kuper, Adam. 1999. *Culture: The Anthropologists' Account*. Cambridge, MA: Harvard University Press.

Lamb, W. Kaye, ed. 1970. *The Journals and Letters of Sir Alexander Mackenzie*. Toronto: Macmillan of Canada.

Lévi-Strauss, Claude. 1982. *The Way of the Mask*, trans. Sylvia Modelski. Seattle: University of Washington Press.

Linnekin, Jocelyn. 1991. "Cultural Invention and the Dilemma of Authenticity." *American Anthropologist* 93: 446-49.

-. 1992. "On the Theory and Politics of Cultural Construction in the Pacific." *Oceania* 62: 249-63.

MacCannell, Dean. 1976. *The Tourist: A New Theory of the Leisure Class*. New York: Shocken.

-. 1992. *Empty Meeting Grounds: The Tourist Papers*. London and New York: Routledge Press.

McDowell, Jim. 1996. "A Symbolic Victory: Natives Go to Court to Scuttle the Sale of a Mask." *British Columbia Report*, 26 August: 37, 39.

McIlwraith, Thomas F. 1966. "The Ancestral Family of the Bella Coola." In *Indians of the North Pacific Coast*, ed. Tom McFeat, 58-71. Seattle and London: University of Washington Press.

–. 1987. *At Home with the Bella Coola Indians*, annotated by John Barker. *BC Studies* 75: 43-60.

–. 1992 [1948]. *The Bella Coola Indians*. Vol. 1-2, intro. John Barker. Toronto: University of Toronto Press.

McLennon, Bill, and Karen Duffek. 2000. *The Transforming Image: Painted Arts of the Northwest Coast First Nations*. Vancouver and Toronto/Seattle: UBC Press/University of Washington Press.

Macnair, Peter L. 1998. "Power of the Shining Heavens." In *Down from the Shimmering Sky: Masks of the Northwest Coast*, ed. Peter L. Macnair, Robert Joseph, and Bruce Grenville, 36-112. Vancouver: Douglas and McIntyre.

Macnair, Peter L., Alan L. Hoover, and Kevin Neary. 1984. *The Legacy: Tradition and Innovation in Northwest Coast Indian Art*. Vancouver and Toronto/Seattle: Douglas and McIntyre/University of Washington Press.

Macpherson, C.B.M. 1962. *The Political Theory of Possessive Individualism: Hobbes to Locke*. Oxford: Oxford University Press.

Marcus, George E., and Fred R. Myers, eds. 1995. *The Traffic in Culture: Refiguring Art and Anthropology*. Berkeley, Los Angeles, and London: University of California Press.

Mason, Arthur L. 1996. "In a Strange Turn of Events: How Alutiiq Cultural Pride Became a Commodity." MA thesis, Department of Anthropology, University of Alaska.

–. 2002. "The Rise of an Alaskan Native Bourgeoisie." *Etudes/Inuit/Studies* 26 (2): 5-22.

Meek, R. Jack. 1970. "House of Noomst." *Midden* 2: 2-4.

Meskell, Lynn, ed. 1998a. *Archaeology under Fire: Nationalism, Politics and Heritage in the Eastern Mediterranean and Middle East*. London and New York: Routledge Press.

–. 1998b. "Introduction: Archaeology Matters." In *Archaeology under Fire: Nationalism, Politics and Heritage in the Eastern Mediterranean and Middle East*, ed. Lynn Meskell, 1-12. London and New York: Routledge Press.

Messenger, Phyllis Mauch, ed. 1989. *The Ethics of Collecting Culture Property*. Albuquerque: University of New Mexico Press.

Miller, Daniel. 1987. *Material Culture and Mass Consumption*. New York: Basil Blackwell Inc.

–. 2001. "Alienable Gifts and Inalienable Commodities." In *The Empire of Things: Regimes of Value and Material Culture*, ed. Fred R. Myers, 91-115. Santa Fe/Oxford: School of American Research Advanced Seminar Series/James Currey.

–, ed. 1995. *Worlds Apart: Modernity through The Prism of The Local*. London and New York: Routledge Press.

Miller, J.R. 1991. *Skyscrapers Hide the Heavens: A History of Indian-White Relations in Canada*. Rev. ed. Toronto, Buffalo, London: University of Toronto Press.

Milroy, Sarah. 1998. "Mask Magic." *Globe and Mail*, 13 June: C10.

Morphy, Howard. 1995. "Aboriginal Art in a Global Context." In *Worlds Apart: Modernity through the Prism of the Local*, ed. Daniel Miller, 211-39. London and New York: Routledge Press.

Myers, Fred R. 1994. "Culture-Making: Performing Aboriginality at the Asia Society Gallery." *American Ethnologist* 21 (4): 679-99.

–. 1995. "Representing Culture: The Production of Discourse(s) for Aboriginal Acrylic Paintings." In *The Traffic in Culture: Refiguring Art and Anthropology*, ed. George E. Marcus and Fred R. Myers, 55-95. Berkeley: University of California Press.

–, ed. 2001a. *The Empire of Things: Regimes of Value and Material Culture*. Santa Fe/Oxford: School of American Research/James Currey.

–. 2001b. "Introduction: The Empire of Things." In *The Empire of Things: Regimes of Value and Material Culture*, ed. Fred R. Myers, 3-64. Santa Fe/Oxford: School of American Research/James Currey.

Napier, A. David. 1997. "Losing One's Marbles: Cultural Property and Indigenous Thought." In *Contesting Art: Art, Politics and Identity in the Modern World*, ed. Jeremy MacClancy, 165-82. Oxford and New York: Berg Press.

Nater, H.F. 1984. *The Bella Coola Language*. National Museum of Man, Mercury Series, Canadian Ethnology Service Paper 92. Ottawa: National Museums of Canada.

–. 1990. *A Concise Nuxalk English Dictionary*. Mercury Series, Canadian Ethnology Service Paper 115. Ottawa: Canadian Museum of Civilization.

Nooter, Mary, ed. 1993. *Secrecy: African Art That Conceals and Reveals*. New York/Munich: Museum for African Art/Prestel.

Ostrowitz, Judith. 1999. *Privileging the Past: Reconstructing History in Northwest Coast Art*. Seattle and London/Vancouver and Toronto: University of Washington Press/UBC Press.

Pask, Amanda. 1993. "Cultural Appropriation and the Law: An Analysis of the Legal Regimes Concerning Culture." *Intellectual Property Journal* 8 (1): 57-86.

Phillips, Ruth B. 1995. "Why Not Tourist Art?: Significant Silences in Native American Museum Representations." In *After Colonialism: Imperial Histories and Post-Colonial Displacements*, ed. Gyan Prakash, 98-125. Princeton: Princeton University Press.

–. 1998. *Trading Identities: The Souvenir in Native North American Art from the Northeast, 1700-1900*. Seattle and London/Montreal and Kingston: University of Washington Press/McGill-Queen's University Press.

Phillips, Ruth B., and Christopher B. Steiner. 1999. "Art, Authenticity and Baggage of Cultural Encounter." In *Unpacking Culture: Art and Commodity in Colonial and Postcolonial Worlds*, ed. Ruth B. Phillips and Christopher B. Steiner, 3-29. Berkeley: University of California Press.

Pierce, William Henry. 1933. *From the Potlatch to the Pulpit: A Link with the Colourful Past of Indian Life*. Vancouver: Vancouver Bindery.

Pootlass, Archie. 1997. "Environmental Groups Must Not Claim to Represent the Interests of Nuxalk Nation." *Coast Mountain News*, 19 June: 8.

Pratt, Mary Louise. 1992. *Imperial Eyes: Travel Writing and Transculturation*. London: Routledge Press.

Prince, Paul. 1992. "Acculturation and Resistance in Kimsquit." MA thesis, Department of Archaeology, Simon Fraser University.

Richardson, Joanne. 1982. "'The Miracle Is to Make It Solid': An Analysis of Transformation in Bella Coola Myth and Ritual." MA thesis, Department of Anthropology and Sociology, University of British Columbia.

Rohner, Ronald P., ed. 1969. *The Ethnography of Franz Boas: Letters and Diaries of Franz Boas Written on the Northwest Coast from 1886 to 1931*. Chicago: University of Chicago Press.

Root, Deborah. 1996. *Cannibal Culture: Art, Appropriation, and the Commodification of Difference*. Boulder, CO: Westview Press.

Sahlins, Marshall. 1988. "Cosmologies of Capitalism: The Trans-Pacific Sector of 'The World System.'" In *Proceedings of the British Academy* 74: 1-51.

Sandoval, Ronda. 1997. "Fred Schooner Sees Fifth Generation." *Coast Mountain News*, 31 July: 9.

Schapiro, Meyer. 1953. "Style." In *Anthropology Today: An Encyclopedic Inventory*, ed. E.L. Kroeber, 287-312. Chicago: University of Chicago Press.

Schildkrout, Enid, and Curtis A. Keim, eds. 1990. *African Reflections: Art from Northeastern Zaire*. Seattle and London/New York: University of Washington Press/The American Museum of Natural History.

–. 1998. *The Scramble for Art in Central America*. Cambridge: Cambridge University Press.

Schooner, Brenda. 1989. "Acwsalcta Play Potlatch." *Coast Mountain News*, 17 May: 12-13.

–. 1994. "The Nuxalk Nation Welcome Greenpeace." *Coast Mountain News*, 21 July: 3.

Scott, Michael. 1998. "Divine Faces." *Vancouver Sun*, 30 May: C1-2.

Seip, Lisa P. 1999. "Transformations of Meaning: The Life History of a Nuxalk Mask." *World Archaeology* 31 (2): 272-87.

–. 2000. "Early Nuxalk Masks." MA thesis, Department of Archaeology, Simon Fraser University.

Simmel, Georg. 1950. *The Sociology of Georg Simmel*, trans. and ed. Kurt H. Wolff. New York: The Free Press.

–. 1978 [1900]. *The Philosophy of Money*. 2nd ed., trans. Tom Bottomore and David Frisby. New York: Routledge Press.

Sirois, W. James. 1996. *Kimsquit Chronicles, 1776-1996.* Hagensborg, BC: Skookum Press.

Smith, Linda Tuhiwai. 1999. *Decolonizing Methodologies: Research and Indigenous Peoples.* London and New York: Zed Books Ltd.

Smith, Valene L., ed. 1989. *Hosts and Guests: The Anthropology of Tourism.* 2nd ed. Philadelphia: University of Pennsylvania Press.

Spencer, Victoria. 2001. "Intellectual and Cultural Property Rights and Appropriation of Hopi Culture." In *Katsina: Commodified and Appropriated Images of Hopi Supernaturals,* ed. Zena Pearlstone, 170-77. Los Angeles: UCLA Fowler Museum of Cultural History.

Spivak, Gayatri. 1987. *In Other Worlds: Essays on Cultural Politics.* London: Methuen.

–. 1993. *Outside in the Teaching Machine.* New York and London: Routledge Press.

Stack, Carol. 1974. *All Our Kin: Strategies for Survival in a Black Community.* New York: Harper and Row Publishers.

Stainsby, Mia. 1994. "Gallery Showing Passport to Survival for Nuxalk Artisans." *Vancouver Sun,* 10 May: C5, C7.

Steiner, Christopher B. 1994. *African Art in Transit.* Cambridge: Cambridge University Press.

–. 2001. "Rights of Passage: On the Liminal Identity of Art in the Border Zone." In *The Empire of Things: Regimes of Value and Material Culture,* ed. Fred R. Myers, 207-331. Santa Fe/Oxford: School of American Research Advanced Seminar Series/James Currey.

Sterngold, James. 1998. "Art Abroad: A Spirit Lives on, as Magical Masks Guard Indian Traditions." *New York Times,* 26 August: E1-2.

Stewart, Susan. 1993. *On Longing: Narratives of the Miniature, the Gigantic, the Souvenir, the Collection.* Durham and London: Duke University Press.

Stott, Margaret A. 1975. *Bella Coola Ceremony and Art.* National Museum of Man, Mercury Series, Canadian Ethnology Service Paper 21. Ottawa: National Museums of Canada.

Strathern, Marilyn. 1988. *The Gender of the Gift.* Berkeley: University of California Press.

–. 1994. "The New Modernities." Paper presented at the Conference of the European Society for Oceanists Knowing Oceania: Constituting Knowledge and Identities, Basel, Switzerland.

–. 1999. *Property, Substance and Effect: Anthropological Essays on Persons and Things.* London: Athlone Press.

Suttles, Waynes. 1991. "Streams of Property, Armor of Wealth: The Traditional Kwakiutl Potlatch." In *Chiefly Feasts: The Enduring Kwakiutl Potlatch,* ed. Aldona Jonaitis, 71-134. New York/Seattle and London: American Museum of Natural History/University of Washington Press.

Tallio, Peter. 1997. "History of Acwsalcta: The Tenth Year under One Roof." *Acwsalcta Play Potlatch Newsletter* (Bella Coola), pp. 1-9.

Tennant, Paul. 1990. *Aboriginal Peoples and Politics: The Indian Land Question in British Columbia, 1849-1989.* Vancouver: UBC Press.

Tepper, Leslie H., ed. 1991. *The Bella Coola Valley: Harlan I. Smith's Fieldwork Photographs, 1920-1924.* Mercury Series, Canadian Ethnology Service Paper 123. Ottawa: Canadian Museum of Civilization.

Thomas, Nicholas. 1991. *Entangled Objects: Exchange, Material Culture, and Colonialism in the Pacific.* Cambridge and London: Harvard University Press.

–. 1992. "The Inversion of Tradition." *American Ethnologist* 19 (2): 213-32.

–. 1995. "Kiss the Baby Goodbye: Kowhaiwhai and Aesthetics in Aotearoa New Zealand." *Critical Inquiry* 22 (1): 90-120.

–. 1996. "A Second Reflection: Presence and Opposition in Contemporary Maori Art." *Journal of the Royal Anthropological Institute* (new series) 1: 23-46.

–. 1999. *Possessions: Indigenous Art/Colonial Culture.* London: Thames and Hudson.

Thommasen, Harvey, ed. 1993. *Grizzlies and White Guys: The Stories of Clayton Mack.* Vancouver: Harbour Publishing.

–. 1994. *Bella Coola Man: More Stories of Clayton Mack.* Vancouver: Harbour Publishing.

Thornton, Mildred Valley. 1966. *Indian Lives and Legends.* Vancouver: Mitchell Press.

Todd, Douglas. 1996. "Injunction Halts Sale of Famed Mask to US Collector." *Vancouver Sun,* 3 July: B2.

Todd, Loretta. 1990. "Notes on Appropriation." *Parallelogramme* 16 (1): 24-32.

Townsend-Gault, Charlotte. 1991. "Having Voices and Using Them: First Nations Artists and 'Native Art.'" *Arts Magazine,* February: 65-70.

–. 1995. "Translation or Perversion? Showing First Nations Art in Canada." *Cultural Studies* 9: 91-105.

–. 1997. "Art, Argument and Anger on the Northwest Coast." In *Contesting Art: Art, Politics and Identity in the Modern World*, ed. Jeremy Clancy, 131-64. Oxford: Berg Press.

Trinh, T. Minh-ha. 1989. *Woman Native Other: Writing Postcoloniality and Feminism.* Bloomington and Indianapolis: Indiana University Press.

Van Evra, Jennifer. 1998. "Forgotten Masks Come Home." *Vancouver Courier,* 7 June: C1.

Varty, Alexander. 1998. "Culture Merchants Dangle Wares." *Georgia Straight,* 18-25 June: 75.

Walden, David A. 1995. "Canada's Cultural Property Export and Import Act: The Experience of Protecting Cultural Property." In *Material Culture in Flux: Law and Policy of Repatriation of Cultural Property* (special issue), *University of British Columbia Law Review,* 203-16.

Wallis, Brian. 1991. "Selling Nations." *Art in America* 79: 85-91.

Webster, Gloria Cranmer. 1995. "The Potlatch Collection Repatriation." In *Material Culture in Flux: Law and Policy of Repatriation of Cultural Property* (special issue), 137-41. Vancouver: University of British Columbia Law Review.

Weiner, Annette. 1992. *Inalienable Possessions: The Paradox of Keeping-While-Giving.* Berkeley: University of California Press.

Westdorp, David. 1987. "New Chief Counselor Archie Pootlass Aims to Improve Native Education." *Coast Mountain News,* 4 March: 3, 5.

Wild, Paula. 2004. *One River, Two Cultures: A History of the Bella Coola Valley.* Canada: Harbour Publishing Company, Ltd.

Wilk, Richard. 1995. "Learning to Be Local in Belize: Global Systems of Common Difference." In *Worlds Apart*, ed. Daniel Miller, 110-33. London and New York: Routledge Press.

Ziff, Bruce, and Pratima V. Rao, eds. 1997. *Borrowed Power: Essays on Cultural Appropriation.* New Jersey: Rutgers University Press.

Index

Printed and bound in Canada by Friesens

Set in Stone by Artegraphica Design Co. Ltd.

Copy editor: Joanne Richarson

Indexer: Adrian Mather

Proofreader: Dianne Tiefensee

Cartographer: Eric Leinberger